THIS BOOK
BELONGS TO

DON'T FENCE ME IN

Images of the Spirit of the West

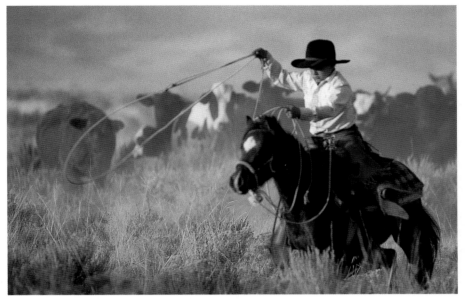

Spike Hoggan

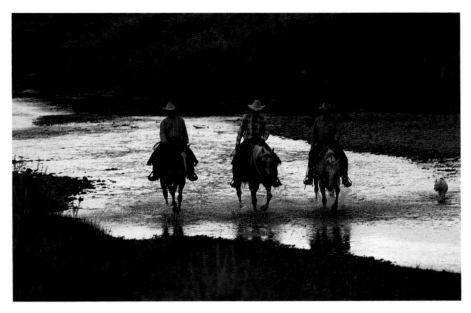

Jack Hall with father Chuck and grandfather Tom Hall

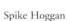

Dedicated to Spike Hoggan and Jack Hall

In the West, family is everything.

The children are the next generation; they are why we preserve it.

These two young men left us in the summer of '95. They were the next generation of two great western families.
I had the honor of knowing and being friends with these two young men who embodied the spirit of the West and the spirit of ranching families.
This book is dedicated to both of these young men whose fathers, mothers and grandfathers are in this book.

We will all miss them, but we know that they are watching us from above and that they want us to keep the spirit of the West alive—and to do it right.

David R. Stoecklein

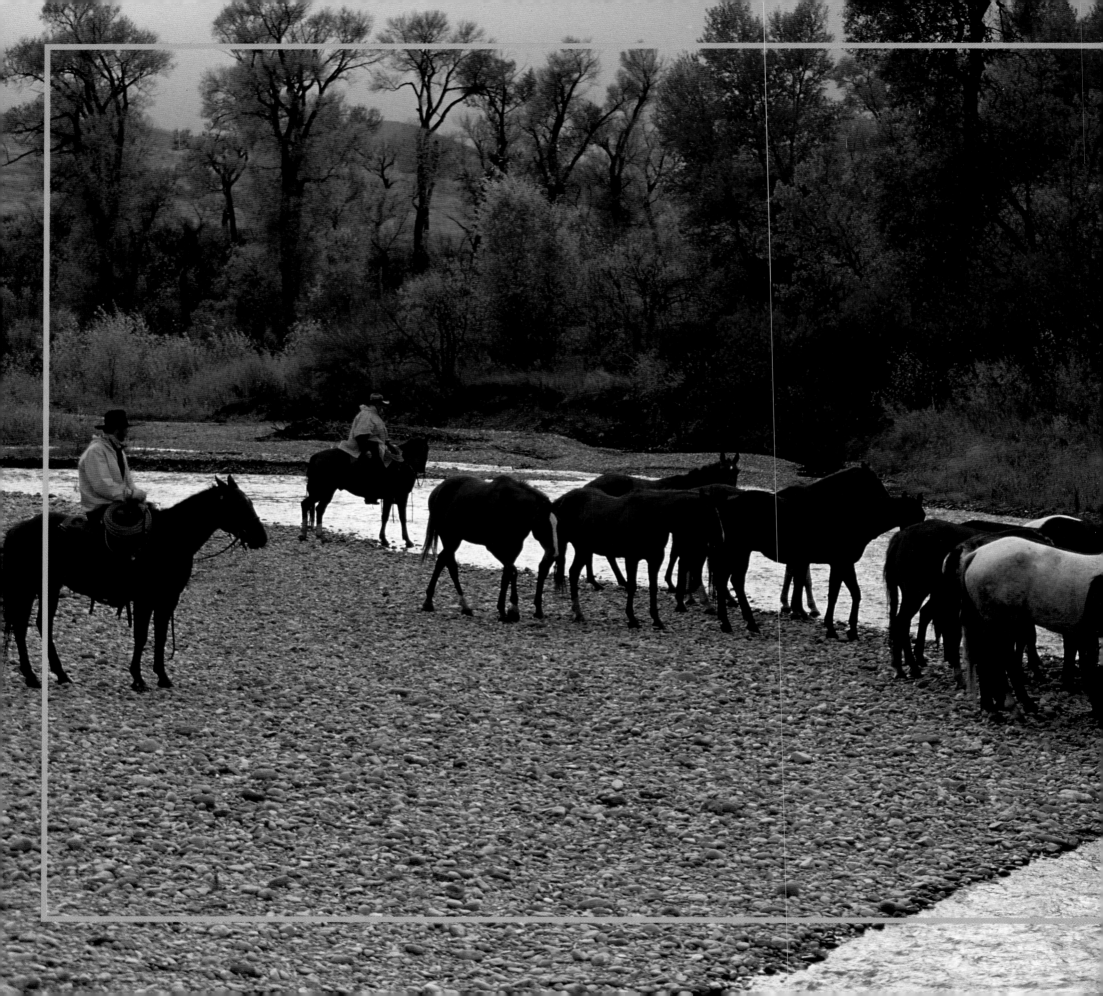

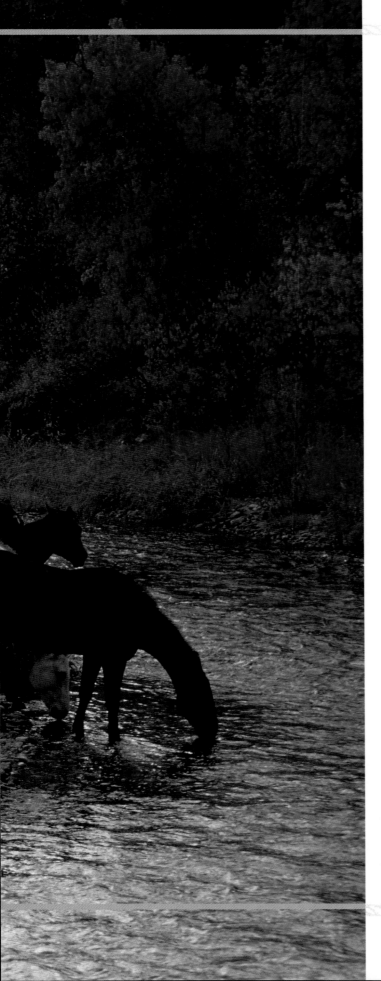

"There are very few businesses so absolutely legitimate as stock-raising and so beneficial to the nation at large; and the successful stock-grower must not only be shrewd, thrifty, patient, and enterprising, but he must also possess qualities of personal bravery, hardihood, and self-reliance to a degree not demanded in the least by any mercantile occupation in a community long settled. Stockmen are in the West the pioneers of civilization, and their daring and adventurousness make the after settlement of the region possible. The whole country owes them a great debt."

Theodore Roosevelt
from Hunting Trips of a Ranchman (1885)

Watering the Remuda
J2 Brown and Shane Hoopes, Sunlight Ranches; Wyola, Montana

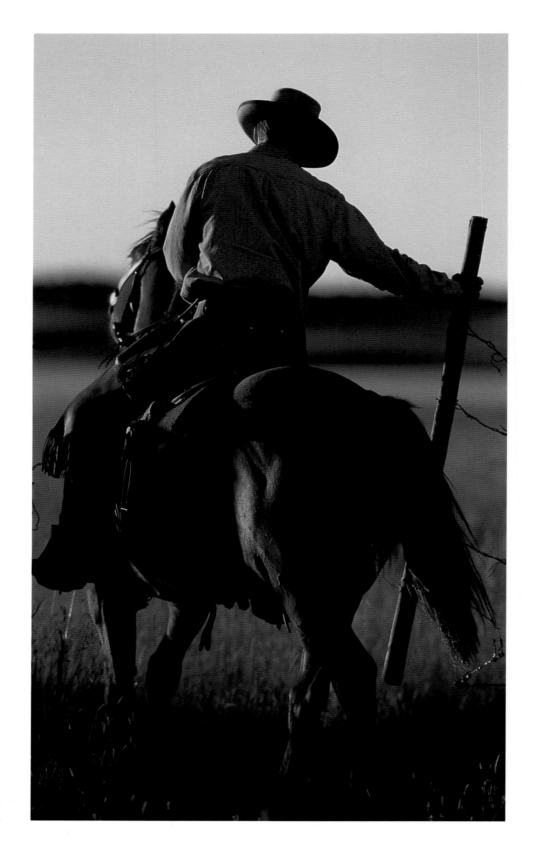

I'll Get It
Charlie Lyons, Big Springs Ranch; Bruneau, Idaho

DON'T FENCE ME IN

Images of the Spirit of the West

Photography by David R. Stoecklein

Illustrations by Buckeye Blake

Published by

Dober Hill Ltd. an Imprint of

STOECKLEIN PUBLISHING

DON'T FENCE ME IN

Photographer/Creative Director David R. Stoecklein

Illustrations/Design Buckeye Blake

Photographer's Assistant Eric Evans

Cowboy Interviews David R. Stoecklein

Production Coordinator Jennifer Rowland

Pre production Vicky Hanson

Design & Production woodland&kopfer design

Editor Dan Streeter

Cowboy Song Consultant Scott Preston

Case Cover Art Ricky Link and Craig Boyd; Woods Livestock Ranch; Crowley Lake, Owens Valley, California
Dust Jacket Photo Front: Ricky Link and Craig Boyd; Woods Livestock Ranch; Crowley Lake, Owens Valley, California **Back:** Lewis Feild, Diamond G Ranch; Elk Ridge, Utah

All images in this book—including original illustrations by Buckeye Blake—are available as original gallery prints as well as stock photography and photo CD's for all your advertising needs. Please call our office with your special request. 1-800-727-5191

Published by
Dober Hill Ltd. an Imprint of
STOECKLEIN PUBLISHING

Printed in Hong Kong through Palace Press International
Copyright ©1996 David R. Stoecklein/Stoecklein Publishing
ISBN 0-922029-26-1
Library of Congress Catalog Number 96-92268

SPECIAL THANKS

I would like to thank all my friends and companions who helped me and put up with me while I learned about the West and about cowboys.

Ray Seal, Mike Seal, Jack Goddard, Jay and Nancy Hoggan, Monte Funkhouser, Chuck Hall, Tom Hall, Ann and Tom B. Saunders IV, Thomas Saunders V, J-2 Brown, Brett Reader, Bobbie Marriott, Jim Martini, Jo N. Mora, Spider Teller, Lester and Leona Hatch, Lloyd Davies, Ace Black, Martin Black, Raymond and Jackie Jayo, Lewis Feild, Mickey Young, Darrell Winfield, Darrell Leavitt, Chester Stidham and Buckeye Blake.

Also important to my success has been *Western Horseman* magazine, The American Paint Horse Association, The American Quarter Horse Association, The National Cowboy Hall of Fame, *American Cowboy* magazine, *Cowboys and Indians* magazine, Canon cameras, BWC Chrome labs and Kodak film.

I would also like to thank my wife, Mary, and my three sons, Drew, Taylor, and Colby, who gave me so much encouragement and support as I traipsed around the west taking these photographs and playing cowboy.

Thanks,

David R. Stoecklein

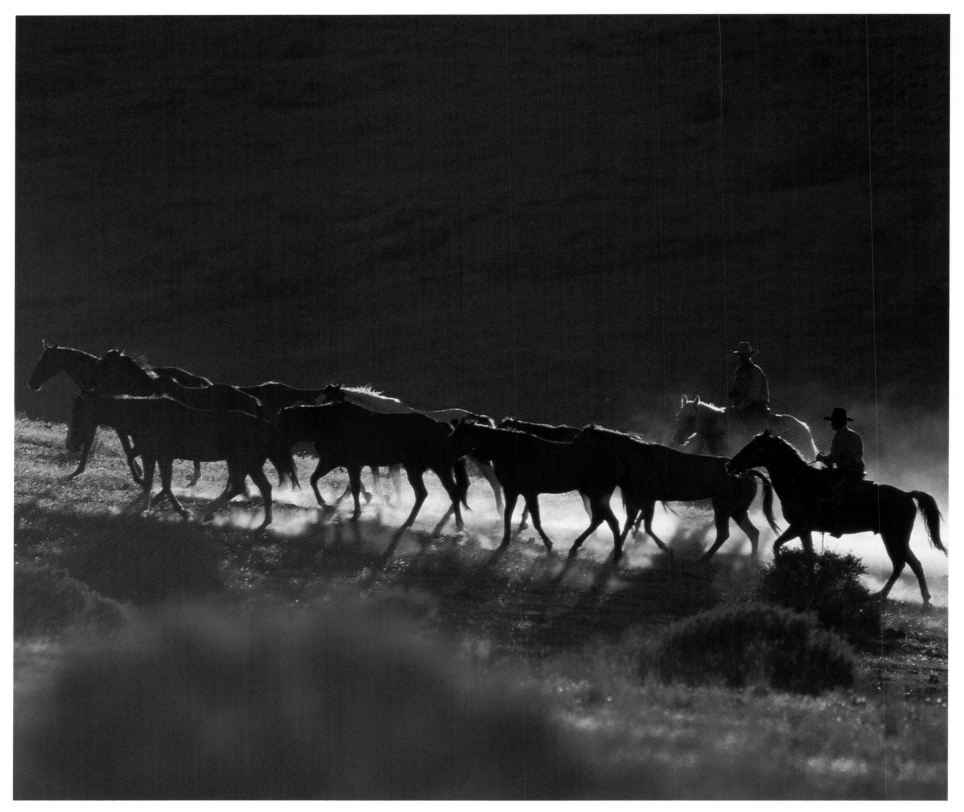

Evening Gold
Chuck Hall and Bob Howard, Howard Ranch; Bruneau, Idaho

FOREWORD

I love to sit and gaze at maps of the Western United States, to look at all the places I have been and all the places I would like to go.
The West has always been a mystical and magical place for me—a place to dream about.

When I was young, I used to draw pictures of rugged log cabins tucked in remote valleys, nestled at the bottom of majestic mountains.
I dreamed of living there with horses, cows, wide-open spaces, big blue skies, red rock canyons, clear freshwater mountain streams, rivers, and lakes.
I dreamed of driving down long, endless roads, and being able to look out and see for a hundred miles.

For the last 27 years I have lived my dream. Along the way, I have photographed those wild and beautiful places.
My photographs have appeared in photo books, calendars, cards, and prints, communicating my vision of the past, present, and future.
Corporations use my photos of the West to promote their products in advertisements and on posters and billboards.

My goal is to make my photographs different, to make them powerful.
I strive to create images that talk to the viewer, telling a story and conveying a sense of the West and the people who lived there in the past and who live there now.

The stories my photos tell have been told before by painters, sculptors, poets, authors, song writers and, of course, fellow photographers.
We each have looked at the West and immersed our lives in it. We have become a part of it and have told our story through our own special mediums and in our own special ways.

I try to make my vision true to the spirit of the West and the people who live there. To do this right, I became a student of the West, the cowboy, the cowgirl and the cattle business.
My classrooms have been the great and not-so-great ranches sprawling from Texas to Idaho. During my studies I have read every book on the West I could find, and asked every
question I could think to ask concerning the business of raising cattle. Then, eight years ago with my brother Walter, I bought a ranch, a bunch of horses, and a few cows.

Since then, I have learned to ride and rope; not very well, but good enough to get a job done or to compete, gaining a little respect from men and women who give it only if you
earn it. It is important that I know how to do all these things, because in my work I try to show the world a realistic representation of a special and unique way of life.

It is an honor to be a part of all of this. I hope my photographs help to keep the spirit of the West alive.

David R. Stoecklein

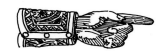

CONTENTS

Cowboy Meeting
Lynn Smith, Bucky Johnson, Monte Newman, and Bill Barrett—Eastern Idaho cowboys

On this day July 18th 1995
Monte Newman and Bucky Johnson enter
Into this agreement with the picture taker,
with us, having a sound mind.

It is understood that we will not
be photographed, riding Paint horses or
wearing Stupid looking costumes.

Any nude scenes will be negociated
indiverdually, and we pick the starletts.

Any action on the part of the picture
taker, either intentional or by accident
to make either of us look worse than
we are, will result in the picture taker
being Soundly pistol whipped.

Sign

[signature]

THE COWBOY CONTRACT

A Personal Statement

In the summer of 1995, Bucky Johnson and Monte Newman asked me to sign the contract you see at the left. At first I thought the contract was funny, and I continue to find humor in it. But shortly after my first reading of that hand written document, I came to understand how important it was.

It was not only a contract between Bucky, Monte, and me, but it was the contract I had been working under for the last 10 years with cowboys throughout the West. Before it had always been an unspoken contract . . . the law of the West.

The terms of the contract were this: it was okay for me to enter these cowboys' lives, to stay on their ranches, to take photographs of them, and to show the world how they lived, saddled their horses, used their gear and tack, tended their cattle, and cared for their families and their land. I was let in and put up with, and my questions were answered, as I was taught how to ride, rope, and behave in the cowboy way.

Over the years, I have come to deeply respect the men, women, and children of the West, and the art of being a cowboy. I have been lucky to photograph the best, the guys who do it right, who work to preserve the Western tradition—the proper way to ride and care for horses and cattle while maintaining good stewardship of the land.

These people are preserving a style of horsemanship and a way of life found nowhere else in the world. Cowboys do things the way their grandfathers did, not just because he did it that way but because it is the right way and the best way to do it. Sometimes it is the only way.

The way you dress, the type of gear you use, the way your horse handles, how you rope, and what you know or sense about cattle and horses tells a cowboy how good you are. There is an art to their profession, and cowboys are artists in every sense of the word.

I hope I have kept my end of the contract in all my photographs documenting the Western way of life.

David R. Stoecklein

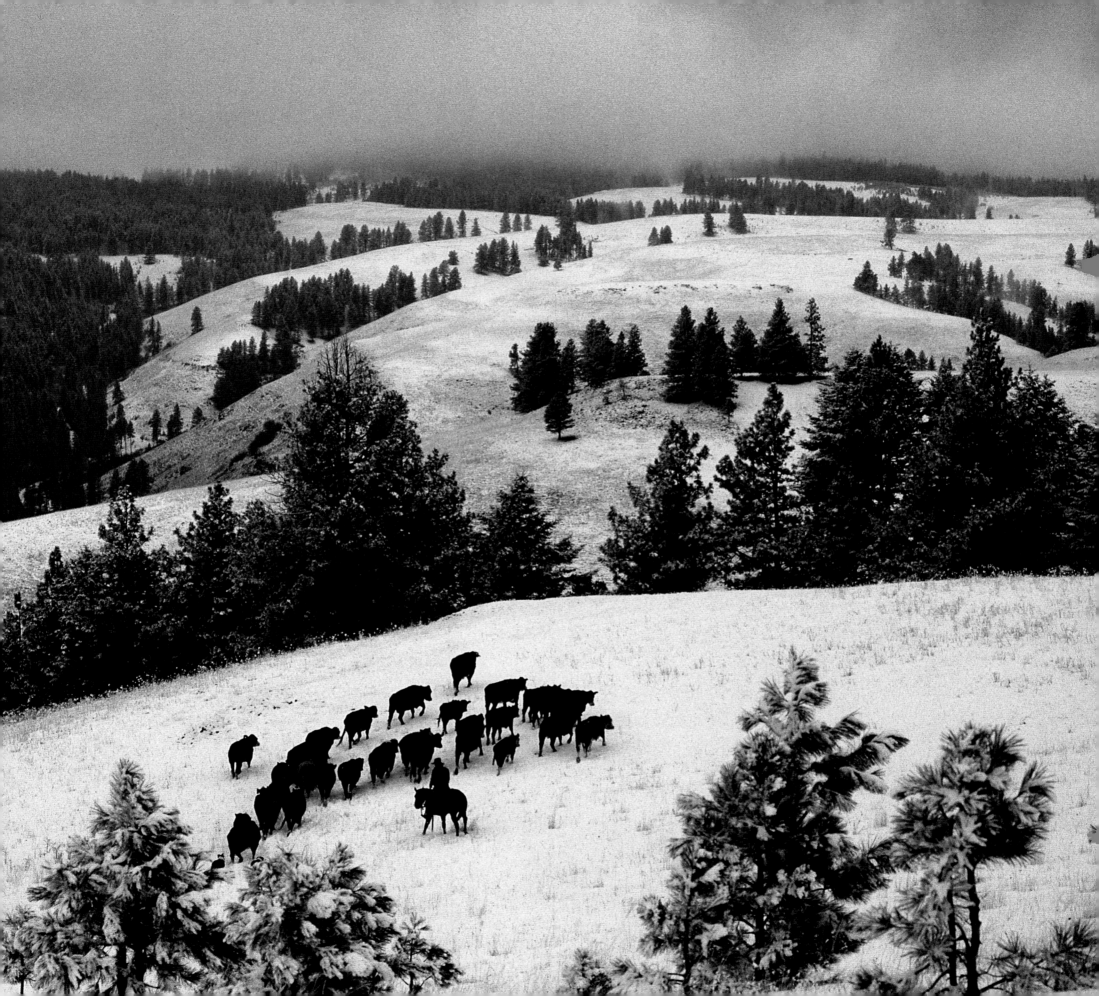

INTRODUCTION

The legends of the cowboy, the great stories of honor, bravery, and hardship, were born almost as soon as the West was settled in the 1800s. Popular accounts of the cowboy's adventures appeared throughout the world, brought to life by dime novels and newspapers. Books written by outstanding authors such as Will James and Jo Mora were read and re-read by men, women, and children. The masterpieces of Charles M. Russell and Frederic Remington received worldwide acclaim.

The myths and images of the West were so well promoted that by the 1950s everyone knew of the cowboy—or thought they did. But the movies and books did not always portray the men as they really were, often romanticizing the cowboy's life. In fact, a life in the saddle was a life spent working from before sunup to after sundown with men you could trust to be there when you needed them. It was a life spent herding cattle in all types of weather, riding wild horses, chasing wild cows, and sleeping under the stars.

But by the 1950s the once-boundless West was divided into homesteads, ranches, towns, and government-owned land. The range was fenced, and asphalt highways and steel railroad tracks crisscrossed the tamed country.

The days of the great cattle drives were over. The infamous outlaws, cattle rustlers, and sheriffs whose names will forever be etched in history were long gone. The wars with the Indians were but a bitter memory. Cowboys now worked on ranches that had boundaries, and the cattle they tended were no longer the wild Texas Longhorns, but had names like Angus, Hereford, and Brahma.

Instead of riding half-broke mustangs, these modern cowboys were mounted on well-trained Quarter Horses, Paints, and Appaloosas. These cowboys wore boots, hats, chaps, and spurs, and used bits and saddles that would have seemed impossibly luxurious to their early range-riding predecessors.

What follows in this book are real stories of modern cowboys, of real men. The traditions of horsemanship and honor that have been passed from generation to generation are now being handed on to these cowhands.

I titled this book *Don't Fence Me In* because the West calls to that spirit of adventure and freedom found in wide-open spaces, big blue skies, and families working together. The subtitle, "Images of the Spirit of the West," reflects the images you will see on the following pages which capture just that.

The cowboys in this book ride much as their fathers and grandfathers rode. They herd their cattle and take care of their land under the same code of the West that has stood as the law of the land since the time when there was no law.

I have tried to capture these cowboys' day-to-day lives on film, and to portray them as honestly and realistically as I can with my camera. I am honored to be able to help document their way of life for future generations. Although this has been done before by great artists and photographers, I hope that my vision and my way of capturing this spirit offers a fresh look. I hope this book remains a record for all time.

David R. Stoecklein

Bringing Them Home
Wade Planner; Riggins, Idaho

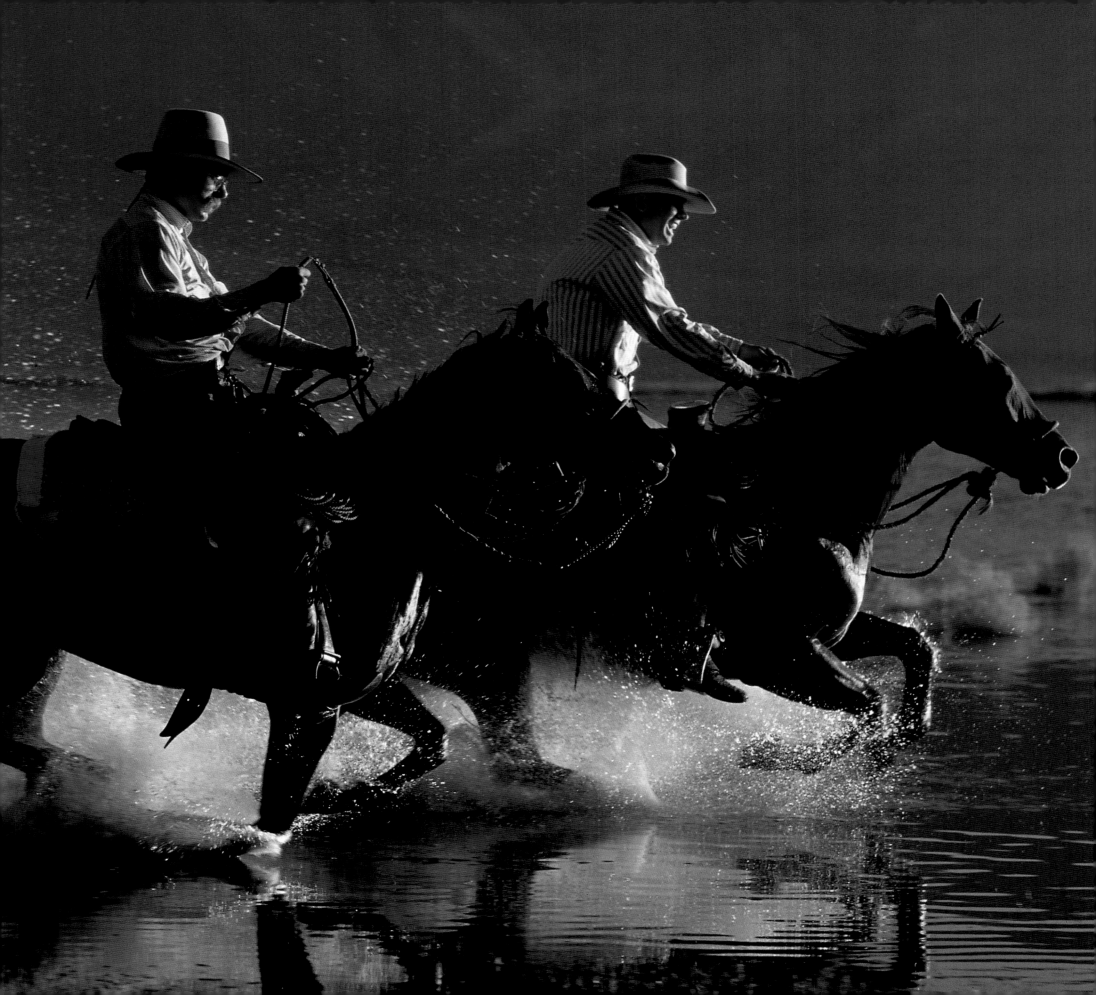

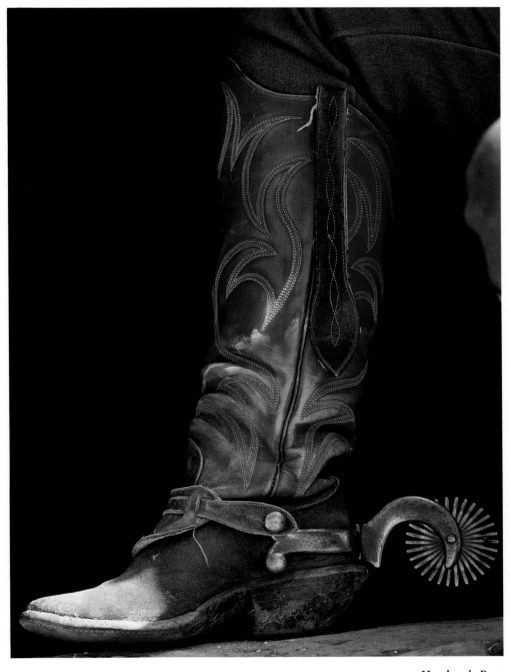

Handmade Boots
George Martin; Bruneau Desert, Idaho

Cool Running
Ricky Link and Craig Boyd of Woods Livestock Ranch;
Crowley Lake, Owens Valley, California

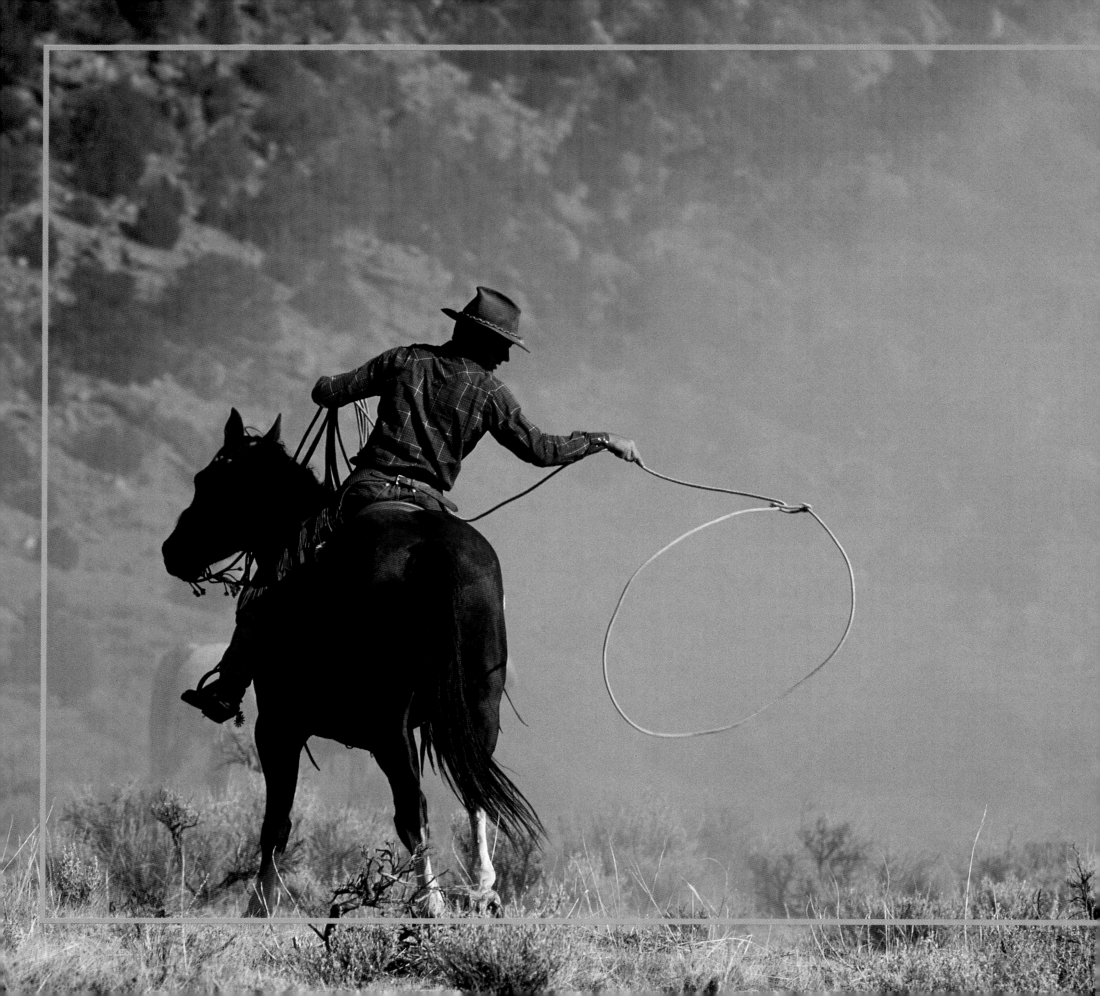

Jess, a wild cowboy, loves whiskey and beer,
And can tail a small yearling or tie down a steer.
While standing night guard—for some fun, that's all—
He twined a wild yearling which loudly did bawl.

—Jess' Dilemma

The Race
Curt Pate and Mike Seal

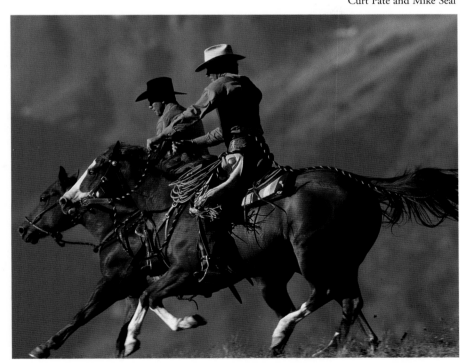

Attitude Is Everything
Chad Williams, Dragging Y Ranch; Grant, Montana

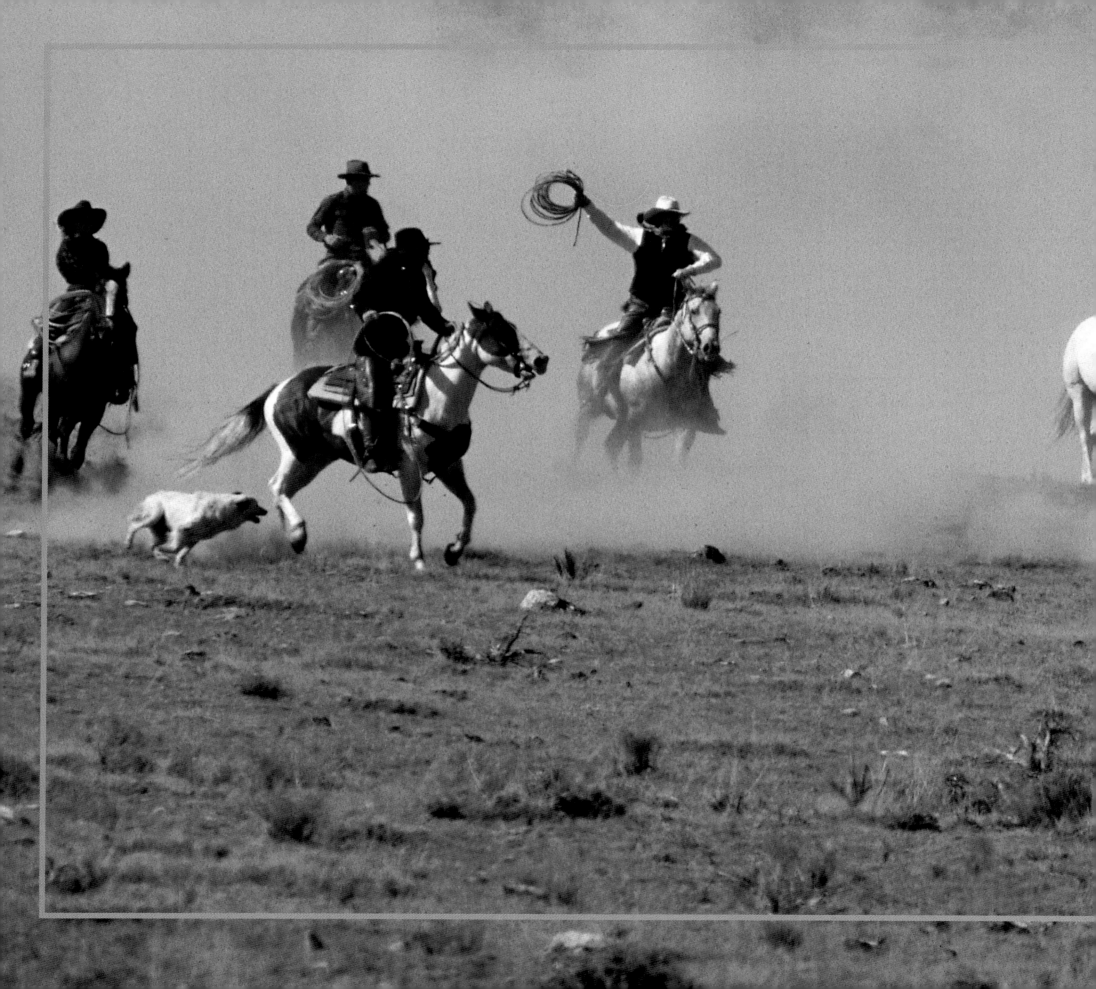

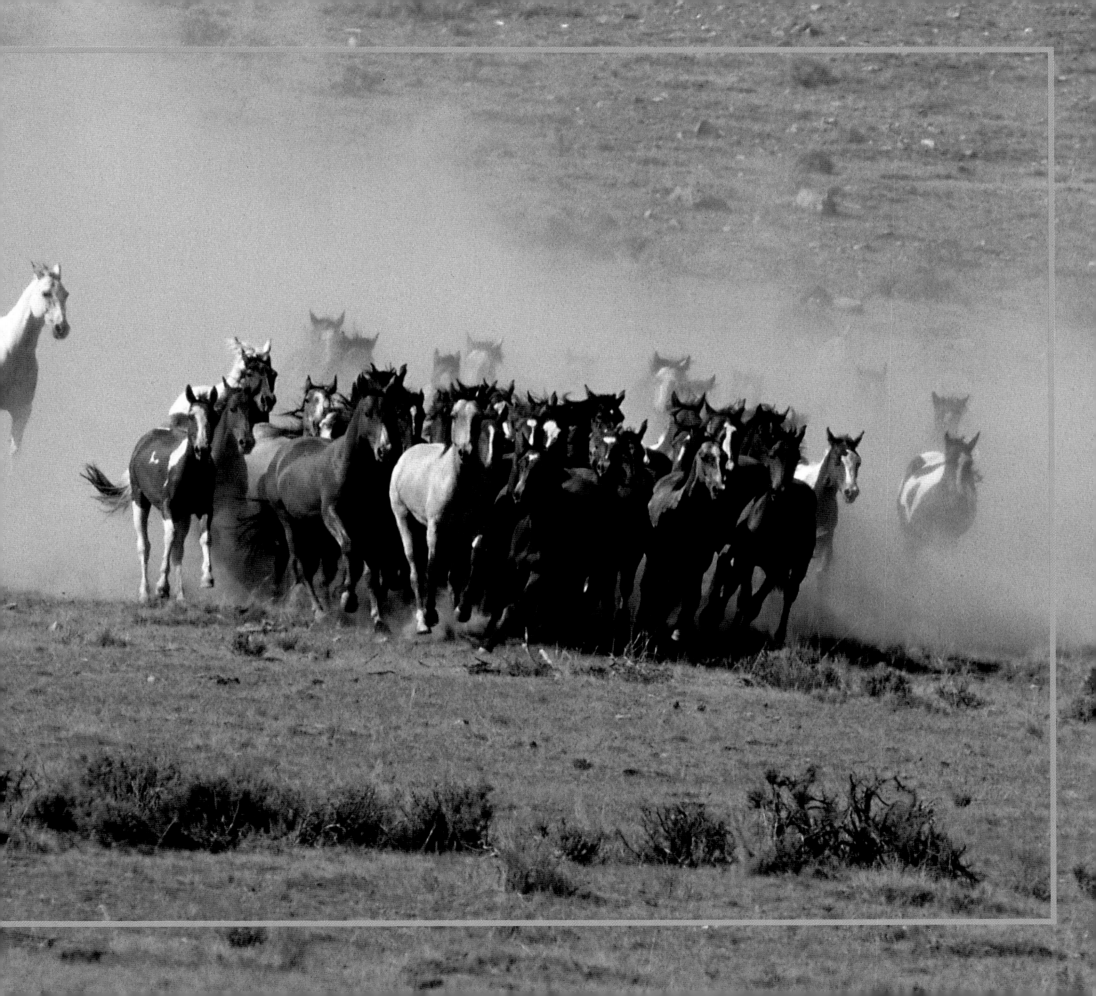

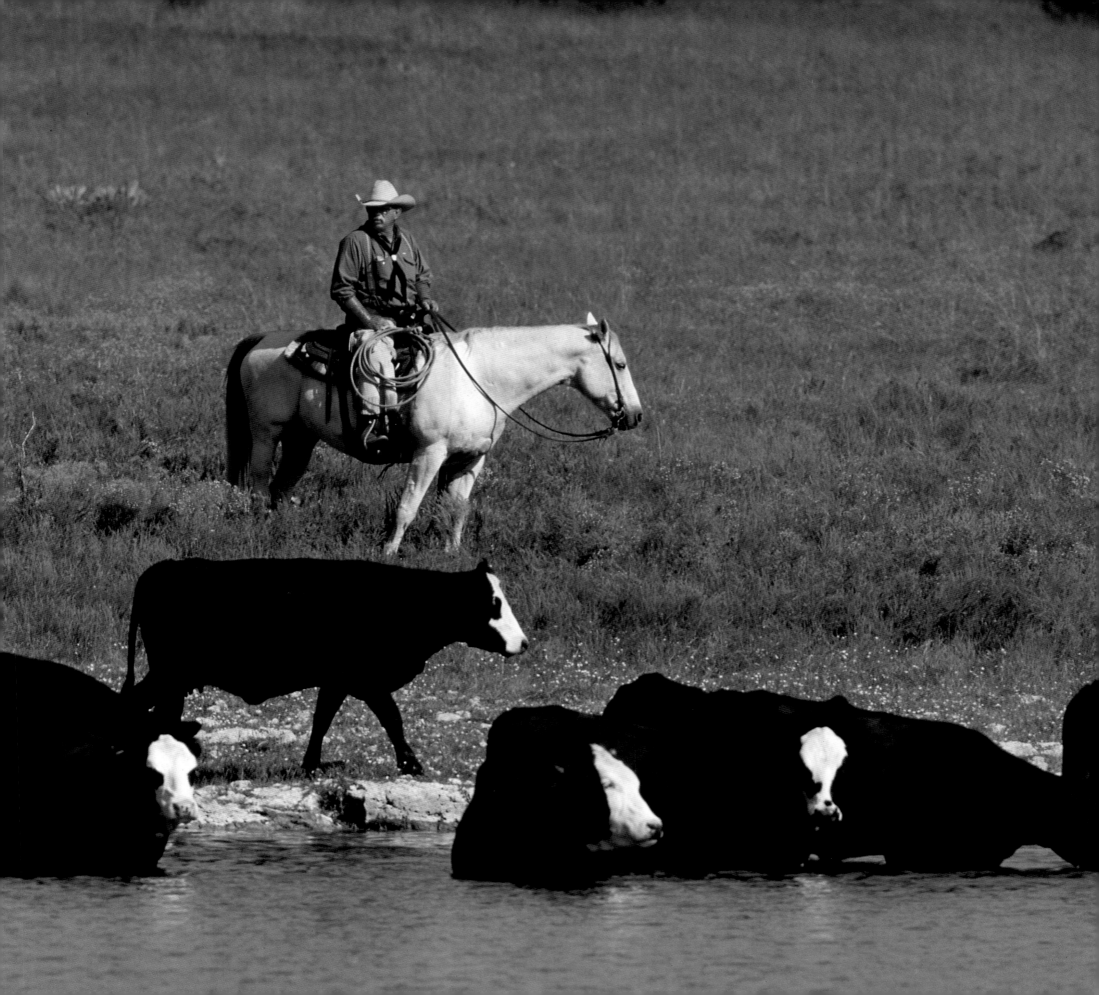

WE ARE RAISERS OF GRASS

It's not the man that makes the times, it's the times that make the man, says Tom B. Saunders IV

As far as I know the history of my family, the last place they resided before coming to Texas was in Mississippi. In 1840, they came to Texas in covered wagons and trailed a beef herd with them. That was Tom B. Saunders the first, who I'm named after. I'm Tom B. Saunders the fourth. They settled in Gonzales County and remained there for eight or nine years before moving up to Goliad County. The cows they brought with them could have been some English breeds, but that strain ran out. They were mostly milk cows and some for beef for their own consumption.

When they got to Texas there were a lot of wild cattle, longhorn cattle, running loose. They caught wild cows or purchased some that were already domesticated. So that's how they finally built their herds and that's when they learned the skills of the cowboy.

In Texas in 1840 it was all open range. There were no fences. There weren't any large towns. We weren't merchants, we were people of the land and it was just natural that the cattle came with the land, and that's how we made a living. A man could get as big as he wanted to get. The range was there and you just built your numbers. The people who were able to sell and get cash money, who could hire people and control more land, could control more cattle. That's how they got bigger and bigger.

Those with foresight knew that if they controlled the water, they controlled the grass. So they'd use the Homestead Act and hire some boys just to homestead around the water holes. Then they would buy them out. It didn't cost anything to homestead. You had to build a structure and stay there so long in order to file and get a deed to it. Then, in the 1870s, the government started selling land. Charles Goodnight and some of the old ranchers were trying to establish a price for the land, and Charlie wanted the government to lease the land for two cents per acre. The government decided on four cents, and Charlie thought that was outrageous.

Once they got the Comanche Indians off the plains in the Texas Panhandle, then the ranchers started moving herds in and establishing ranches. That's when Goodnight established a tremendous ranch in Palo Duro Canyon.

Tom B. Saunders IV

Goodnight was the first, or one of the first, trail drivers. In the late 1850s and early 1860s, he was trailing Texas Longhorn breeding stock into New Mexico and Colorado and selling them to ranchers who were starting herds. There wasn't any market for steer cattle for consumption, it was mostly breeding stock.

Because there weren't any markets in Texas in the 1860s, my family had to seek any kind of sale they could find. Some Texans were selling cattle in Louisiana then. They went there because the French were still dominant and there was a lot of shipping into that area. They were shipping cattle out on boats, taking them to different ports in the United States. That was a slow way of going, and the ships of that time couldn't hold a lot of cattle, but that was about the only market known to anybody in that period where they could receive cash. Otherwise it was mostly all barter, trading for their needs.

Then the Civil War came along and they sold some cattle to the Confederate Army. In 1863, when he was 16, my great-grandfather and several other boys took a herd to Louisiana and then on into Mississippi, trying to locate the Confederate Army. But the Yankees had moved them out and those boys kept riding east, riding up to the Mississippi River. Being young boys with little fear—they had crossed many rivers by the time they left home — they just busted those cows off in that old Mississippi and swam them across. To my knowledge, there's never been another herd swam across the Mississippi at that location. It was a mile wide and 40 foot deep where they crossed.

My great-grandfather took that herd on into Mobile, Alabama, to the Confederate Army.

After the Civil War, they finally got a railhead into Abilene, Kansas, and that's when the trail driving period started. That period lasted into the 1880s. For about 10 or 12 years, Kansas had the closest railhead to Texas. Finally the railroad made it into Fort Worth, but the Fort Worth stockyards didn't get started until 1902.

To a certain extent, those early cattlemen knew the cowboy way when they arrived in Texas. They had some good horses they brought with them, and I imagine they learned

a lot handling the wild cattle, which were a completely different species than they were used to. I'm sure the Mexicans showed them a lot of tricks that they didn't know about, like using the long rope to catch stock.

But I think the American cowboy was really born in Texas. The whole mystique of the cowboy originated here. The big hat, the dress and, of course, the boot were designed for horseback work and the temperatures we experience here. The boots certainly weren't designed for walking, especially in that early period, because they had 3 1/2-inch heels and pointed toes. Their way of life, their dress and their mannerisms all came about because all they did was handle cattle each and every day for their livelihood.

The term "cowboy" means the man that works the cattle. The word comes from the Spanish word, *vaquero*. A vaquero is a tender of cows. Back in the 1500s, that word was put on the Indians that were tending the cattle belonging to the Spanish priests in Mexico, on the Texas border, and along the Rio Grande River. The vaqueros were the ones who started roping and designing saddles to hold rope, and who upgraded the horses to handle ropes and big cattle.

The term "cowman" refers to the owner who has the responsibilities of bookkeeping and finances. But cowboy and cowman are synonymous to me,

because back in that time there weren't any cowmen who weren't cowboys. They came up through the ranks just like all the rest of them. Some of them had bigger dreams or were more dynamic people who had the vision of where the industry was going and tried to gear up for it. Charles Goodnight was one of those people. When he was 14 years old, he camped out and loose-herded his family's herd year-round.

It's not the man that makes the times, it's the times that make the man. That was their way of life. It was their only means of providing for themselves besides what little garden spots they had. They took great pride in what they did and how they could handle wild cattle, how they could get them to where they would herd and could drive them somewhere and do something with them.

Honor is a very important thing to a cowboy. If a man tells you something, then that's the way it is. You don't have to worry about it. Contracts are written on paper, and if a guy's going to beat you, he's going to beat you. But if a man can look you in the eye and say, "Tom, this is what I'm going to do," then that's good enough for me because he'll have to live with himself. If he's not honest enough to look me in the eye and stay with

the deal, then it's good for me to know it.

That's kind of the mystique of the cowboy. He's always been an honest person, like the horse he rides. He doesn't want that horse lying to him. I knew my horse was honest because when it got dark after he packed me all day, he still got me home. That's what counted.

The environment in which a cowboy lives has shaped what he wears. The broad-brimmed hat, brush jackets, and leggings are all part of it, so much a part of it that we probably wear these clothes in places where we don't really need that kind of protection, but just feel comfortable wearing it. It's who we are.

Cowboys dress different in different areas. These differences have evolved over time and reflect the cowboys' pride in who they are, where they come from, and what's worked good for them. In parts of Texas, for instance, the boys all wear different creases in their hats. The way they ride, actually all their gear, depicts where they are from. Just by looking, I can tell the South Texas boys and East Texas boys, and it's been that way forever.

There is something about a cowboy. We are all like cattle. We have herding instincts, we like to be with others, but most cowboys would rather be with God and nature and their horse and the cattle. Those things are probably a better friend to

him than some man.

The cowboy life instills individuality. I know a guy as old as I am, 60, who's worked on the same ranch since he was 14 years old, all his life. He lives in a bunkhouse. If you ask an old boy living in one of those camps somewhere who sees somebody once a week if he's lonely, he'll just laugh at you. There is more to do and more to see where he is than there would be if he was standing on a street corner watching the people walk by. He's not lonely. That's the kind of thing he likes. It might be solitude, but he isn't dictated to or pressured by others. He has a lot of time to think about a lot of things that other people don't even realize exist.

There's a lot of pavement pounders who don't see the stars come out or the moon come up, or see a sunset or sunrise. All they see is the smog. Man, I couldn't do that. They just don't realize what they are missing. You feel next to God because you are seeing creation like He made it, not like man made it.

That's what makes those old boys do what they do. That's what makes them the kind of cowhands they are. A cowboy has a relationship with nature. He still lives his life out

side every day, horseback every day. He studies his cattle and wants them to do well. That's a true cowman.

They say the acorn doesn't fall far from the tree. I'm a fifth-generation rancher in Texas, and my sole income comes from cattle. That's the way my dad was, my grandfather, and on back. I'm holding up the tradition of my family. It's bred in me.

Sometimes you worry about the wisdom of it as far as the financial end of it is concerned, because it's really not a business. Being a cowboy is a way of life, it's not an occupation. Like me sitting here on several million dollars worth of land, and sometimes I worry how I'm going to buy the next groceries. I don't have any money, but I wouldn't trade my life for anything. If I have to sell an acre of land it's like losing part of the family.

A cowboy's work ethic is really his code—it's his belief. I haven't worn a watch on my arm in 30 years. The only time I look at a watch is when I've got to go to an appointment, and then it's a distraction to me. You start your work when it gets light enough to see, and if you've got to ride three or four miles and be in a certain spot before daylight, then that's what you do. You work hard seven days a week, as many hours as there is daylight. And when you get through, then you rest. Cowboys take pride in what they do. They try to be the best they can be at whatever it is they are doing.

I've never really understood when a man's doing something that doesn't go back to nature, like people who make money off other people. Me raising livestock and selling it for consumption, I can relate to that. I'm producing a product for the needs of others, for their health and livelihood. But a guy who makes money off others and doesn't relate that way is hard for me to understand. That's why most people who live in the country, the ranchers, we're all neighbors and all help each other no matter what.

There's four ranches here, and we all swap labor and have a good time doing it. And anything I've got, all the neighbors know they are welcome to borrow it. I trust them to borrow it and return it in as good, if not better, condition than it was, and that's the way I do things. That's how we get along so good.

They call us cowmen, but actually we're growers of grass.

My dad said it, my grandad said it: you can't starve a profit out of an animal. We're growers of grass because without the grass you can't have the cattle. And cattle don't do well on short grass. You can't overgraze and expect to stay, and if you can't stay then you're doomed, because in our business it's not prosperity every year. You have about five years of tough and about two years of good, so you better backlog. Instead of backlogging our money, we backlog our grass. We don't hurt our country, because we know it takes years for country to build back.

The only way you can rebuild the earth is through complete rest. Kind of like having a nervous breakdown. Without complete rest, you're not gonna recover. And it's the same way with nature. You rest the land.

What wrecked things was when they developed barbed wire and started fencing the pastures and building smaller and smaller pastures and not resting anything. That old cow's gonna be there for 365 days, and she's gonna get hers as long as it's there. So you've got to be smart enough to know when to rest the land, and when to take the grass down.

You go back to the beginning, when there were millions and millions of buffalo in the United States in the West they were high-intensity, low-frequency grazers. The buffalo went through in great herds and took the grass down short. Then they'd move on and the country behind them recovered. That's the same thing we practice today when we rotate pastures. High intensity—you put all your herd in a pasture so many days—and then you put 'em in another one, and go all the way around a 12-month period.

A cowman is a man whose whole livelihood is determined by weather conditions. The market has a direct bearing on how well he's going to eat next year, whether he can gear up and buy something different or have to repair what he's got, but the main thing he's interested in is how much stock water he's going to have, how much grass he's going to grow, and how well his cattle are doing. He knows that if he does a good job with his stock, those other things will work themselves out. That's what he thinks about every day.

Are there fewer cowboys now than in days past? I would say that there's probably fewer true cowboys, men that are horseback every day and handling cattle every day. But if a guy makes a living at it, I couldn't say he's any less a cowboy than I am. I've seen guys from East Texas and think, "That sucker, he's got rubber boots on. Man, I wonder if he knows what a cow is thinking about." And you get to talking to him and hell, he knows more than most. It's just where he lives, how he handles his stock. It doesn't make him any less a cowboy. A lot of these dudes run around with their dadgum motorcycles, and I damn sure'd rather be on a horse than on one of them things. But how you do it, proof's in the pudding.

It's a little hard to get hands-on training out of a seat of a pickup, because there's things you have to do that you gotta get your hands on. But Dad had a partner up in Oklahoma, and he was a little, short, heavy-set fellow, and he drove a dadgum pickup places I wouldn't have rode a horse. I never saw him get horseback all the years I knew him, but he could tell you where a cow was and what she was doing and what she did last year.

Continuing the spirit of the cowboy is important, but a true cowboy, with those attributes that we've talked about, he doesn't think about whether it's important or not. To him, he just couldn't do any different. That's him. That's what he is, that's who he is. Most of those boys in cow camps, they don't have mirrors. Most of them don't know what they look like. That's who they are.

I run my ranch differently than they ran ranches when I was a kid. There's a different type of cattle, different in a lot of ways. But basically it's all the same thing. We've geared up to fit today's demands, and that's what we try to produce. You never get too old to learn something. You learn something new every day.

THE WEATHER

By Jack Goddard

Rowdy groggily awoke and flipped the annoying alarm off. He glanced at the translucent green numbers blinking 3:04 a.m. It was time to check the cows again. An extreme cold snap made it necessary to walk through the cows that had been sorted out and corralled in anticipation of them calving tonight. He bundled up and stepped out into the bitter cold of the clear January night and headed for the calving barn.

As he walked, the only noise he heard was the crunching his Pac boots made on the glistening snow. He stopped at the sickroom door and squinted at the thermometer, trying to read the temperature by the faint starlight. It read 35 degrees—below zero.

Calving season was only about three weeks old now, but the constant attention the cattle needed due to the cold was beginning to take its toll on Rowdy. He was tired to the bone and his normally good attitude was wearing thin. The economics of cattle ranching made calving in the dead of winter necessary in order to wean off heavier calves in the fall. And lately, with prices slipping, selling more total pounds was the only way to offset rising costs and lower bids.

But the big hurdle was fighting the weather.

Rowdy didn't usually reflect on just what effect the weather had on his life. It certainly affected his bottom line, and that was very important to him and his operation. But now it dawned on him that everything he did was a direct result of the whims of some jet stream or pressure system. The morning farm program on the radio started with the weather report and the evening news on TV allowed some quirky weatherman a few minutes to point and wave at fancy maps with arrows and funny-looking symbols indicating high- and low-pressure systems and storm fronts.

Rowdy walked slowly through the nervous heifers. Sure enough, a scared and confused black baldy had calved in the far corner, away from the straw and in a snowbank. The wet calf was white with ice, and although he hadn't been there long he was frozen stiff. Rowdy slid him onto the calf sleigh and pulled it up the alley toward the beckoning lights of the warm room. He dragged the stiff little guy into the room, dumped him in the hot box, and clicked on the heat lamps.

Rowdy then heated some frozen colostrum and tubed it into the calf's stomach. Warming him from the inside out, as well as from the outside in, would revive the little critter quickly. Another 10 minutes in that cold, and the calf would have been history. He would probably lose the ends of his ears and tail to severe frostbite, but at least he would be alive.

The cowboy was worn out and needed rest, but the cold and the activity of fussing with the calf blocked any desire to sleep. He sat down in the big duct-taped, broken-legged Lazyboy, leaned his head back and closed his eyes. He began to reflect on the past year and think about the ironies of Mother Nature, and how the weather affected his life. Here he was, stubbornly fighting against her cold, trying to calve at a time she had not intended for babies to be born. The winter storms were providing snow that was piling up several feet deep in the high mountains and that would provide runoff water to fill streams and reservoirs. That water is the lifeblood of crops and pasture during the growing season, because rain is not a normal source of irrigation for farmers and ranchers living in the western states. Water is provided by the snow—the same snow and its accompanying cold that makes life hard for cowboys.

These thoughts made Rowdy less irritable, seeing as how winter calving was his own fault.

Then he thought about last spring when cold winds dried out the hayfields and kept the grass from growing. When it did turn warm, the sprinklers needed to be turned on and the meadows flooded to keep them from burning up. Then, to top it off, a cold front had moved through in May and froze the hay down and the weight of the ice buildup darn near collapsed the pivot. After the frost, the weather cleared, turned hot, and didn't rain a drop again for weeks.

Rowdy chuckled a little at the irony of it all. He had wished it would rain. The snowpack had been normal, so he had plenty of irrigation water, but the grass on the summer range headed out early and was short and sparse. That would hurt his weaning weight in the fall. Rowdy remembered cutting the hay a week earlier than normal, hoping a good, strong second crop would offset the poor production of the first.

The calf struggled to its feet in the box. He stood there, wobbling and blinking as if surprised to be alive. He then tried to take a few steps forward and pitched headfirst, slamming against the front of the box and collapsing in a heap.

The commotion in the box barely caused Rowdy to raise an eyelid, and after things settled down again he closed that tired eye and went back to reliving the past year's weather. The calf's body sprawled on the bottom of the box reminded Rowdy of how some of his friends had ended up in town last Fourth of July. They had partied pretty hard that day, because the next day the hay would be dry enough to bale and stack. They would race the rainstorms to get it up dry, and then get the water back on the fields as quickly as possible to start the second crop.

Winter's Ghost
Lehman Canyon Ranch; Barton Flat, Idaho

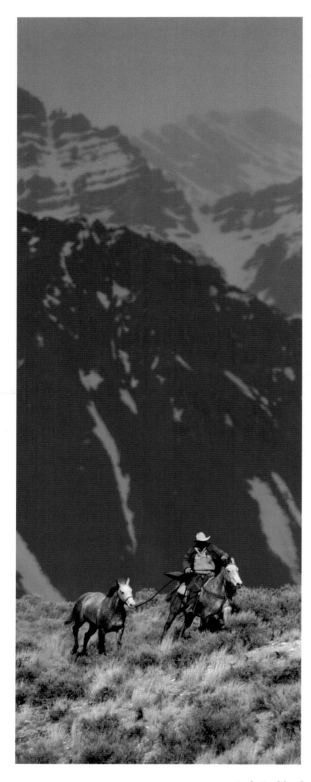

Jack Goddard
Bar 13 Ranch; Barton Flat, Idaho

Rowdy remembered waking to the drumming sound the rain made on the tin roof of his house the morning of July 5th. He got up and peered out the window at the gray light of dawn. Large puddles had formed, indicating it had rained throughout the night. He remembered his exasperation at first, then realizing he couldn't do anything about it became thankful for the moisture. The hay would dry soon enough, and he would use the break to catch up on repairs.

The trouble was, it rained for three days and then quit for three more. Then it rained for another two. After the last shower, Rowdy was fit to be tied, no longer thankful for the moisture, but wishing the heck it would quit.

Lying on the Lazyboy, Rowdy shook his head at the paradox—first wishing it would rain, then wishing it would quit because it made everything too wet.

"You know, little feller," Rowdy muttered to the now-warm calf sleeping in the heat box, "the weather around here is never like we want it to be. Both our lives would be a lot easier if Mother Nature would cooperate with our plans instead of having her own."

The first faint purple hues of sunrise began to lighten the frigid morning sky. Rowdy got up, put on coffee and turned on the radio for the morning farm and weather report. The hot black coffee tasted good. His mind back on the weather, he returned to thinking about the progression of the previous year's seasons.

After the long delay with the first hay crop, Rowdy had no trouble with the second. The rains had been timely on the range, too, allowing a good growth spurt for the grass. That paid dividends in the fall, putting added pounds on the calves.

But then fall had come early, and a heavy snowstorm in September gave the cattle the false impression that winter had begun. Even though it was early, instinct told the cattle it was time to leave the high country and head for home. They trailed head to tail, single file, out of the mountains until they piled up at the last remaining drift fence. Had it not been for the closed gates on that fence, they'd have been on the meadows a month early and would have eaten up all the fall feed. That would have been expensive for Rowdy, because it would have meant feeding hay a month earlier.

Rowdy spent five days pushing the reluctant, piled-up cattle back onto the forest meadows, trying to settle them on snowy range while they were insistent on leaving. Some of Rowdy's friends from back East were visiting then, and thought it sounded romantic and Western to be out driving cattle in the snow, high in the mountains. The romance wore off after about the first half-hour. The truth of the situation was that it was cold as hell, they were getting wet, tired, and mad. What a fight it was for that month's worth of dry feed.

"A lot of what we do is just plain stubborn and ornery," Rowdy said loud enough for the calf to hear.

Rowdy got up, pulled the calf out of the hot box and carried him to the stall where the heifer was waiting. She cowered in the far corner as he stuck the calf in. She acted scared of the youngster, and Rowdy whispered, "Oh boy, this may be a fight getting her to take him." He watched as the calf headed for the quivering young mother. The hungry little guy butted up under her front leg on his way toward the milk store. Then the calf sharply butted the heifer's flank, and instantly she landed a sharp kick to the calf's head that sent him reeling.

The flush of anger rose to Rowdy's temples, but he decided to go get breakfast and then feed. By then he would be settled down and would try the introductions again.

He stepped out into the frigid morning air and turned his cheek into his shoulder, bracing against the sting of the brutally cold morning breeze. He hoped the tractor would start. Maybe the weather would warm up in a week or two. That sure would make life easier.

"I wonder what they're doing in Hawaii this morning," Rowdy said to himself.

Someday he would have to go and find out.

August Storm
A late summer storm over the high desert of Eastern Idaho.

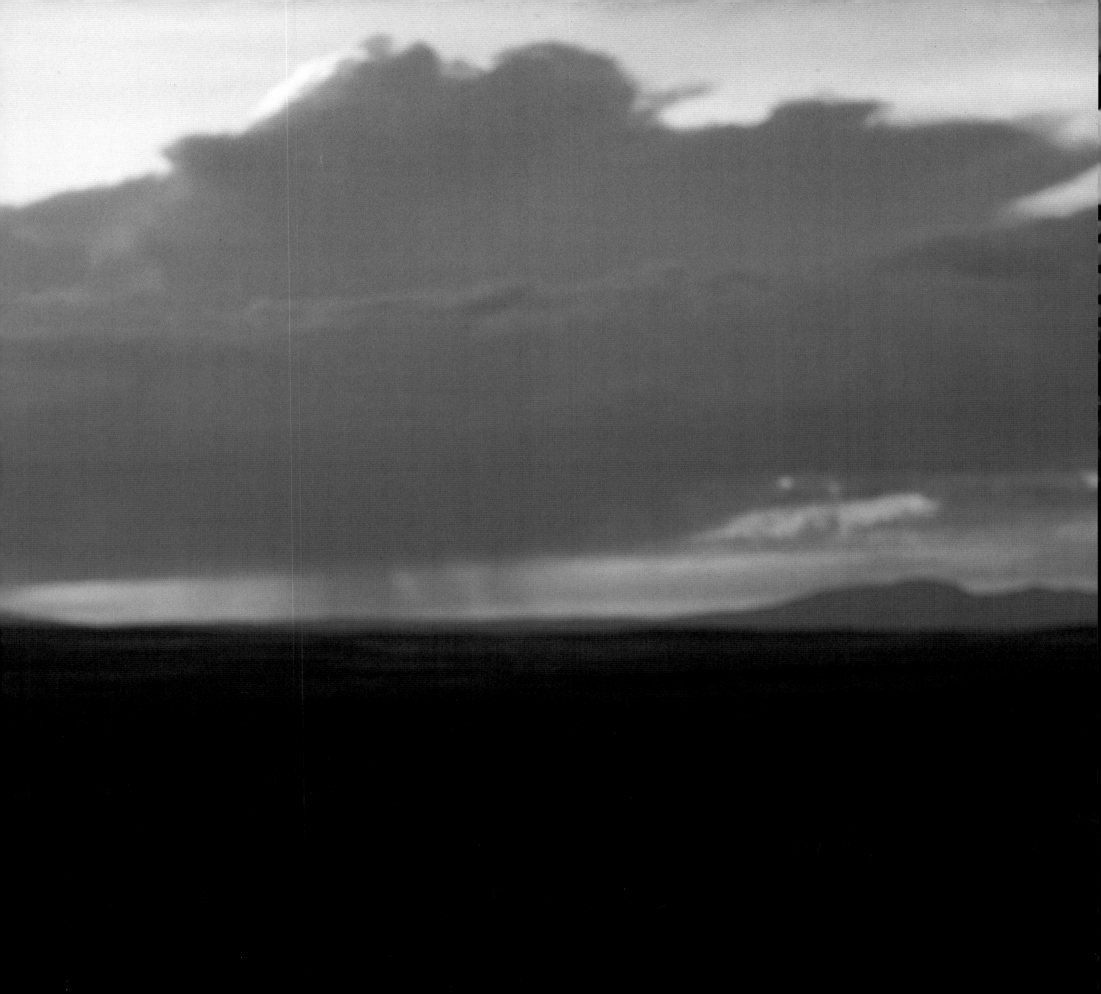

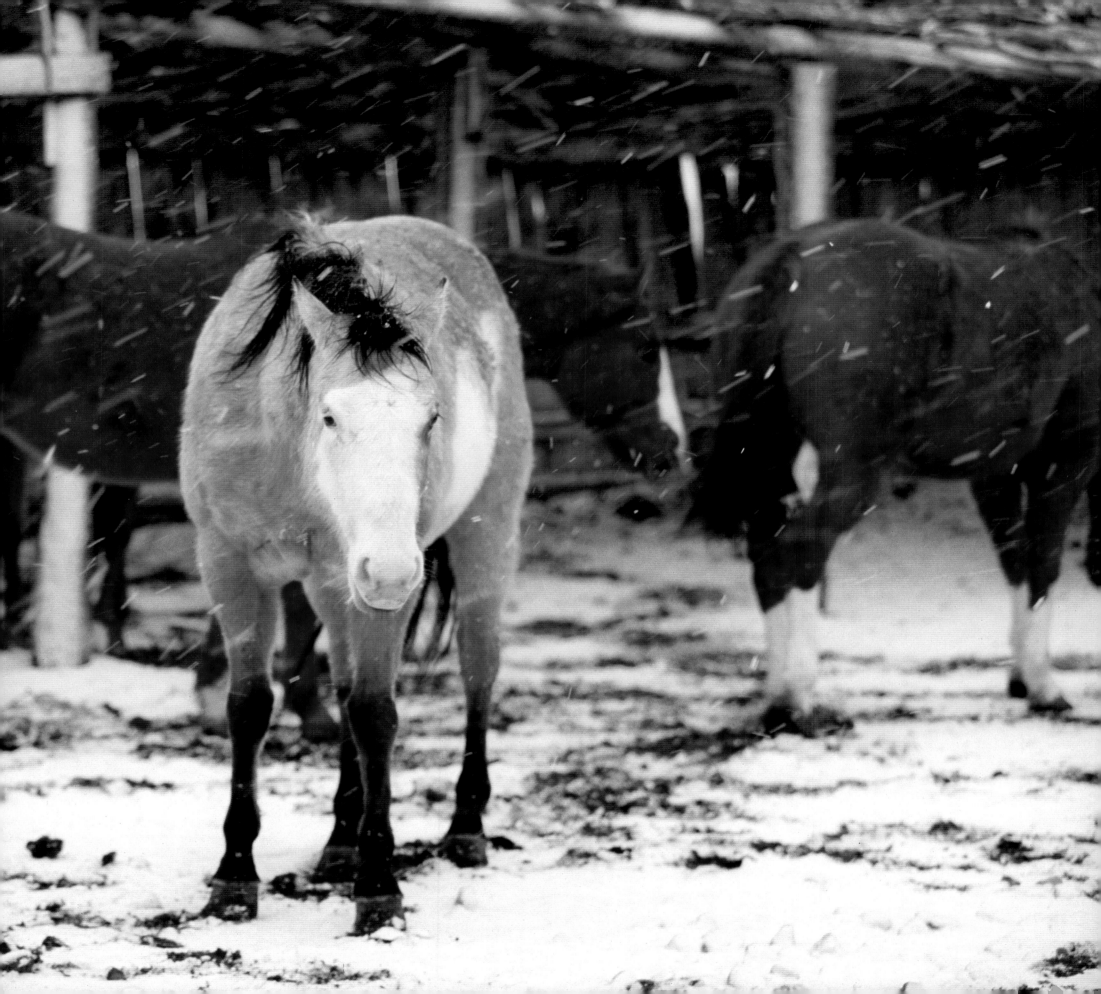

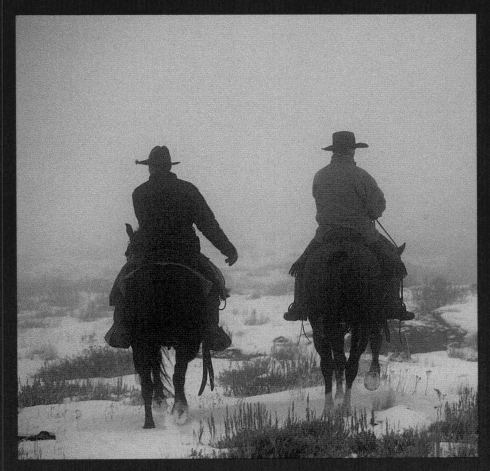

Looking for Strays
Chad Williams and Mark Tillford, Hoggan Rodeo Ranch; Dubois, Idaho

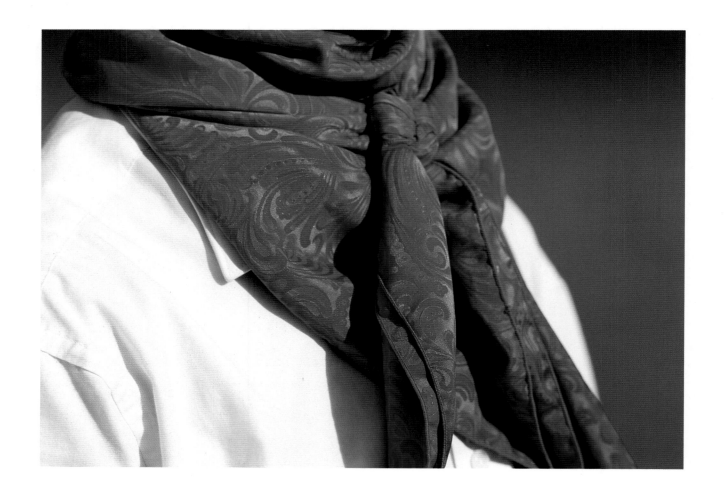

Call it bandanna, neckerchief or wild rag.
Woven from cotton or fancy silk, it began its life in the cowboy's wardrobe
as a dust filter for those blessed with riding drag on the great trail drives.
Now worn freshly cleaned to Saturday dances in town,
or until stiff as a prickly pear on long days branding or riding fence,
a cowboy's scarf is nearly as central to his attire as his hat and boots.

—Scott Preston

T.J. Thompson
Northern Nevada Buckaroo

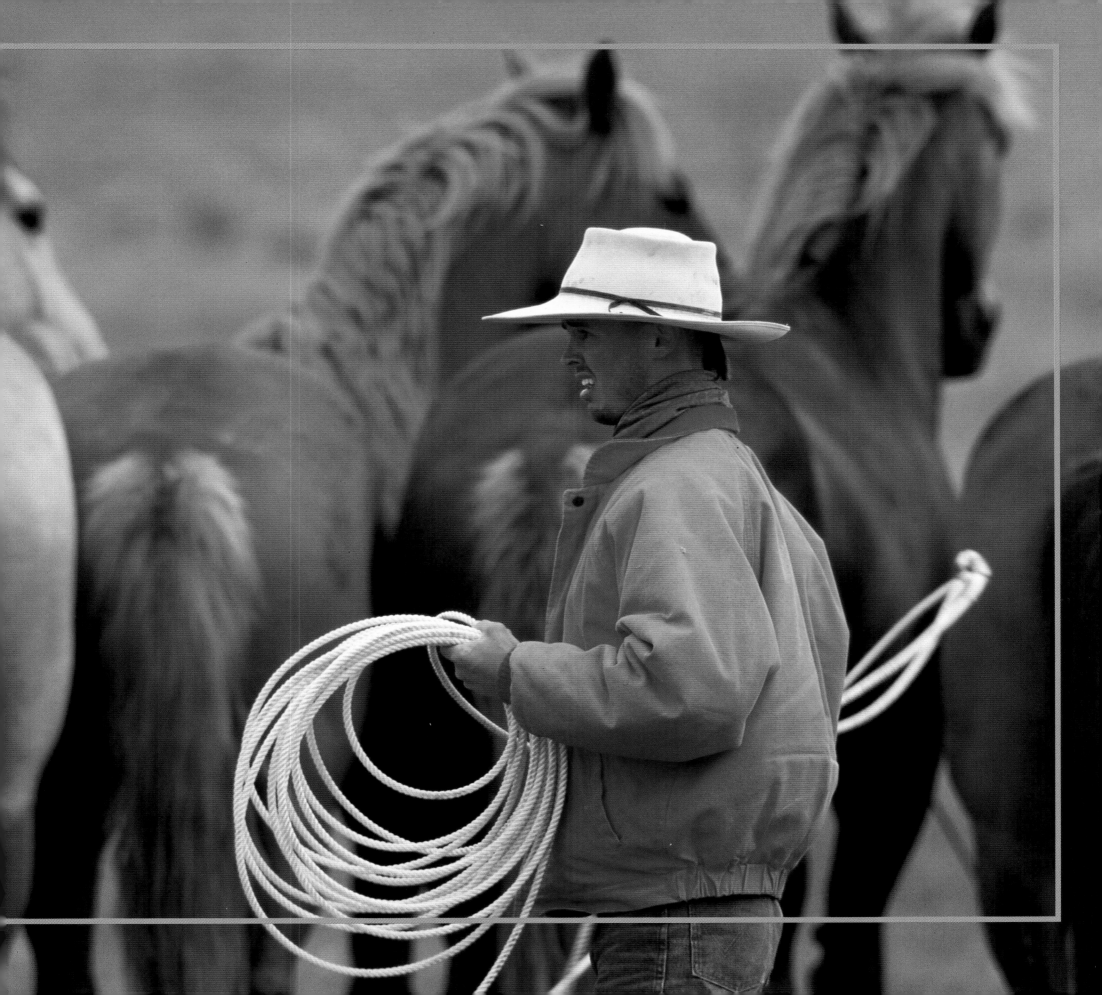

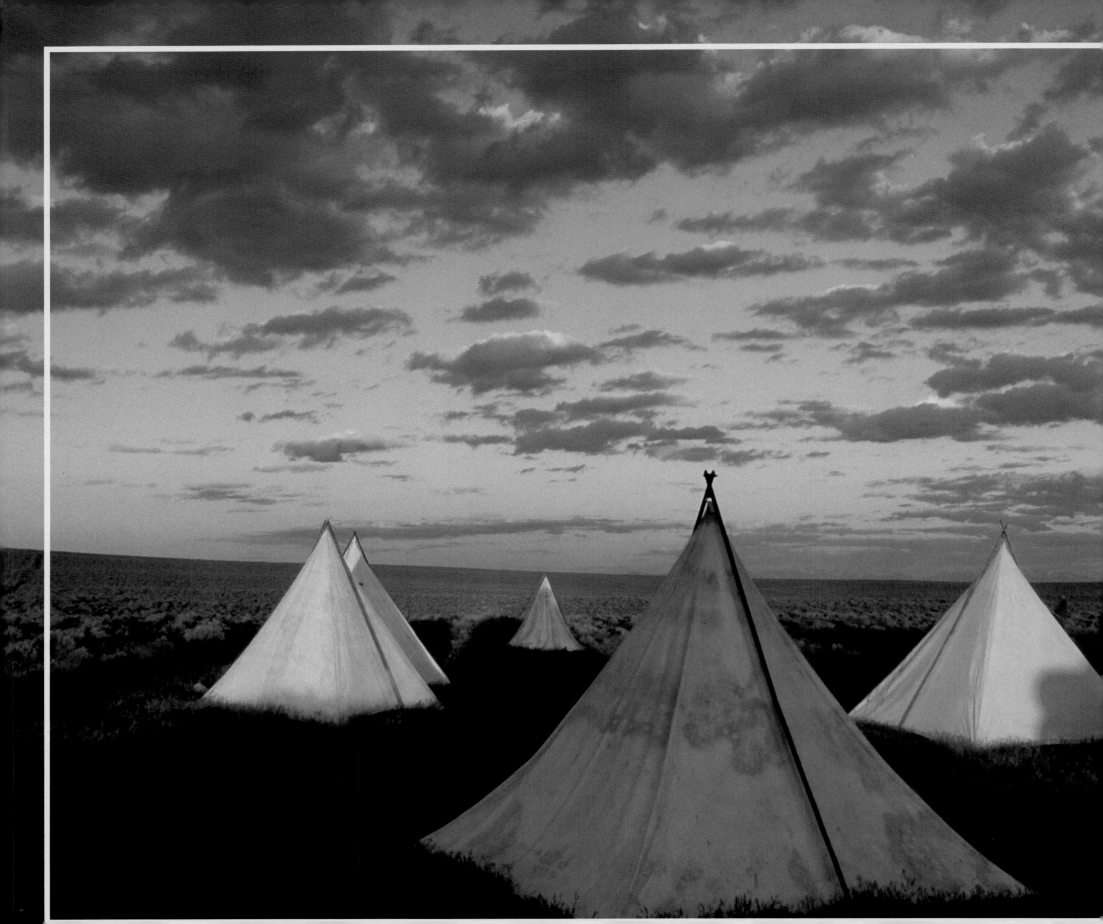

Sky is his ceiling, grass is his bed
Saddle is the pillow for Cowboy's head,
Way out West where antelope roam
Coyote howls 'round Cowboy's home.

—Cowboy's Home

Four Corners Buckaroo Camp
YP Ranch; Tuscarora, Nevada

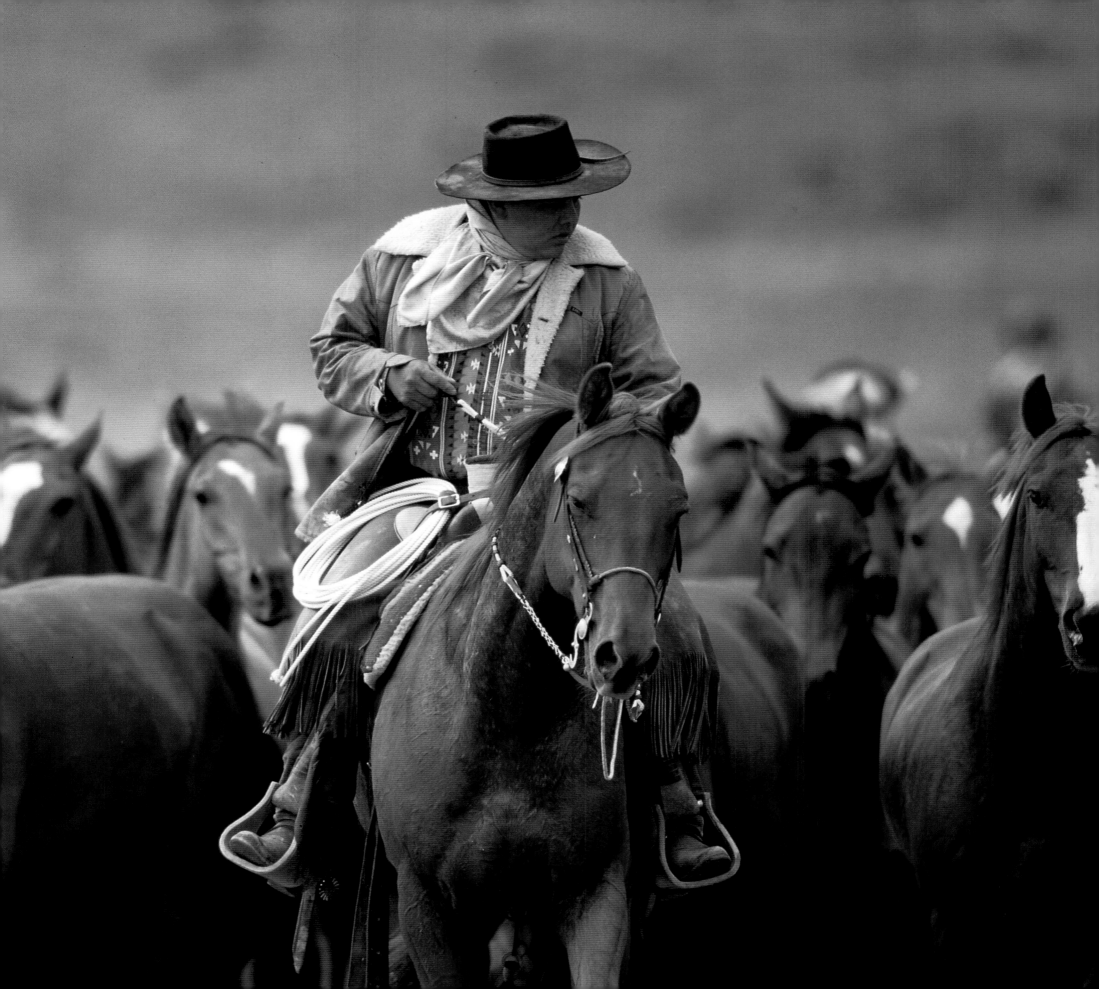

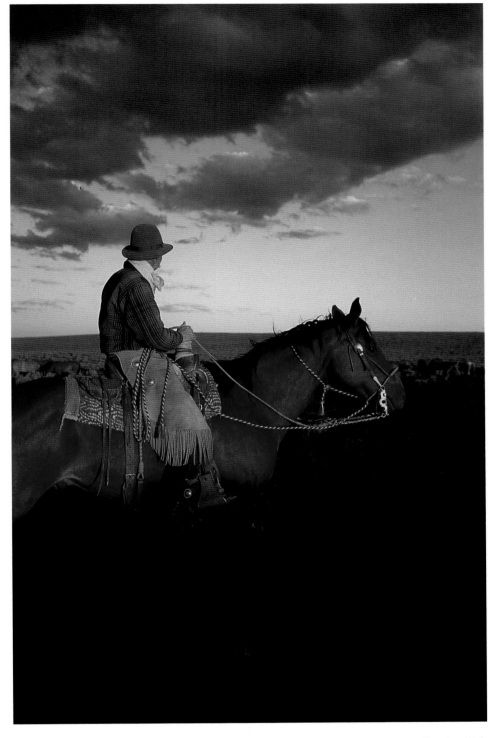

Evening Ride
Dave Thompson, Northern Nevada Buckaroo

Running with the Cavvy
Norbert Gibson, Northern Nevada Buckaroo

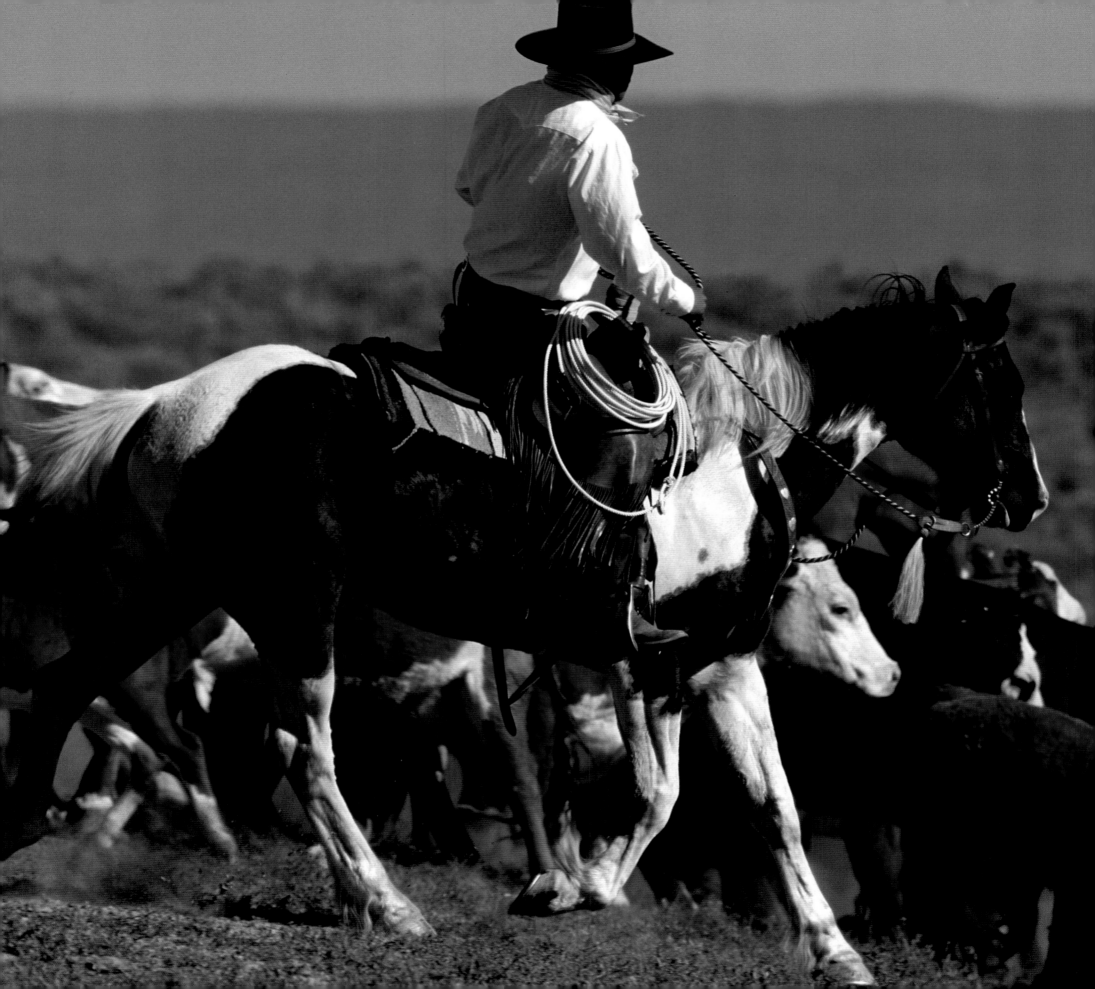

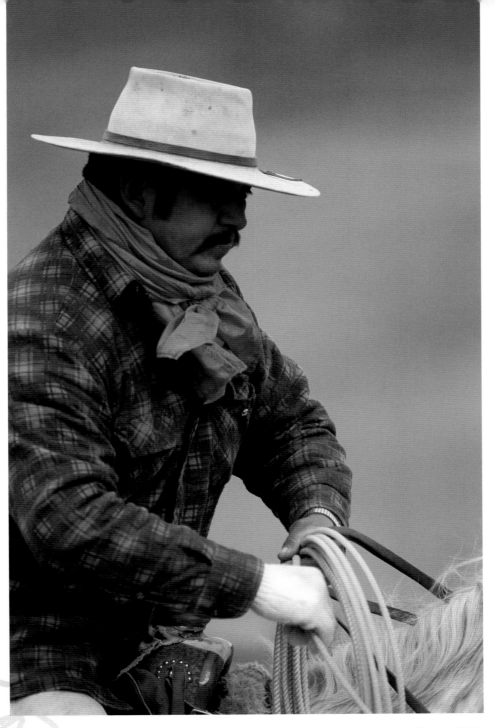

Nathan Kelly
Buckaroo Boss, YP Ranch; Tuscarora, Nevada

Closing the Circle
Woody Harney, YP Ranch; Tuscarora, Nevada

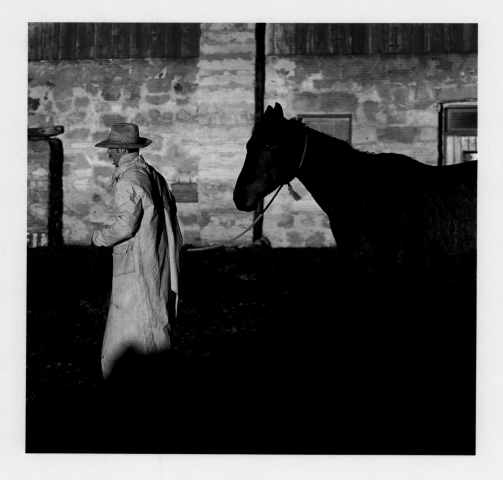

Spring Cloud Burst
Jim Kershner; Jordan Valley, Oregon

Go put up your pony and give him some hay,
Come take your seat by me so long as you stay.

—Ramblin' Gambler

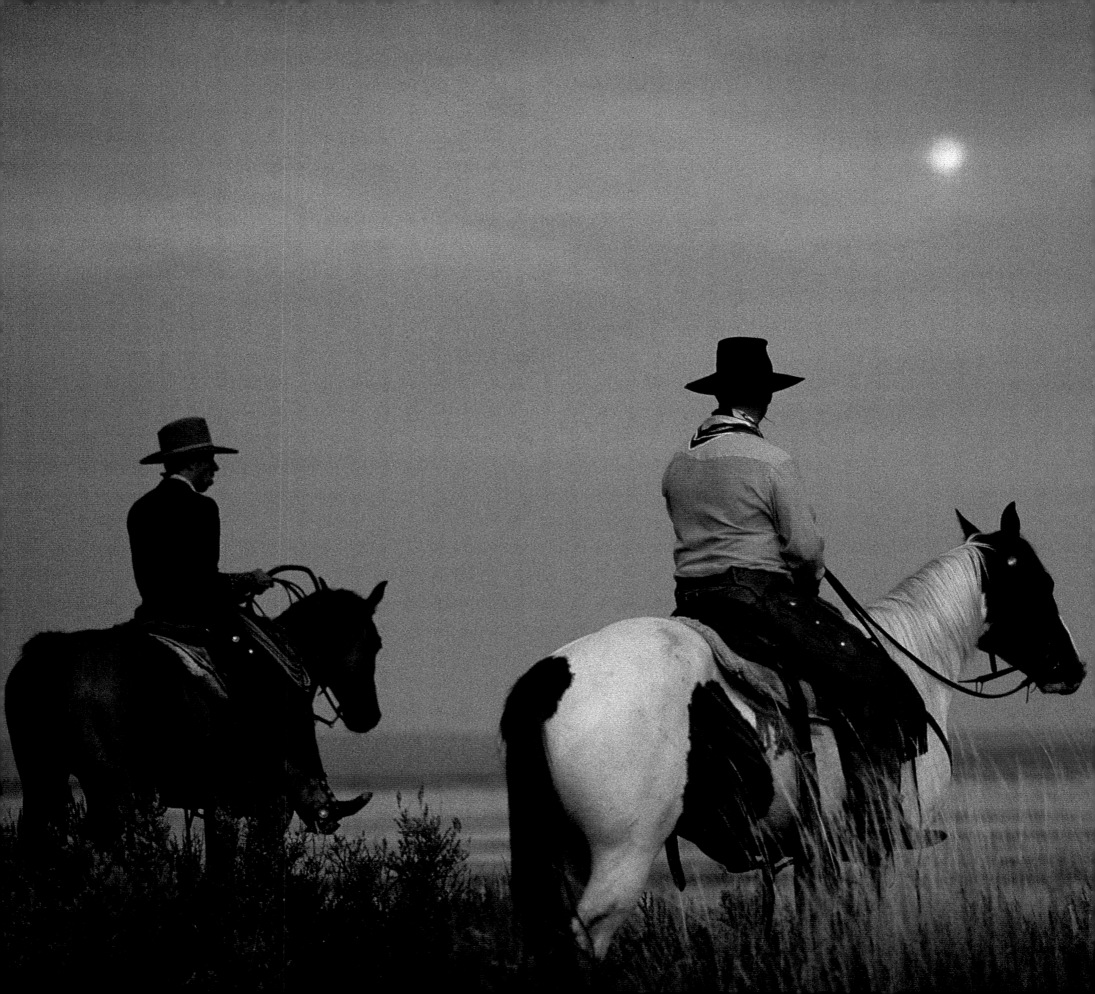

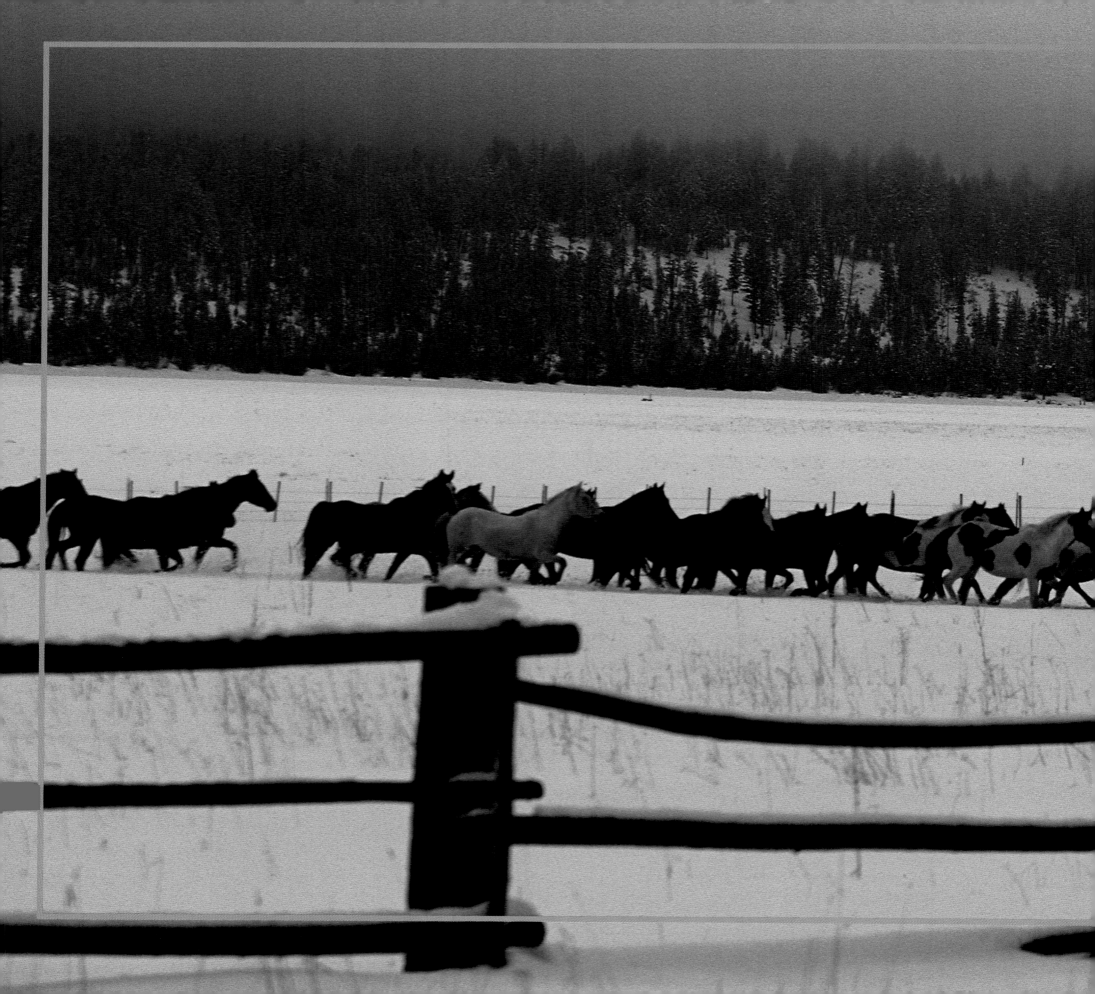

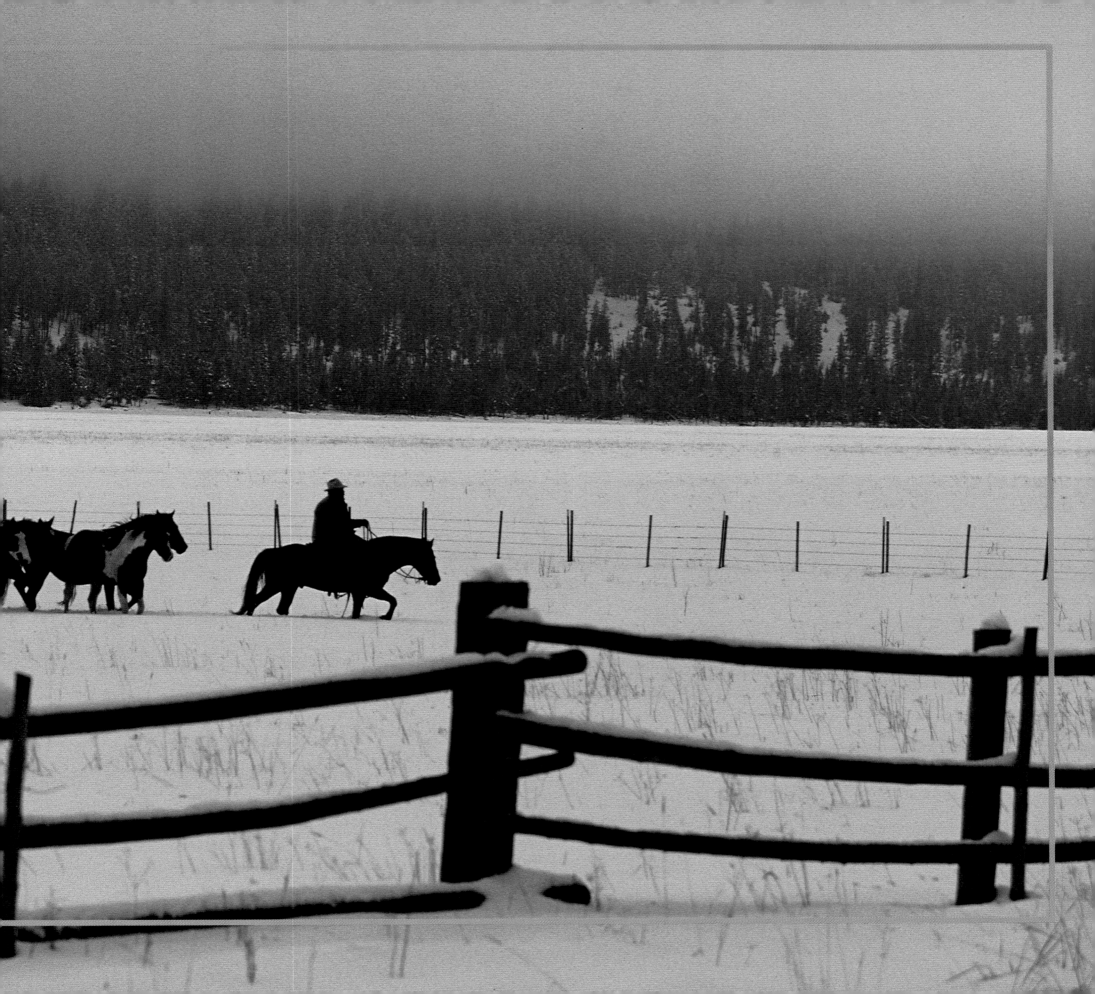

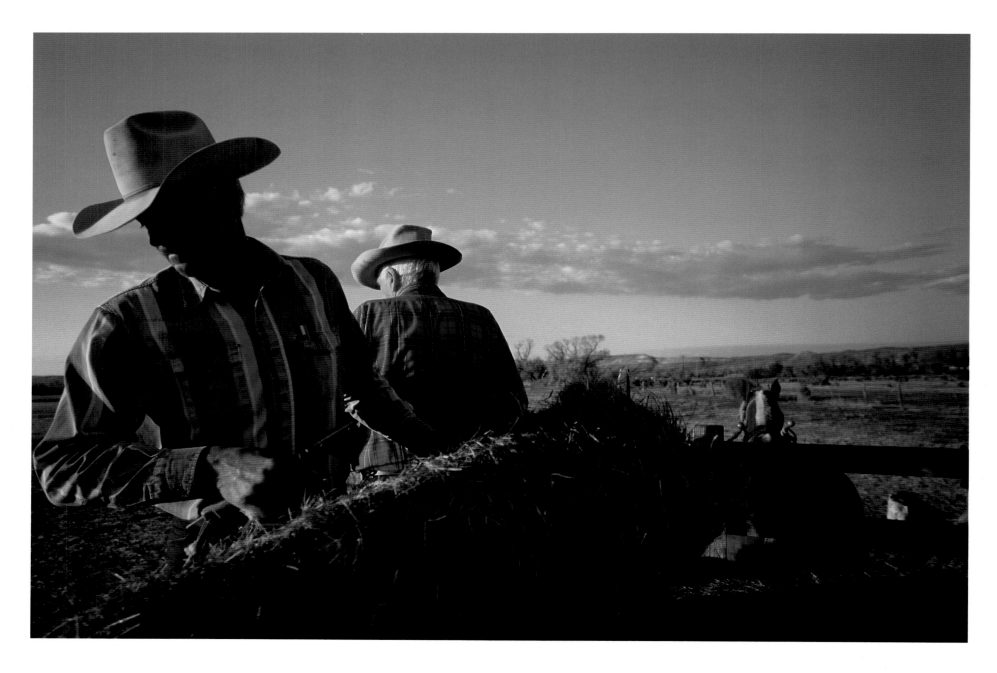

Chuck and Tom Hall; Bruneau, Idaho

FAMILY TRADITIONS

Tom Hall recounts 72 years of life on his family's cattle ranch in Bruneau, Idaho

My great uncle, Abraham Robinson, was one of the first settlers in the Bruneau Valley, and my mother came out here in 1881. She thought this was a nice valley, lots of hot water, fertile soil, and the valley was kind of sheltered in the wintertime. The mountains around it made it an ideal setup for cattle ranching.

The Hall Ranch has been in the family since 1917. My dad homesteaded in the Grassfair area, and when my brothers and sisters got ready to go to school, they had a school out there—dirt floor, one-room building, the teacher didn't last but a month. My dad said that since his kids weren't getting an education there, they'd have to leave. They went to Mountain Home for a while, but that didn't work out, so he bought this place we are on right now because there was a school here.

I was born in the same house, in the same bedroom I'll go to sleep in tonight. When I was 10 years old, I knew what I was gonna be. I was gonna be a rancher and a cowboy, and that was it. I never thought anything else in all my life, and that's what I am.

My work—really I haven't worked—it's been play. I've been here 72 years and I can be away from this place three days and I'm so homesick I can hardly stand it. I just love it. It bothers me to walk, but I can get on a horse and set on that sucker for four days and it don't bother me one bit, maybe because I've been so far horseback all my life.

When I was a kid, potatoes and beets were grown in the garden, the rest was sheep, cows and hay. You were in the mountains to summer the cattle, and wintertime down here is beautiful. Sometimes we have a little snow, but by 10 in the morning it's gone. It's an ideal place for a stock operation. When I was growing up, there were big outfits, cattle ranches, and lots of cowboys—good cowboys. Now it's changed somewhat. There's lots of beets, potatoes and corn grown in the valley, and they do quite well. There's fertile soil here.

We live here by the Buckaroo Ditch. Buckaroo is one way to pronounce the Spanish word *vaquero*. When they started to build a canal to irrigate the valley, they asked one old cowboy if he wanted to help dig on the ditch. He said, "Yeah, I will if I can do it horseback." So they called it the Buckaroo Ditch. A lot of our land lies below the Buckaroo Ditch, and we enjoy the good water.

I was raised during the Depression, and we had hard times. Hats were smaller when I was a kid, and cowboys wore the clothes they had. A lot of them wore suit coats

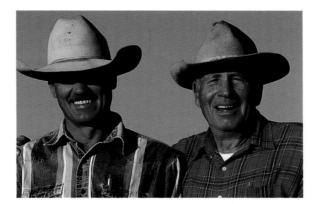

Chuck and Tom Hall

because they'd wear the pants out and they had the coat, so they'd wear it. There's a picture of my dad on the wall, and he's wearing an old suit coat because he didn't want to throw it away. He wore it everyday to cowboy in.

The saddles they use now wouldn't have worked on our horses hardly at all. Those horses were narrow and high-withered, and they made a saddle to fit them. They made a center-fired saddle with a rigging that came down the center of the saddle, and that wouldn't work today on our Quarter Horses. Nowadays you gotta have either a full double, or regular, or a 3/4 double rig to fit these horses.

We used what we had then, lots of spade bits. And when I was a kid I rode with rope reins. That was all I had to ride with, and I'm not riding a rope rein never again! I can afford leather reins now. You see pictures of cowboys riding the rope reins, because that was the old style. I can't think of anything worse on a wet, rainy, cold winter snowy day than holding a wet rope in your hands.

When I was a kid, they got a horse so you could turn him around a little and stop him, and we never went much farther than that. We never thought about reining and cow cutting. The horses we had in the '30s and '40s were distance horses. They were made to go a long way—40 or 50 miles a day—and do it about every day. Now if we go 20 miles on our horses we think of it as a big day. The horses today are not built that leggy to go that many miles.

We traveled those distances because back then there were no fences. If we were going to gather our cattle, then we had to ride that far. You would gather the whole countryside and cut out your cattle from the herd you'd gathered that day. Then you'd take your cattle and sell them or brand them, whatever you was gonna do with them. Now we have allotments. Your cattle are in this allotment or this pasture, and someone else's cattle is over here. You don't have to cut the herd.

When our kids grew up a little, when they got five years old, they were driving a tractor or doing work right on up. They grew up with the outfit. We never said, "This is your horse, this is your cow, this is your chicken or this is your calf." We always told the kids, "These are our cattle, horses" or whatnot. "Let's work for the ranch. Let's work together."

I think if we'd divided the ranch up on the kids—you got 10 cows, you got 15 horses—we'd be in serious trouble. This is our ranch, and the kids accepted that. When they

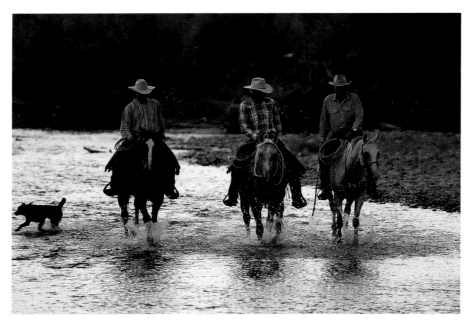

Jack, Tom, and Chuck Hall; Three Generations of Idaho Buckaroos

got big enough to say "our," it was "our ranch." It's still that way today.

It's very important to have family ranches. We raised three kids here. They were never in trouble, never arrested for anything. We taught them family values. We taught them how to live right, not to fight with our neighbors, and to work hard. I think all kids oughta be taught to work and to work hard.

And ours did—they worked hard. When they were 10 years old, they were doing an adult's job. One of our sons wasn't a cowboy—he was a rancher, but not a cowboy. He didn't care much about riding horses. He would come out and ride if he had to, branding and working the cows, and do a good job, too. But he just didn't care much for the horsemanship part of it. Our daughter and our other son did. But they all worked together, and, bless their hearts, they've all prospered. One son, Chuck, is still on the ranch with us. So it worked out real well.

Chuck is a rancher and a brand inspector, and a good one. He works hard every day. Some of his work is seasonal. In the fall and early spring, at turnout time, he's busy sometimes 24 hours a day—on call all the time. But in the summer it slacks off. The cows go to the mountains or the pasture, nobody's trading cattle. He has to go out about every day on brand inspection, but then comes home and does quite a bit of work on the ranch. We couldn't handle it without him.

It's a beautiful thing to get up in the morning and go to work with your son. I probably couldn't get through to anybody how I feel about it. I just love it, I just love my way of life. I feel sorry for the man who gets married young in life, don't have a whole lot of education, who's a janitor in a school or something. He can't quit, he's gotta have that paycheck coming in, he goes through his whole life doing something he hates. I went through my whole life doing something I love, and if I die right now, I die a winner.

I'm doing my thing, we are, because that's what we love to do. We love to feed using a team—we've always fed using the horses. I get horseback about every day and do some little thing, because it's my place.

The ranch is a living thing. It's almost like it is a person, the way we look at it. I can plow a piece of ground out here and I can harrow that ground, and get it all smooth and nice—I don't even want anyone walking on it. I don't want any tracks on it until we get it planted, corrugated, irrigated. Then you can walk on it. And our son feels the same.

We just feel that good about the soil. It's spiritual. We've got a meadow down here that we dearly love; all of us dearly love it. Our meadow produces lots of good hay, it's got good grass on it, and we don't want a road across it. We go around it, stay on the road. The other day we had an old girl helping here, and I told her, "Stay right on this road. I don't want to track the meadow." That's how we feel about the land. We are in love with this place.

Last summer, three sisters came here. They were in their 70s. Their grandfather homesteaded on this place, and they came back here to look at it. They all cried. They hadn't been back all their lives. We had invited them back and had a little party, and it was a beautiful thing to see how those folks reacted to the old homestead.

I've always enjoyed my family. My wife and I have fought like hell, we still fight, but I love her dearly. All my kids were good kids. We've enjoyed it so much I really wouldn't know where to start talking about it. A whole multitude of things come to mind—the cattle, how we've raised our cattle and what we've done, how we've fed them, our home. Our house is 125 years old, and a million dollars of work on it has made it a home.

The most important thing for me is waking up in the morning and looking around, seeing what we've got here. Hard work, the love for the land, the valley, the neighbors, the children. It all brings tears to my eyes sometimes.

It's like an old story I've heard all my life. The farmer took a homestead on the side

Chuck Hall

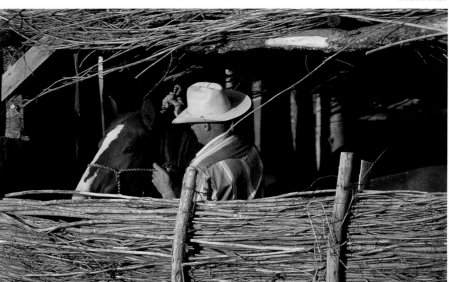

of the hill and he farmed it and he hauled rocks and he dug ditches and he built a house. He had five kids. He had hay going and he had a garden and he was doing fine. One Sunday he had the preacher out for dinner. The preacher was out looking at the land and said, "My, you and the Lord have sure done fine on this ranch." The old farmer said, "Yeah, but you shoulda seen it when the Lord had it by Himself."

A cattleman today has to be a businessman. And a cowboy in today's world has to get off his horse and do other things. He has to be a carpenter, a truck driver, he has to help with the hay, and be a mechanic. A straight-up cowboy doesn't hardly work today.

I know one rancher here who said, "I'll never hire a cowboy again. I'll hire a ranch-hand that can help with the cattle because a cowboy sits on his horse. He won't get off to build a fence, he won't drive a truck or hay." In today's world, a cowboy has to do a multitude of things.

During the 1930s when I was growing up, the range was plum depleted. There was no BLM control, there was no BLM at all. That didn't start until 1934. You could roam at will, wherever you wanted to go and take your cow. And the range was in bad shape. It's in better shape right now than I've ever seen it in my life.

Back in my mind someplace, I know it's BLM land, and it does belong to them. As far as the kayaker and the hunter, he has his place here, too. Still, the range is what the cowman made it today. They planted maybe a million acres of better grass and developed the water and water holes, fenced and cross-fenced and made pastures. It's way better than it was in 1934.

I fear for the family ranch, the family farm. It's gotten out of hand, it seems. Companies here in the valley own a good percentage of the land now—not that they aren't good neighbors, very good to us, fine people. I hate to see the family ranch go by the wayside. The best people in the world come from family farms and ranches.

It bothers me sometimes what'll happen to this ranch. I hope it's never sold. I hope all my kids can come back here.

I wouldn't mind being buried on this place, but I wouldn't want to be buried on some good ground. I wouldn't want to be laid out in the middle of the field where they had to plow around me. But I will be buried a couple of miles from this place, up in the valley.

If you're in the cow business or ranch business for the sole purpose of making money, then you're in the wrong business. But if you are in it because that's what you like to do, somewhere down the road you might make a dollar. I know there are other enterprises that make a lot more money than ranching, but I couldn't do anything else. I'll never leave this ranch.

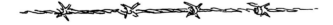

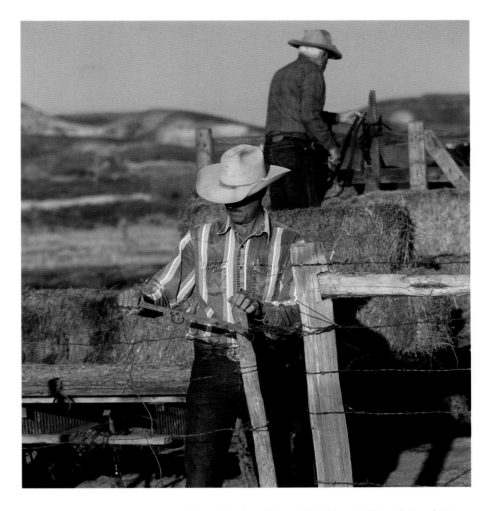

Above: Chuck and Tom Hall Below: Hall Family Ranch House

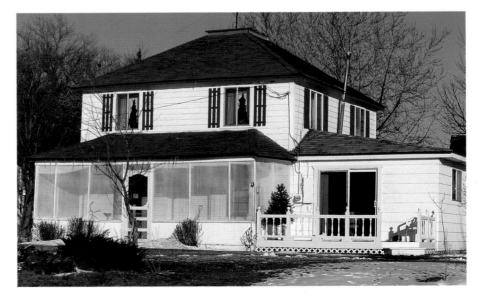

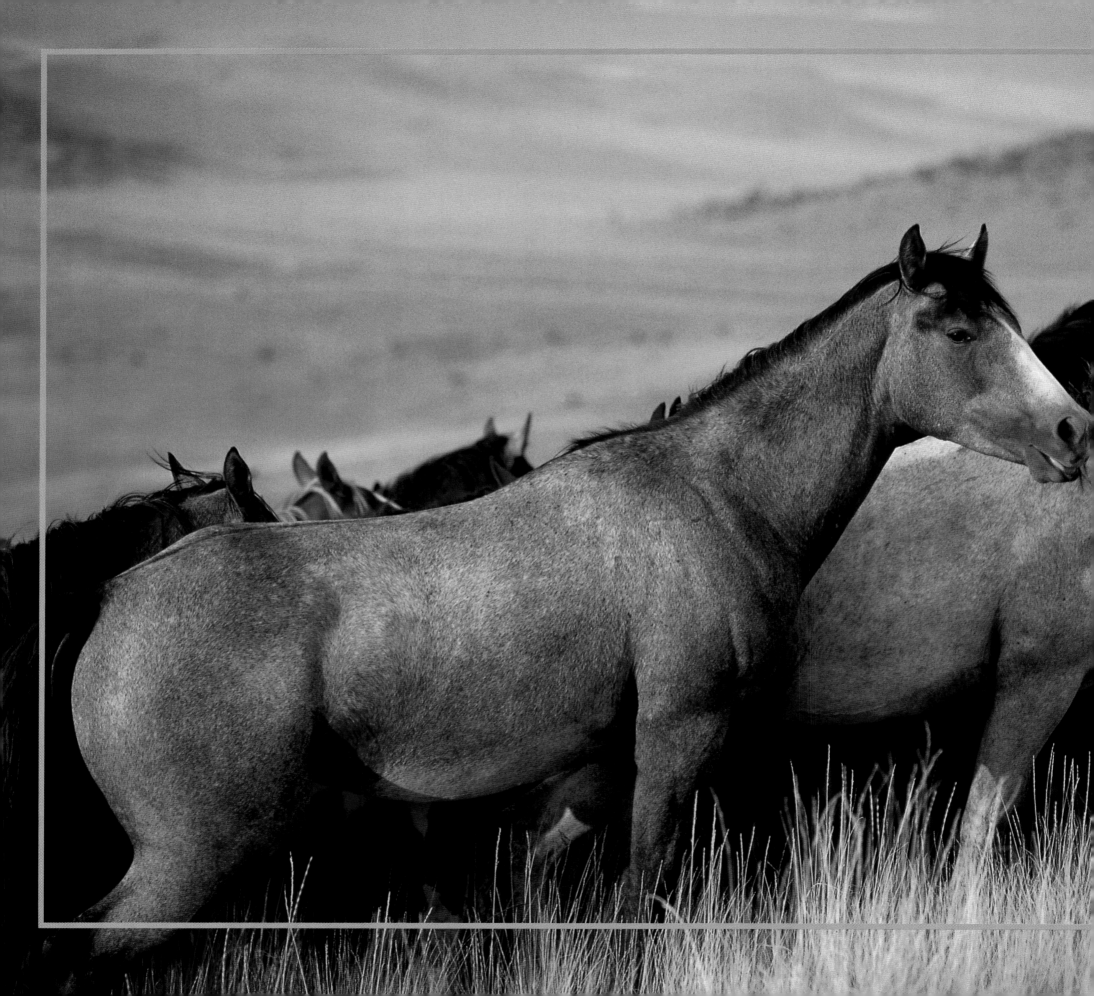

THE WESTERN HORSE

By Dan Streeter

When talking about the evolution of the American cowboy, Texas cattleman Tom B. Saunders IV summed it up perfectly when he said, "It's not the man that makes the times, it's the times that make the man." That was true in all facets of a cowboy's life in the early West. The clothes he wore, the tools he used, the way he did his job all reflected the task at hand—living life in a rugged environment, working cattle every day. Those times also "made" the cowboy's main working tool—his horse.

Whether the job at hand was riding a 60-mile loop to check the range, busting wild cattle out of mesquite thickets so dense a man couldn't see 20 feet ahead of him, or setting up a rider so he could rope a calf and drag it to the branding fire, the Western horse was a product of all that was expected of him.

The ancestry of the Western horse is grounded in the Spanish Barb stock brought to the New World in the 1600s. These were small animals by today's standards, but they were also surefooted and robust, horses that could carry a rider through all types of terrain, in all types of weather. Those attributes were without a doubt more important then than now, because a man who found himself afoot in the vast untamed wilderness of that time was in true peril of losing his life.

As time went on and ranching became a way of life, horsemen began selectively breeding the most desirable animals, building on those traits most useful to men working cattle. These horses possessed agility, endurance, and "cow sense," the ability to chase down a cow and work with a cowboy as he moved stock. At the same time, horses escaped captivity and began roaming the land in feral bands. These horses were also selectively bred, this time fashioned by the hand of nature. They became sturdy animals, capable of prospering in an

Gray Mares
Dragging Y Ranch; Grant, Montana

unforgiving environment that could unleash extremes ranging from devastating winter storms to agonizingly hot, dry, summers. When captured by cattlemen or Native Americans, these horses proved to be valuable working assets.

Development of the modern Western horse began when breeders introduced Thoroughbred blood to their herds. The result was a Quarter Horse-type stock horse endowed with the speed and refined body of the Thoroughbred and the stamina and working ability of the original Spanish Barb. Built to hold a saddle well and hold up under long hours of punishing work, these horses thrived in the Western environment and became the preferred working mount of the American cowboy. They could travel the long miles required to tend stock, and could also pull a doctor's buggy, a Plains Indian's travois, or pack supplies to a remote camp. These horses were also the basis for the development of the Western breeds that we know today.

The story of the people who settled the West and of the cowboys who developed the cattle industry cannot be separated from the horses they rode. On the following pages meet four breeds of Western horse—the Quarter Horse, the Paint, the Palomino, and the Appaloosa—each of which played a role in the history of the West, and which today remains an integral part of the modern livestock industry.

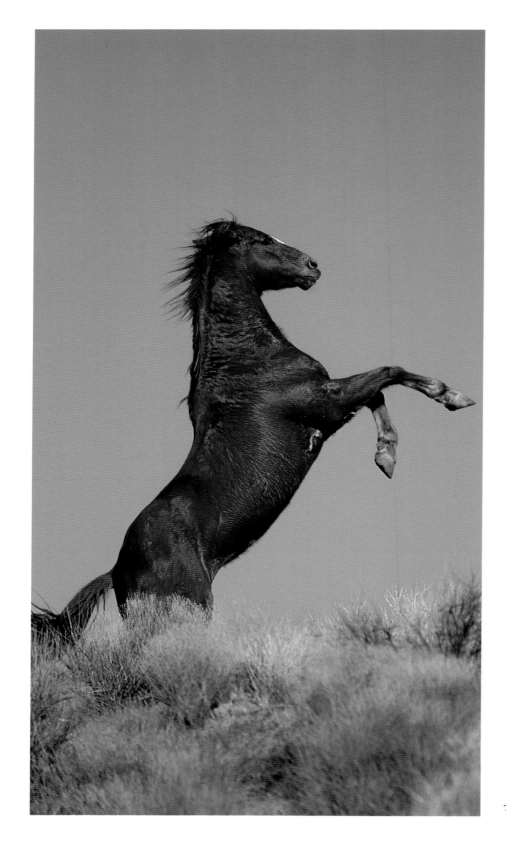

Juniper
Turtle Ranch; Dubois, Idaho

His arched neck
was hidden by his
swift-flowing mane,
And I called him Pattonio
the pride of the plain.

—Pattonio,
The Pride of the Plain

Donnells Gray
Donnell Ranch; Fowlerton, Texas

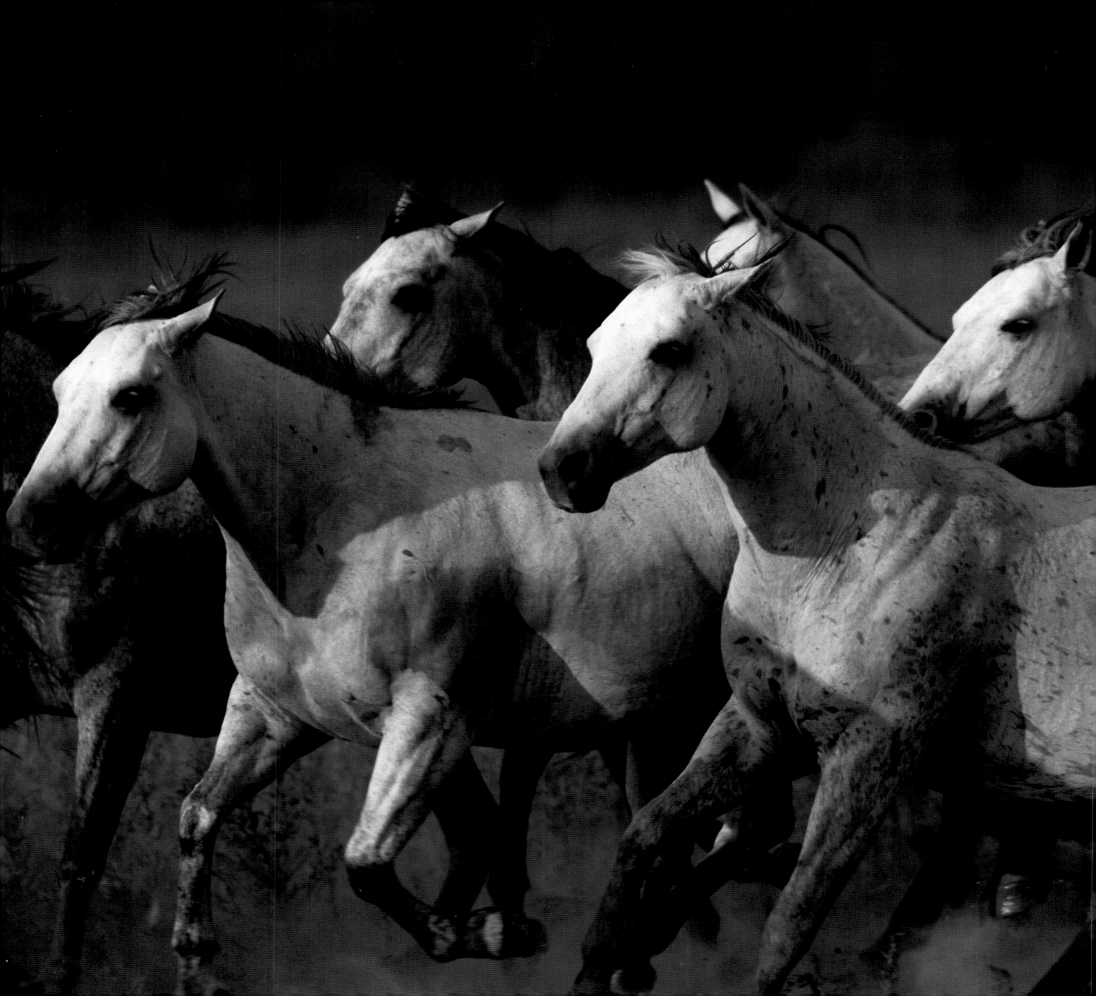

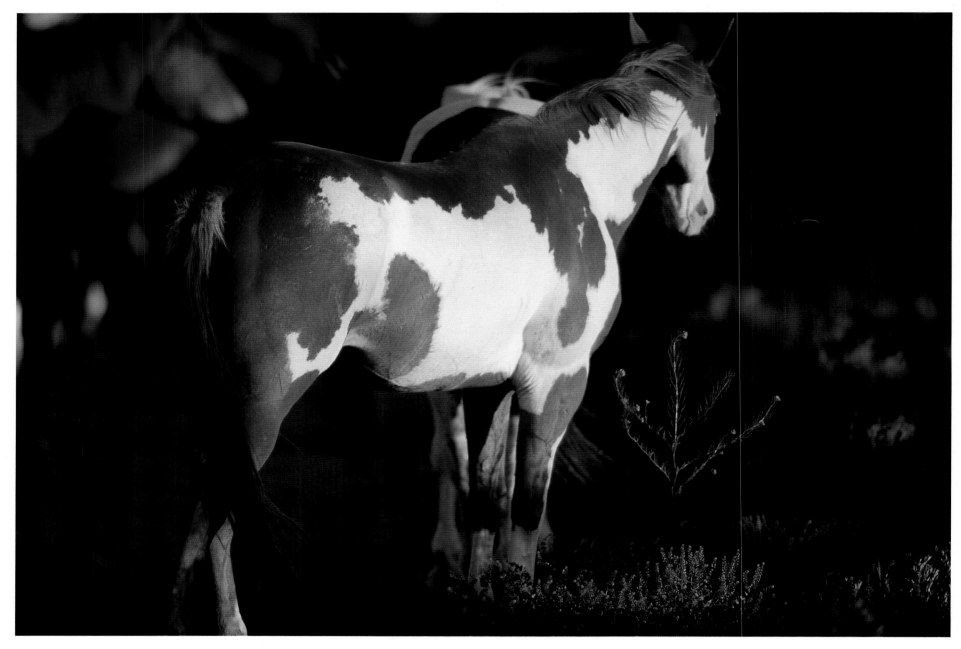

Cavvy
YP Ranch; Nevada

THE PAINT HORSE

Add a splash of loud color to the sturdy Quarter Horse and you have the Paint horse. Native Americans found significance beyond mere cosmetics in the markings on these horses. It was their belief that these specially marked animals carried with them strong "medicine" that the owner could put to good advantage in war or on the hunt. The more practical-minded cowhand found a beautifully marked Paint not only useful in his work, but also a horse that made a good impression when he went "calling" or made a trip to town.

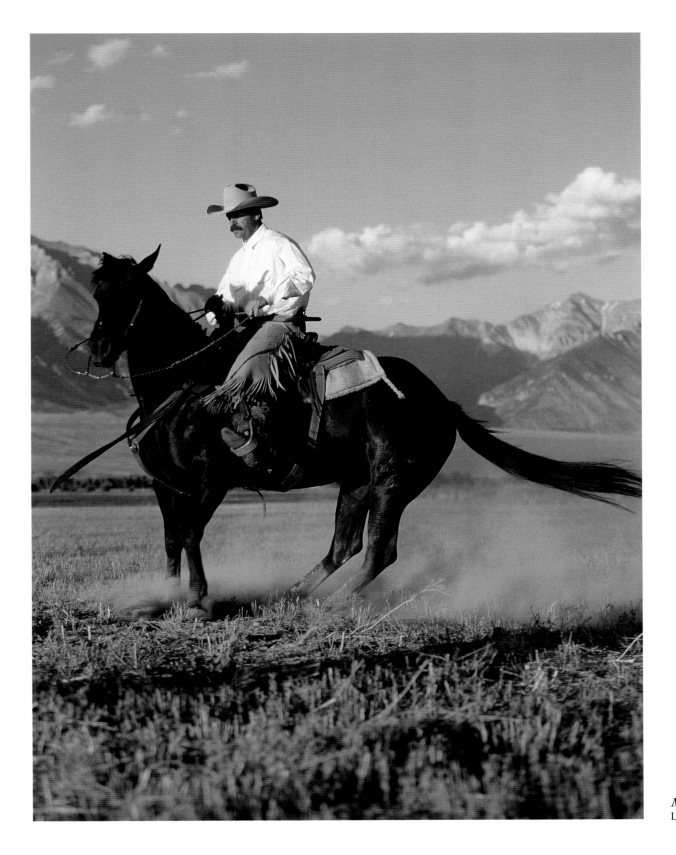

THE QUARTER HORSE

With the inherent ability to work cattle and the constitution to provide reliable transportation, the solid-colored Quarter Horse became perhaps the most widely used horse in the West. With a string of these good horses, a cowboy could cover wide expanses of range while caring for his herds. And when it was time to play, more than a few of these horses found themselves being used in roping competitions or match-raced on whatever kind of track was handy.

Monte Funkhouser
Lehman Canyon Ranch; Idaho

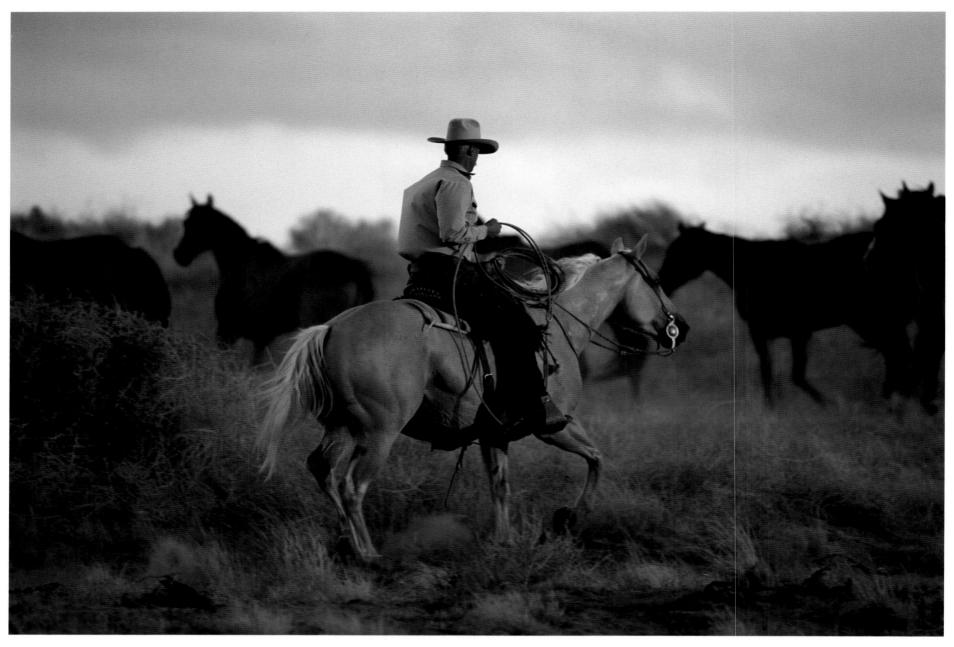

Chuck Hall
Hall Ranch; Bruneau, Idaho

THE PALOMINO

The unique golden coloration of the Palomino was a favorite of Europe's aristocracy for hundreds of years before the horse made its way to the New World. With a hair coat the color of a brilliant golden coin and sporting a white mane and tail, in this land the Palomino found favor with those who appreciate not only a good working horse, but also a beautiful link with the glories of ages past.

THE APPALOOSA

The Appaloosa horse with its unique spotted pattern also originated in Europe, but in the New World became most closely associated with the Nez Perce Indians who inhabited the areas now encompassed by the states of Oregon and Washington. As did the other people who came to rely on horses for a variety of purposes, the Nez Perce used their mounts to hunt, pull plows, and ride in war—finally, in their futile attempt to fell the U.S. Cavalry.

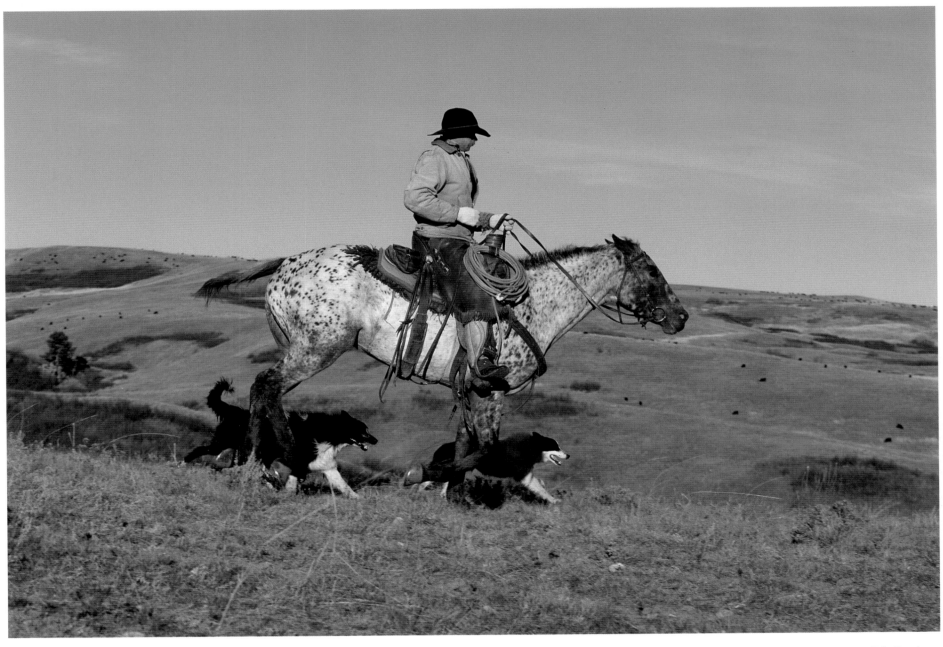

Colt Barelman
Sunlight Ranches; Wyola, Montana

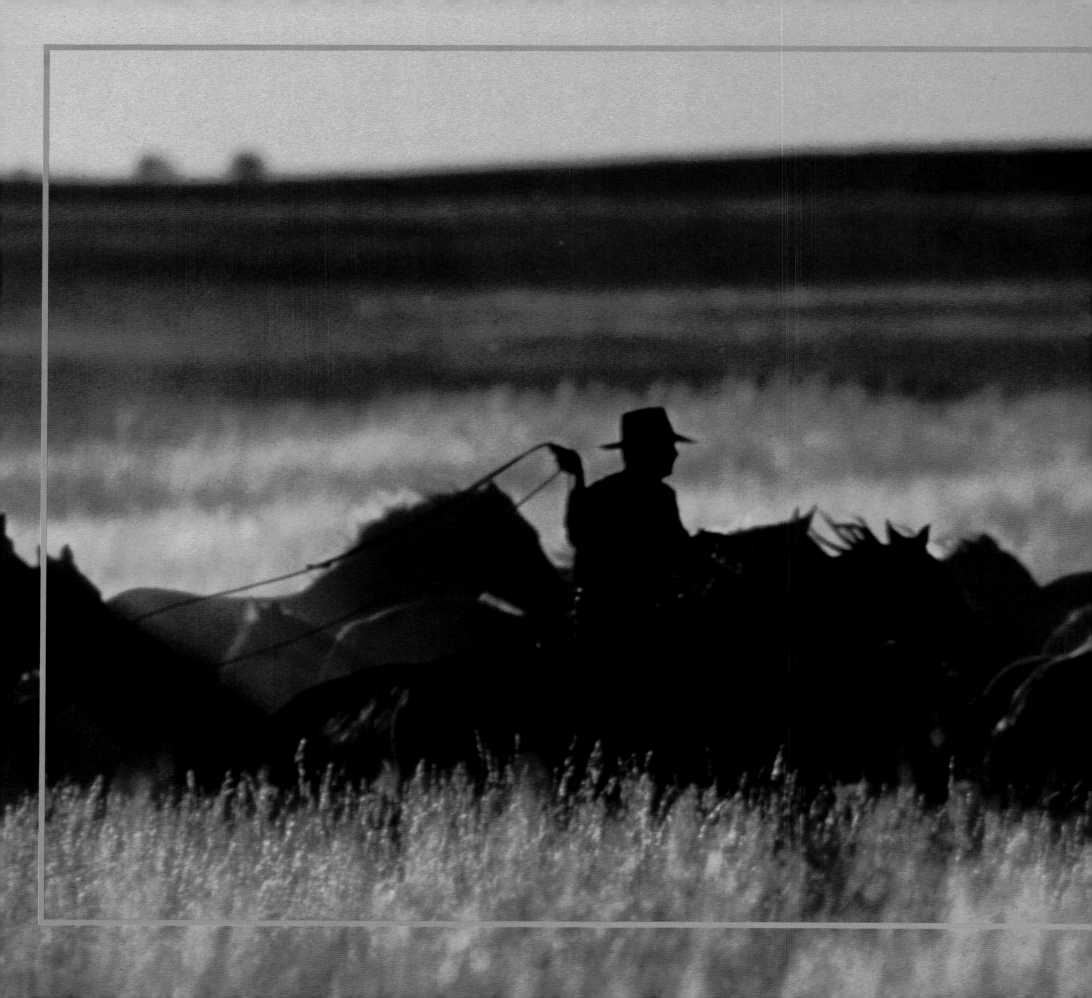

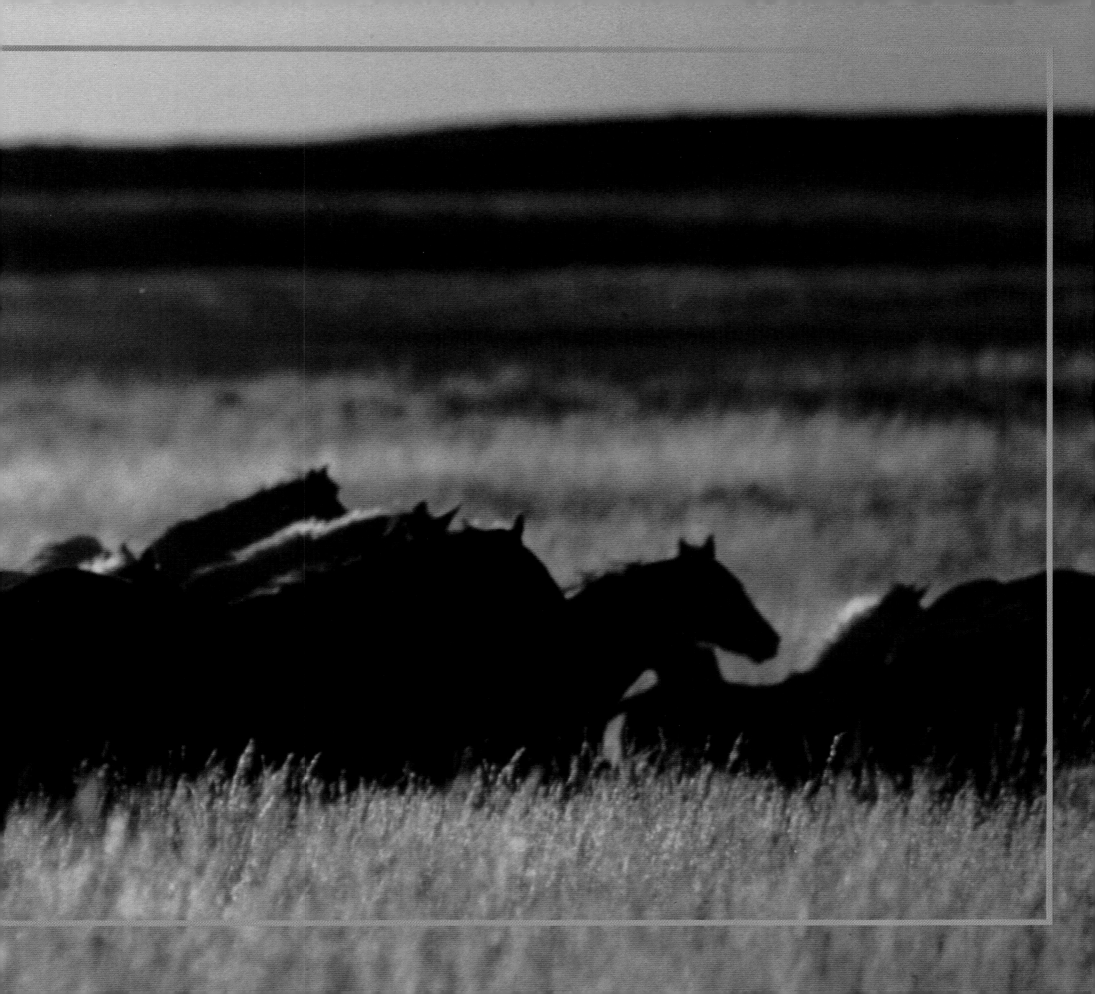

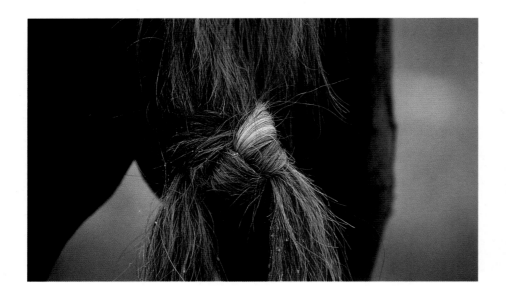

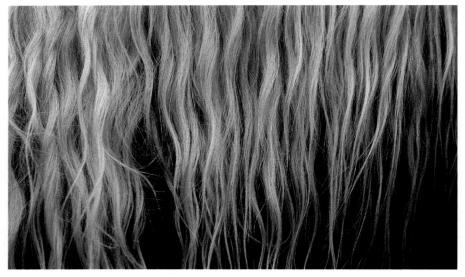

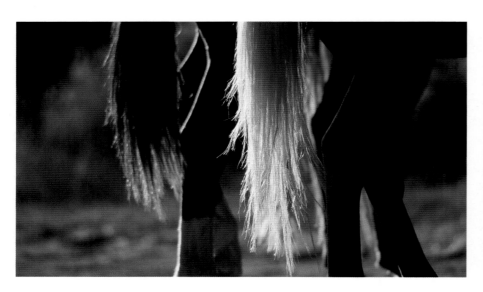

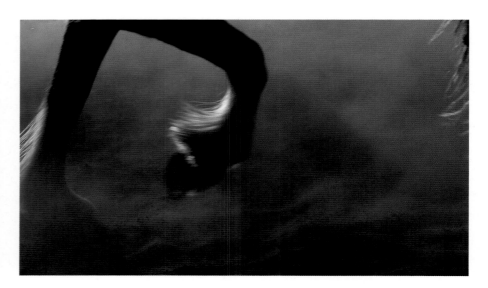

Previous two pages: ***Running with the Bunch***
Dwight Hill, Jacobs Ranch; Dubois, Idaho

What's that, no horses in Heaven you say!
Hold on, Preacher, please, don't talk that way!
Don't call it a country of pleasure and rest
for us sun-dried punchers out here in the West,
unless there are horses across that Divide,
that we can lasso and pal with and ride.

—The Cowboy's Faith

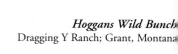

Hoggans Wild Bunch
Dragging Y Ranch; Grant, Montana

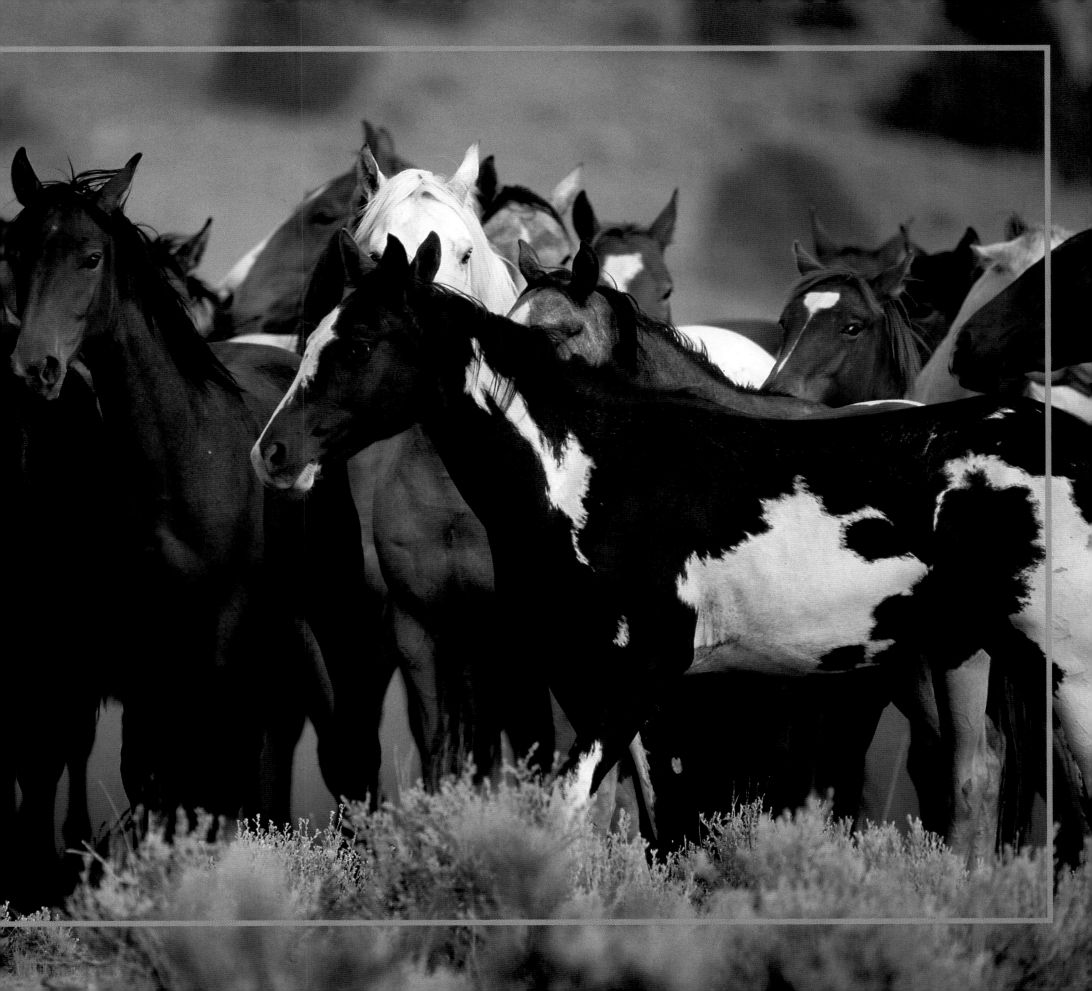

EVERY MULE IS A PRETTY GOOD MULE

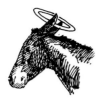

Donald "Cotton" Riley, of Richfield, Idaho, knows mules.
The 74-year-old cowboy has been working with them all his life.

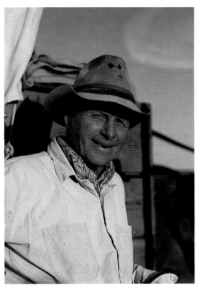

Cotton Riley

They've been breeding mules here since the 1600s, and some of the first jack stock that ever came to America came out of Spain and France. They've been working on them for a long time.

A mule is a hybrid cross between a jackass and a horse mare. Or, if you breed your stallion to a jenny ass, you get a hinny. A hinny is a little more refined mule. It has shorter ears, more like a horse. But if you go the other way, that's where you get your true mule and they're usually a little rougher, with longer ears and bigger heads, and they're sterile.

If you want to get a saddle mule, instead of going to the Mammoth jack, go to the Spanish jack. He's smaller, more fine-boned and more agile. The Mammoth jack's got a nice personality and he'll throw you a big, flat-boned, stout, drafty kind of colt out of a good mare, where your Spanish jack will give you a saddle mule.

In the old days, before there were any roads, there was a lot of mules rode and packed. People packed mules real heavy, and then when they started moving across the country, they used mules a lot more than they used horses because mules are tougher.

I don't think there's as many mules around today as there used to be. In the days of the farms, they had lots of mules. And the wheat farmers in Washington, I got pictures there where they'd have as many as seven combines in a row with 42 head of mules on them.

A mule is a lot tougher than a horse and a lot stronger. When I was riding with the Montana Wagon Train, I saw mules that weighed 600 pounds less than those big draft horses do the job much easier up the steep mountains that we went on. Mules don't have to be big.

I got into mules when I was cowboying with some small mules. They weighed 700 pounds, and I packed 250 pounds of salt on them. That's five blocks—two on each side and one in the middle. My honest opinion of a mule is that he's a lot stronger than a horse at a dead pull or packing a load, and it takes less feed for him and you can't founder him. You can pour out three gallons of oats, he'll eat a quart of them and walk away and leave the rest. That's more than you can say for a horse. A horse'll stand there and eat until he kills himself.

When I was young, I'd often heard the oldtimers tell how a mule'd pull hard enough that his front feet would come off the ground. Then, once I was working this team on a thrashing machine, hauling grain out of the field to the machine. The old gentleman in charge told me, "When you get unloaded, you go over there across the road to my place and you'll see out there in that big corral a four-section harrow. We're going to put the thrashing machine in the corral and blow the straw out there, so I want you to hook onto the harrow and pull it out so we don't cover it up."

I went over there and the redroot hogweed was grown up high around the harrow—a four-section harrow that's 16 feet wide. I backed the wagon up and tied the harrow to the back axle of that wagon, and when I spoke to them mules, they took the slack out of everything and they began to pull. Before that harrow broke loose out of the weeds, one mule's front feet was two feet off the ground. He woulda fell over backwards if the weeds hadn't give way!

On that Montana Wagon Train, I went from here to Montana with my team, and then hooked in with the Centennial Wagon Train and went 250 miles more. The terrain was steep in some places. There was a contractor in the bunch, and he told me, "You might not believe this, but we are going up a 20 percent grade!"

This modern mule, they got most of the meanness bred out of them because the mares are bred much gentler and the jack stock is gentler. The mules are coming into the world with a different outlook. But the old mules, a lot of them was mean, but they worked them hard. These days, most people just play with mules, work them just hard enough to barely exercise them. Guys'll ride them a little bit. But these mules have a different personality.

You drop back to these burro jacks, the little Mexican burros, I got some of the meanest mules I ever had out of them. They just wasn't bred gentled out.

I had one mule colt out of a Man O' War mare, and that mule was like old Man O' War—

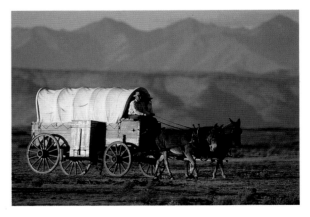

she had her good days and she had her bad days. She wasn't very big, but every day she was wide awake and she was paying attention to what you were doing. When you went to catch her, you could figure out what kind of a day you was gonna have with old Kate that day. If you set the pack saddle on her and it didn't set down just exactly as she thought it should, she'd buck it off and then jump on it and paw it all to pieces.

I worked her in the wintertime, fed stock with her. She wasn't very big, only weighed 790 pounds. I had a wreck or two and stopped to fix something, and she would be the best mule in the world. Then you'd start to walk away from her and she'd kick you with both feet just as hard as she could, for no reason.

One time I was up there cowboying, and I had her and this other little mule. A cowboy from Gooding named Bill was with me. We went up on the mountain to bring down an elk, and I had put the elk's hindquarters on old Kate. Bill was holding her and I didn't have the hindquarters tied on too good, so I went to walk around to the other side. The mountain was really steep, and I told the cowboy, "Hold her kinda easy, Bill, 'cause she don't mind me putting this elk on her, but she don't like you!" She was just standing there looking at Bill with her ears tipped forward, looking him right eye to eye.

When I walked around her, she had one leg kinda dropped down, and I just kind of slapped her between the legs and said, "Stand up, Kate, you're gonna fall down." She jumped as high as this ceiling and she came right down on Bill. I mean right on top of his head, smashed him down, then she jumped down on him again. Then she bucked me off, stepped on the halter rope, turned upside down, and rolled down the mountain quite a ways. She jumped up and I could hear her 20 miles.

I asked Bill, "Are you hurt?" He said, "I don't think I'm too bad. My back seems all right." And I said, "By god, she jumped you pretty good. You gotta be hurting!" He said, "Listen, I'm not hurting bad enough for you to haul me down the mountain on that son of a bitch!"

I think every mule is a pretty good kind of mule. I've traded a lot of them, bought a lot of them, and used them when I was packing over on the mountain. They are smarter than horses when it comes to packing. If you're gonna go through a path of willows, where the limbs are gonna hit them on the face, if you've got three or four mules they'll put their chins up on the other mules' hips so the limbs don't fly back and hit them in the face.

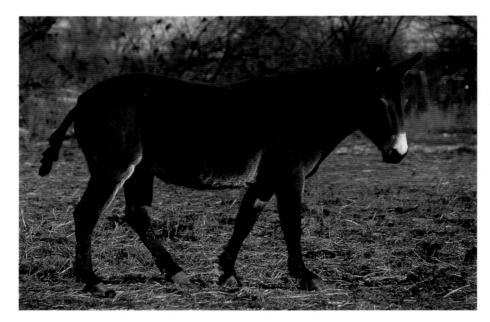

Tom Hall's Mule
Tom keeps Bessy's tail cut in the old military-style bells.

And when you come to a bog and it's really a bad spot, horses have to walk right in and bog down. But a mule, he's pretty hard to get in a bad spot to where he's not gonna be able to get out. And they're just a little bit more cautious on the trail. They don't get out to where it's gonna break off. They seem to sense that they better stay where they should. I don't know whether they just pay more attention or they're just more intelligent.

Last year I was coming out of the Selway Wilderness and had six mules strapped together. I never had to look back at them. We also had three horses strapped together that the guy with me was trying to drag out, and we had about 10 wrecks before we got that 18 miles. Most mules have a smooth gait. Very few of them will shake you. Once in a while you get one that'll get kind of rough walking, but most of them are pretty smooth.

I had a little brown mule that I bought last fall, and riding her was just like riding a Missouri Foxtrotter. When you sat down on her, you couldn't feel her vibrate. She was very agile, and light on the mouth. Like a fool I let her slip through my hands. I sold her to a guy who took her hunting for a couple of weeks and said, "Boy, she never slowed down." She was a small mule, but she was smooth.

I had a big sorrel mule that weighed 1,360 pounds. I cowboyed on her all summer, and she could outrun a cow instantly. That was something you don't find in many mules. They might be able to outrun a cow, but to get them to do it, that's a different story. But that mule would, because she knew if she didn't get around the cow pretty early, she was gonna have to go farther. She'd run out there ahead of the cow just like a good Quarter Horse, and turn right back on it.

I rode some mules when I was cowboying, just rode them on a snaffle bit. A lot of guys put all kinds of shanks on them, and a fellow back East makes a special mule bit that has a clamp on the nose. But I just rode them.

I used my regular saddle on a mule. A lot of people say you gotta have a mule saddle, but I never saw any of them. Some of these mules now are very much Quarter Horse-backed. They're pretty flat on their withers, and some of them out of those good Quarter mares don't have any withers at all.

Besides their personality, another thing has changed over the years. I've got some old mule shoes here that's six inches long and less than three inches wide. They were used on the mules they used to work around here. Now, a lot of these mules you just take a horse shoe and you don't hardly have to bend it. Just stick it on them.

You want to trust a mule, you don't want to be afraid of him. If you are afraid of him, the mule knows it. But I don't think it makes any difference who's around them, if a person wants to take on mules and knows what they are doing, they'll get along fine.

I don't think mules are harder to handle than horses, but they're smarter and they remember your mistakes, that's the thing. While you're asleep, a mule's awake and thinking. Hell, they're thinking all the time.

The old mules, you used to have to get their attention with a two-by-four. Then you put him in a harness and you worked him 10 hours so he was wore down to a point where he had all the edge off him, didn't want another beating. But now you treat them with kindness because you don't work them that hard. And they're not mean to start with, so you get along with them fine.

Mules have a perfect memory. They never forget anything, and if you make a mistake with them, they remember it for a long time. And if it's a bad mistake, like if one of them gets to jerking away from you, that's awful hard to break. If he's a fully grown mule and you trade for him and he's already got that habit, you can almost bet he'll keep it. He may not do it every time, but he'll get you when you're not expecting it and he will just turn his head away from you, run his shoulder into you and knock you over. Then he'll just take off with that lead rope.

To tell you about a mule's memory, let me tell you about old Ribbon. I took her on the Montana Wagon Train trip, and she didn't want nothing to do with anybody but me. But after a while she tolerated all the people coming by wanting to pet and touch her. I had her around three or four more years, then, two years ago I sold her and her teammate to a guy down in Jerome. Last fall I bought them back.

They told me they were never able to catch that old mule, and they sure couldn't trim her feet. Those mules were in a 3,000-acre field out there, and they told me it'd take all the cowboys in Jerome County on four-wheelers to get them in the corral.

We drove around and finally found them down in the back end of the pasture. I told the woman I was with to stay in the pickup and not get out. I got the halters and I hollered at those mules. I had some grain with me and here they came. I caught the young mule without giving her any grain, but I let the old mule have a bite and then caught her.

Old Ribbon's feet were growed down like cow's feet. I brought her home, tied her up to the hitching rail, walked up beside her and touched her with my elbow and said, "Give me your foot, Ribbon." She just picked it up, but her feet were so hard that I couldn't trim them. I had to put her in the corral and turn the water on them for 24 hours before I could bob them off.

But Ribbon tolerated me working with her. She remembered me.

They don't forget what you teach them. You can break them to work and then turn them out for a long time and pick them back up and they haven't forgotten a thing. If you don't let them get away with some kind of mischief that they shouldn't be doing in the first place, they'll stay broke all their life.

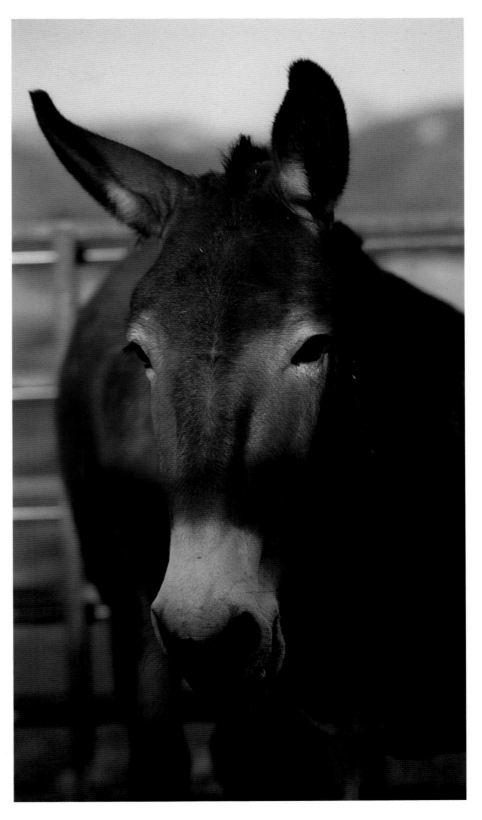

Tom Hall's Mule, Barbie

Curt Pate bridling up Apache
with a two rein outfit and half breed bit.

"*Any bit is as severe as you want to use it. The spay bit was a little pre-notion of what you were gonna do. When the bit moved a little, the horse knew you were gonna do something.*"

—*Tom Hall*

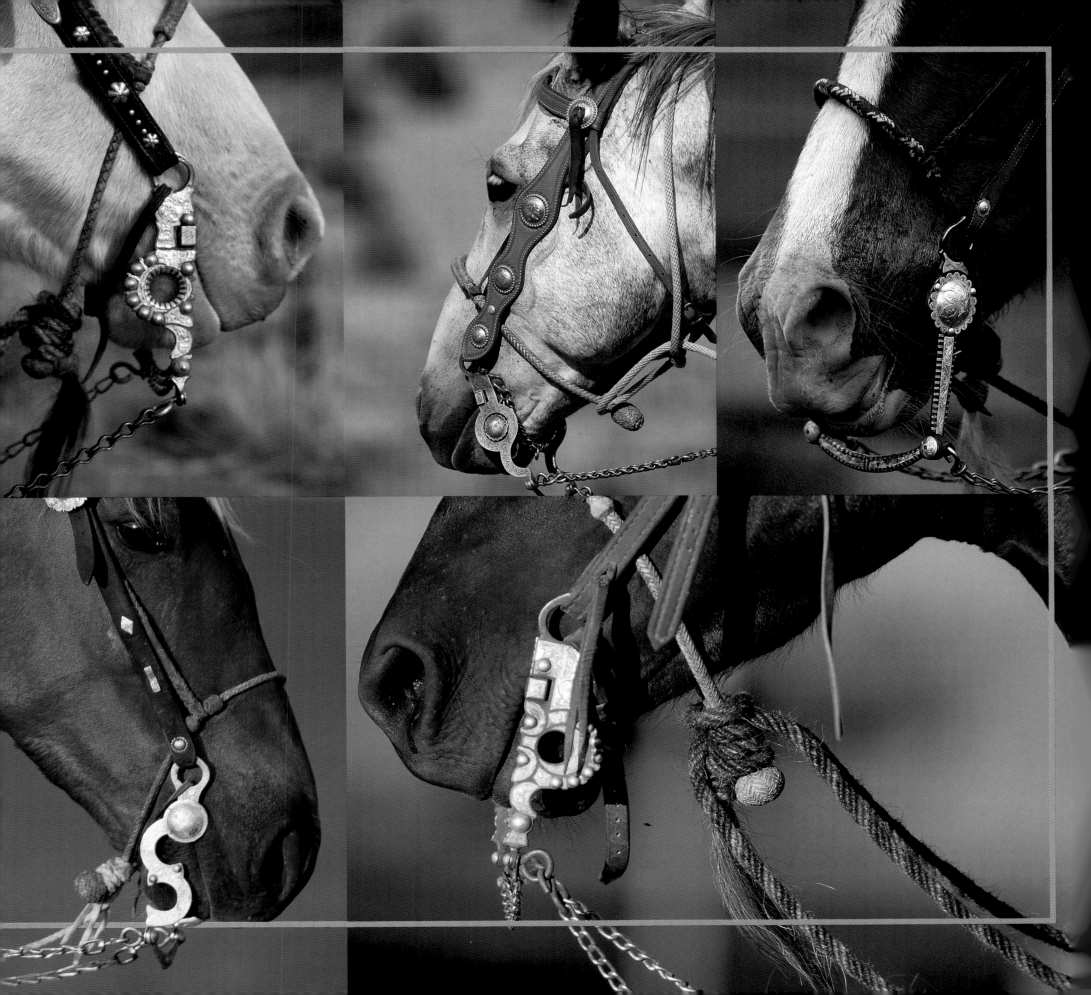

THE BEST SEAT IN THE HOUSE

Nancy Hoggan builds saddles for the most demanding customers in the world—working cowboys

It's critical that a saddlemaker know horses. If you're a saddlemaker and you don't understand fit, you better not be building saddles for people who are going to use them hard or you're going to be in a lot of trouble. Customers will start coming back and saying, "Hey, this didn't work." You better know what they're talking about.

I have an advantage when building saddles because I ride. I'm around horses and see how they're built. I see the difference in horses and I have some working knowledge of them. I've lived all my life on the ranch. My sister and I were older than my brother, so we had to work just like we'd been boys.

The hardest part of building a saddle is getting everything perfect, getting everything just how you want it. I may be 37 years old, but I'm just a little kid when it comes to getting started in the saddle-making business. This will be only my seventh steady year of building saddles.

My saddles, with the exception of a handful, are going to guys who are using them, working cowboys who are using them if not every day, then a lot. I've had guys already wear some of my saddles out, and guys who came back for their second or third saddle because they are riding that much and they need more saddles.

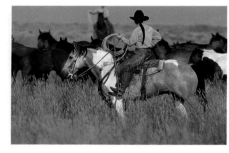

I don't advertise. I don't go to shows. And when my husband and I rodeo, we go to the semi-pros or amateur and see a lot of guys who are working cowboys that also go into town and compete. That kind of helps my business in that a real rodeo cowboy usually isn't interested in a handmade saddle. A lot of them win saddles or they're just going to go with a factory-made saddle. And they use a roping-style saddle, a little different than the style I build—and that costs a lot less money.

The difference between a handmade saddle and factory saddle, besides the quality of the material, is the custom features. When a saddle is handmade, you can order what you want. The tree is more than

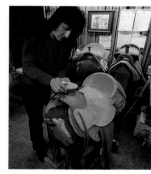

Nancy Hoggan

likely going to be a handmade tree, and it's going to be a tree that fits your horse as best it can. You can get buy with a sorrier tree if you're not going to ride very much. But if you put a lot of miles on, it's going to start showing on your horses if the tree doesn't fit. The rawhide's going to be good, and there's not going to be staples in it. There's going to be little ring-shaped nails. Everything in the saddle is going to be the best that the saddlemaker can get.

Anybody who's cowboying realizes that a factory saddle isn't going to fit their horse just because of the tree and the way they ride. Like the sheepskin under a handmade saddle is genuine. On a lot of factory saddles, it's a synthetic. The sheepskin is there to absorb moisture and for cushioning. Nylon, or whatever they make the synthetic out of, just isn't going to hold up. It's going to mat down and won't fluff back up. It just doesn't have the qualities of natural sheepskin.

A saddle starts with the tree. The tree's got two bars and a fork, which is the front end, the cantle, which is the back of the seat, and the horn, which is set into the fork. You order the tree to fit your horse. It's flatter for a wide-backed horse, or straight up for a narrow horse. You order the front end according to how you're going to ride. Everything is what you order, according to what's going to fit you and your horse.

From there, everything is basically leather. You have your bronze, rigging plates, that are set into the leather, and then you have nails and screws and linen thread, some nylon thread, that holds it together.

The tree is the most important part of saddlemaking. But a sorry saddlemaker could take a good tree and still build a saddle that could hurt a horse. A good saddlemaker can take a sorry tree and build a saddle that won't hurt a horse. Part of the quality has to be with the making.

A wood tree is carved out by hand, sometimes all by hand or by a panograph, and it has four pieces—two bars, a fork and a cantle.

Good trees are made out of fir, a softer wood. A plastic tree is actually fiberglass that's shot into a mold, and it's one solid piece. Plastic trees have their purpose, but they're not for cowboy saddles.

A tree has to give, and that plastic doesn't have much give. In the wooden tree, the four pieces don't really move so much, but there is some give. If you have something roped and have a wooden tree, it has some give and will take the shock of a hit. A plastic tree, you can break the bars or snap the horn out pretty easy.

Generally speaking, a Wade or a Homestead tree should fit a Quarter Horse, where it's probably not going to fit a Thoroughbred. Their withers are too high, and saddles built with those trees are going to sit low, the gullet is low, so the withers of your narrower-built horse would be hitting. If you ride an Arab, then you better get a tree built for an Arab.

If you want a slick-fork, most guys will go to a 3-B or a Weatherly tree. They sit higher, give more clearance. You'll see them more in Nevada, where the guys ride long miles and are riding more Thoroughbred-type horses.

The first thing you should consider when you're going to get a saddle built is what kind of horse you ride so you can get the tree to fit the horse. It's good if the saddle's comfortable for you, and if you have a good saddlemaker, it should be comfortable. But it won't do you any good if you ride a real roundback Quarter Horse and you've got a saddle that only going to fit a narrowback Thoroughbred.

Most saddles are tooled. I've built 89 saddles and only two of them have been full roughout. Most people want some flowers, and almost always get a basket stamp with a little flower mixed in. It depends on how much money they can spend. To my way of thinking, you're already starting at fifteen, sixteen, eighteen hundred, you might as well spend a couple hundred more and get it nice.

I try to make my saddles nice, but not really artsy. I still try to make more of a working saddle than just something to look at. I guess I'd like to see saddles kept more as a piece of functional work, some guys say functional art, but there's guys that carve leather a lot better than I do and they can make a real pretty saddle. But I

Nancy made this saddle for left-handed Curt Pate. This is one of her fanciest saddles and one of the few rigged on the left-hand side.

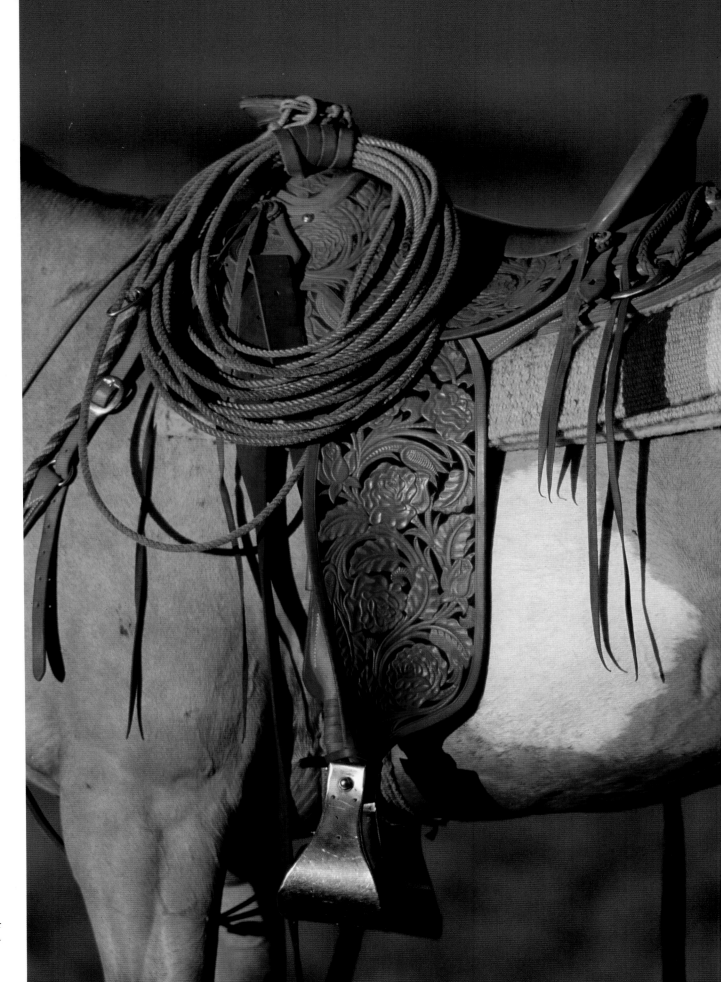

still want a saddle to be one I wouldn't be afraid to ride.

The cost of a handmade saddle varies with every saddlemaker, but I guess that most guys are starting anywhere from fifteen hundred to two thousand. My saddles are pretty much running eighteen to twenty-four. It's one of those deals where it's not how long it takes to make it, it's how long it takes to get it. I'm about a year and a half to two years out on my orders. So, if you order today, in about a year I'm going to check with you and say that we need to get the tree ordered. It takes about three months to get the trees right now, so in six or twelve months from then you're going to be getting a saddle.

There's a lot of saddlemakers around. You can throw a rock from here and hit a saddlemaker, and they all seem to be busy. I know a lot of them aren't really making a living at it, but they keep thinking they are, and it's hard to figure where all those saddles are going.

Building a saddle for a working cowboy is a challenge, because you know you gotta do it right—that saddle isn't going to go sit in somebody's tack room. It's going to be used and be put to the test. They put in hard miles and they ride a lot.

What they really need is two or three saddles so they can let them dry out between rides. What happens when a cowboy uses just one saddle is that the moisture never gets out, the pads just can't keep them dry enough, and the saddle rots. The sweat goes right up through the skirts, right onto the bars, and there is never any relief so the leather just rots off the bars.

Building a saddle is challenging in that sometimes you know somebody who's a good hand, a cowboy you admire, and he orders a saddle. Then you think, "Now's the test. Is my saddle going to live up to their standards? Is it going to hold up?"

I've been building saddles for seven years, and it's embarrassing the amount of stuff I don't know. You can't just go to the library and get a book and read about saddle making. You have to learn it from old sources, learn it from somebody who has more experience or through practical experience. It's fascinating to me to look at old saddles. The progression in saddles has been made in the trees more than in the carving of the leather. Back 100 years ago there were guys who carved leather beautiful and who could build a beautiful saddle. But the tradition is still there. Today a saddlemaker can go look at an old saddle and still pick up ideas.

There seems to be a lot of guys starting into saddlemaking today. There's always been a fascination with the West, cowboys and everything that goes with them, and a lot of that is what keeps saddlemaking going. I'm probably an exception in saddlemaking, in that most of my saddles go to working cowboys. A lot of guys, if they build a nice saddle and get into a show, or go to these cowboy poetry deals, they start meeting people who have money and they'll become their clients—people with money who enjoy horses and have the money to get a saddle built. Those people buy a handmade saddle for the prestige and get a bonus—something comfortable to ride.

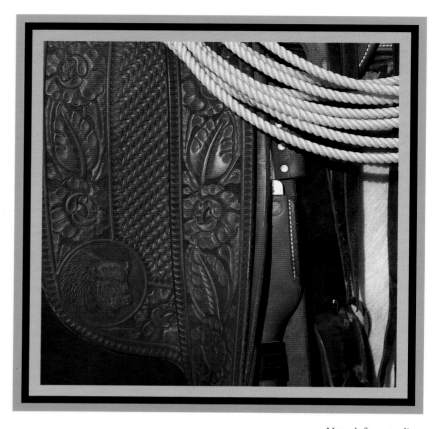

Nancy's fancy tooling

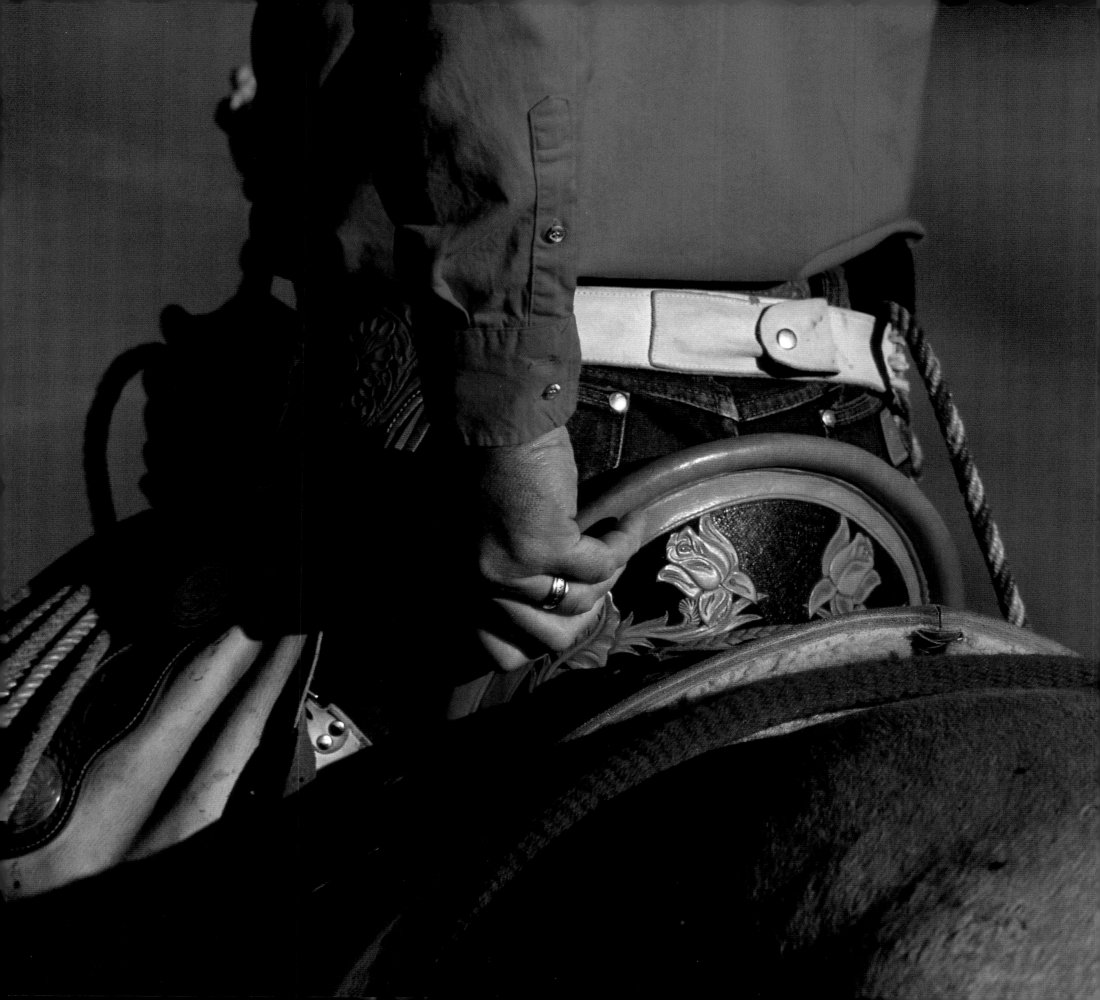

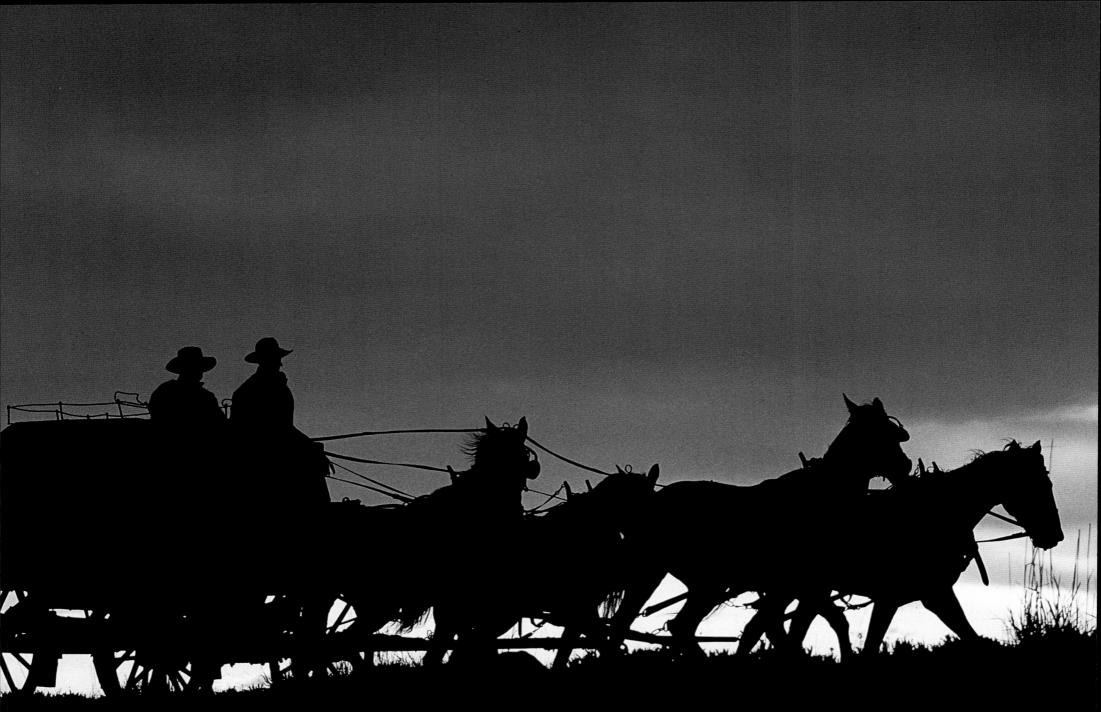

He carried mail and passengers / And he started them on the dot,
And those teams of his, or so they say, / Was never known to trot.
But they went it in a gallop / And kept their axles hot.

—Bill Peters, *The Stage Driver*

Stage Coach
Mike Hanley and Jim Kershner; Jordan Valley, Oregon

THE FIRST AMERICAN COWBOY

By Jo Mora from his book, **Californios**

The American vaquero or cowboy—call him what you will—first rode his pony into Alta, California and what was later to be our own United States on May 14, 1769. A kerchief was bound about his head, atop which, at a very rakish, arrogant angle, sat a trail-worn, weather-beaten hat, wide of brim, low of crown, held in place by a *barbiquejo* (chin strap) that extended just below the lower lip. His unkempt black beard scraggled over his jowls, and his long hair dangled down his back to a little below the line of his shoulders. His ample colonial shirt was soiled and torn, and a flash of brown shoulder could usually be seen through a recent tear. The typical wide, red Spanish sash encircled his lean midriff. His short pants, reaching to his knees, buttoned up the sides, and were open for six inches or so at the bottom. Long drawers (which were once white) showed wrinkles at the knees and were folded into wrapped leather *botas* (leggings). He wore a rough pair of buckskin shoes with leather iron spurs. This costume was finished off by a *tirador* (a heavy, wide-at-the-hips belt) that helped him to snub with the *reata* (rawhide rope) when lassoing on foot. The ever-present long knife in its scabbard was thrust inside the garter on his right leg.

He rode a typical Mexican *silla vaquera* (saddle) of the period, Spanish-rigged. Dangling down on either side from the large, rounded horn were two huge slabs of cowhide that could be drawn back over the thighs and lower legs. These were the *armas* (chaps) of the Baja California cactus ranges. The reata was tied to the saddle strings in back of the cantle on the off side, with the rolled and pendent *serape* passing through the coils. There was your very first California cowboy!

I have had some grand arguments in years past as to who the first cowboys were. It is curious the twist lots of folks have on Western history. My last verbal tilt on this subject was with a "back East" professor who considered himself quite a rooster in his history and who had been touring the West making a "study" of the cowboy. He claimed that the first American cowboy appeared on our national scene in Texas in the 1850s, and with this I heartily disagreed. I maintained that the honor belonged to the California vaquero, who had arrived some eighty years earlier, and thus the argument started.

He asserted that my candidate should not be considered, since California was under the flag of Spain when the first vaquero arrived—all of which should brand him as a "foreigner" and not a genuine American cowboy. That sounded logical enough at first, but for all that, the argument was full of holes and wouldn't hold water.

At the time California stepped into the spotlight Texas was under the very same flag—Spanish—and under the Mexican flag later, since both regions were contiguous parts of the same empire. Then the Texans, by force of arms, took their land away from the Mexicans in 1836 and established themselves as a separate nation under the Lone Star flag, and were accepted as such by the United States and other nations. Well, that wasn't the United States,

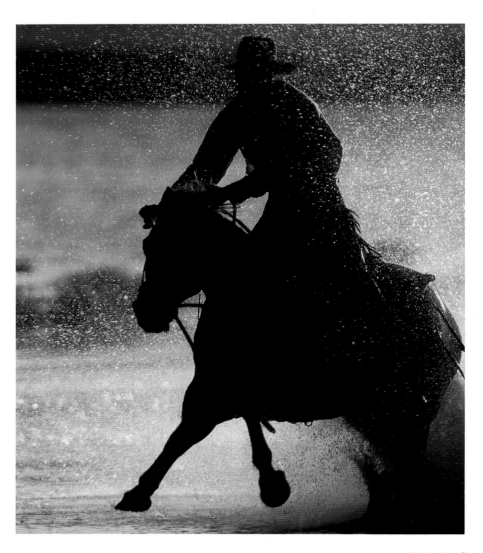

Craig Boyd
Woods Livestock Ranch, California

was it? Then came the ups and downs of those turbulent, scrappy days with our sister republic across the Rio Grande. After a lot of this and that, Texas was finally admitted into the Union in 1845.

Now let's look back and see what was happening to Alta California during those hectic

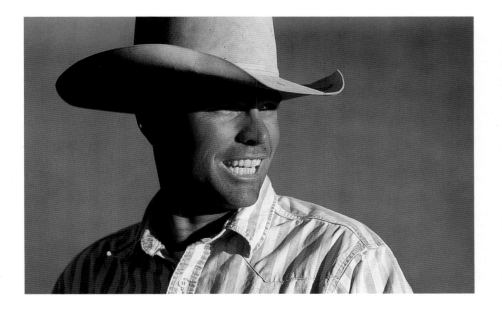

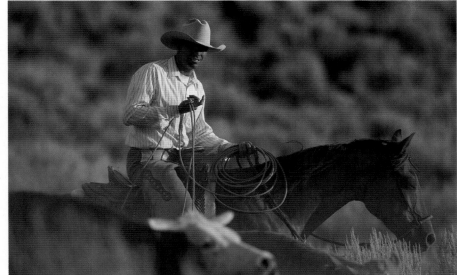

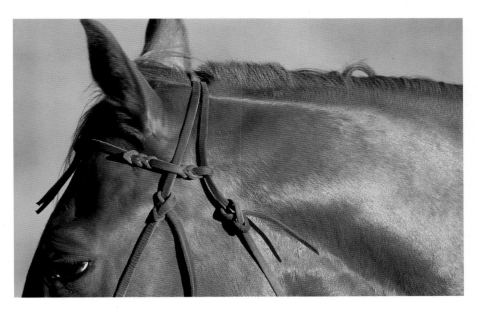

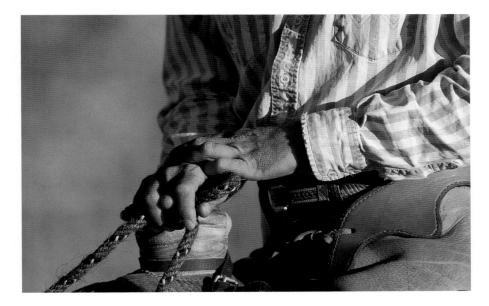

days. We'll find that while all the fireworks were going on south of the Rio Grande, the Stars and Stripes were hoisted at Monterey, California, by Commodore Sloat in 1846, and California became part of the United States and has remained so ever since. Texas in 1845, California in 1846. Pretty close timing, but as yet the Texas cowboy hadn't made his appearance on the United States stage as a distinct character.

You see, my professor claimed the cowboy came into being in the 1850s. Well, he was correct more or less, because with the Texas cowboy you just can't set a definite date. But we still find that the California vaquero had been taking his dallies on what was now United States territory for eighty years before the Texas cowboy came into the picture. And you can

start a lot of broncs and take a heap of dallies in that time, brother.

My opponent in the argument had trouble trying to clear away this hurdle, except with hems and haws and then finally with the statement that the very name my candidate bore, "vaquero," really stamped him as a foreigner. Of course that was plain ignorance on his part, and I think, way down deep, he still thought the only "Americans" were the original tourists who came over in the *Mayflower*. I assured him, however, that even when I was a child, in much of the cow country in Texas the word "cowboy" was seldom used. They all called themselves "vaqueros" and, I believe, do so to this day in many sections.

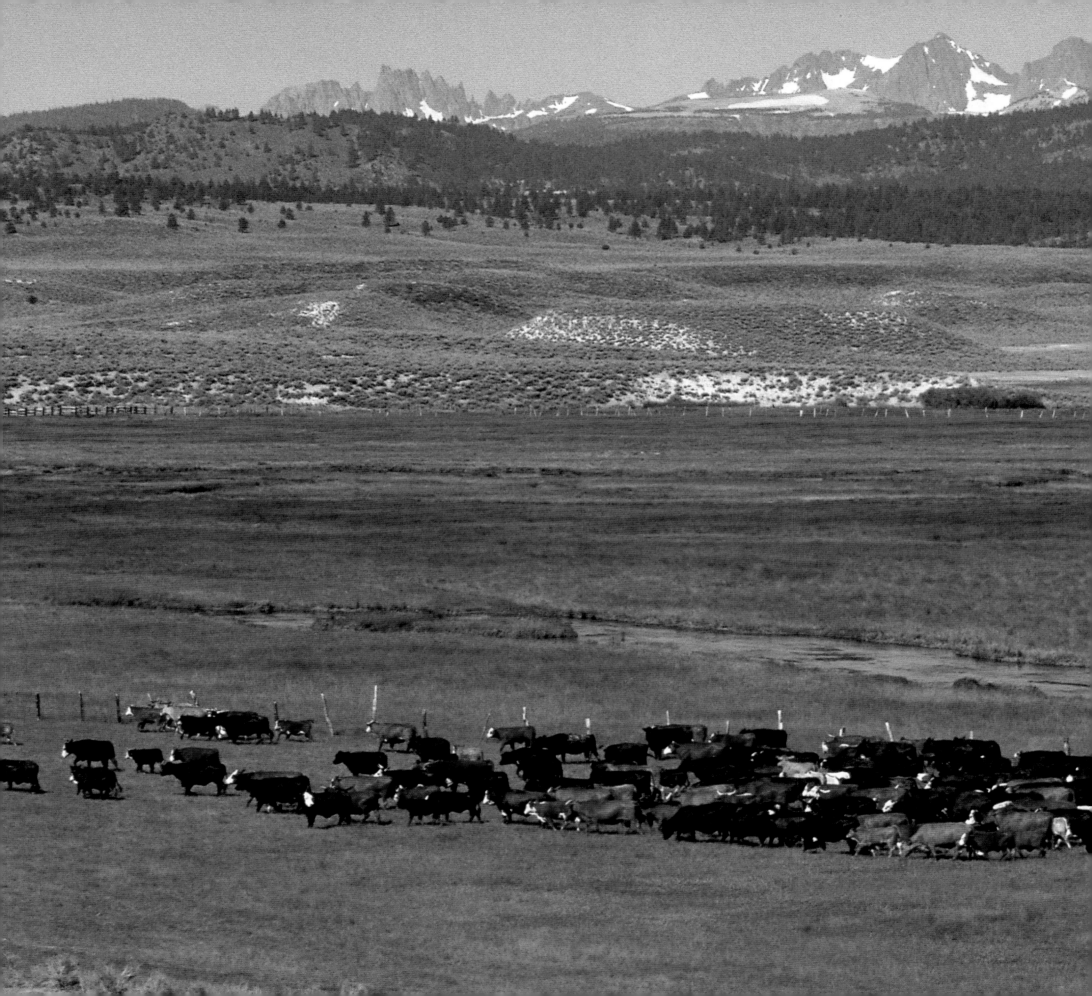

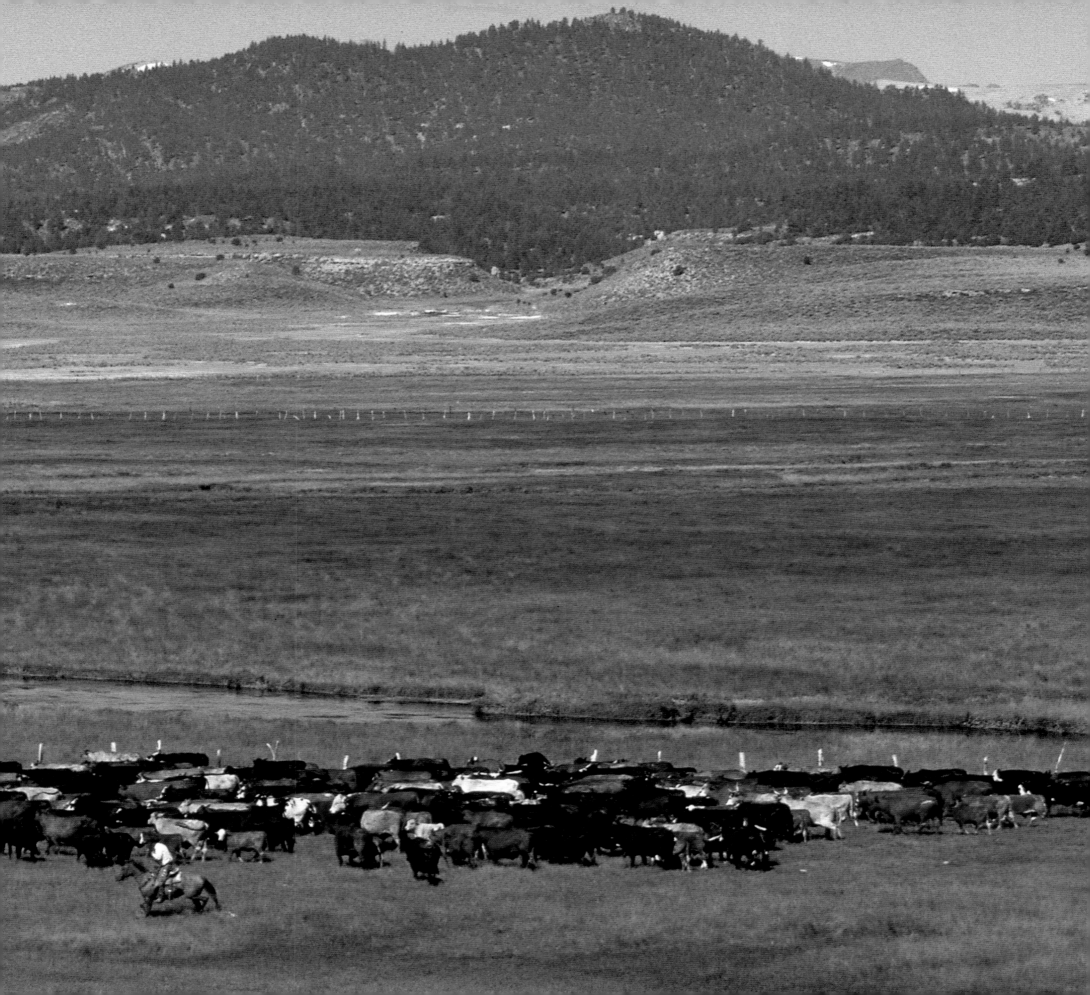

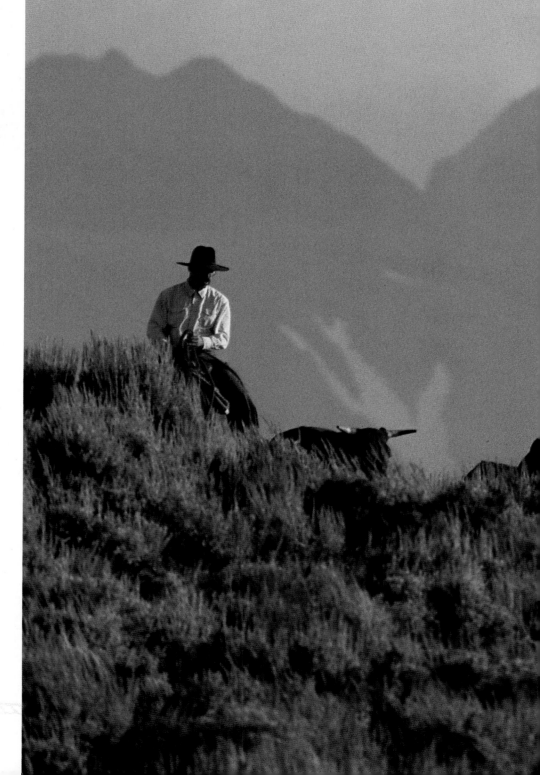

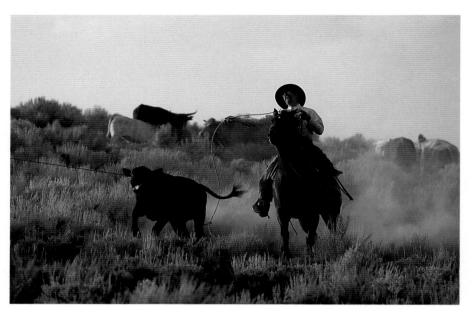

The Miss
Chris Regali

Previous Page
Jim Cashbaugh, Cashbaugh Ranch; Mammoth Lakes, California
Craig Boyd, Chris Regali
Woods Livestock Ranch; Owens Valley, California

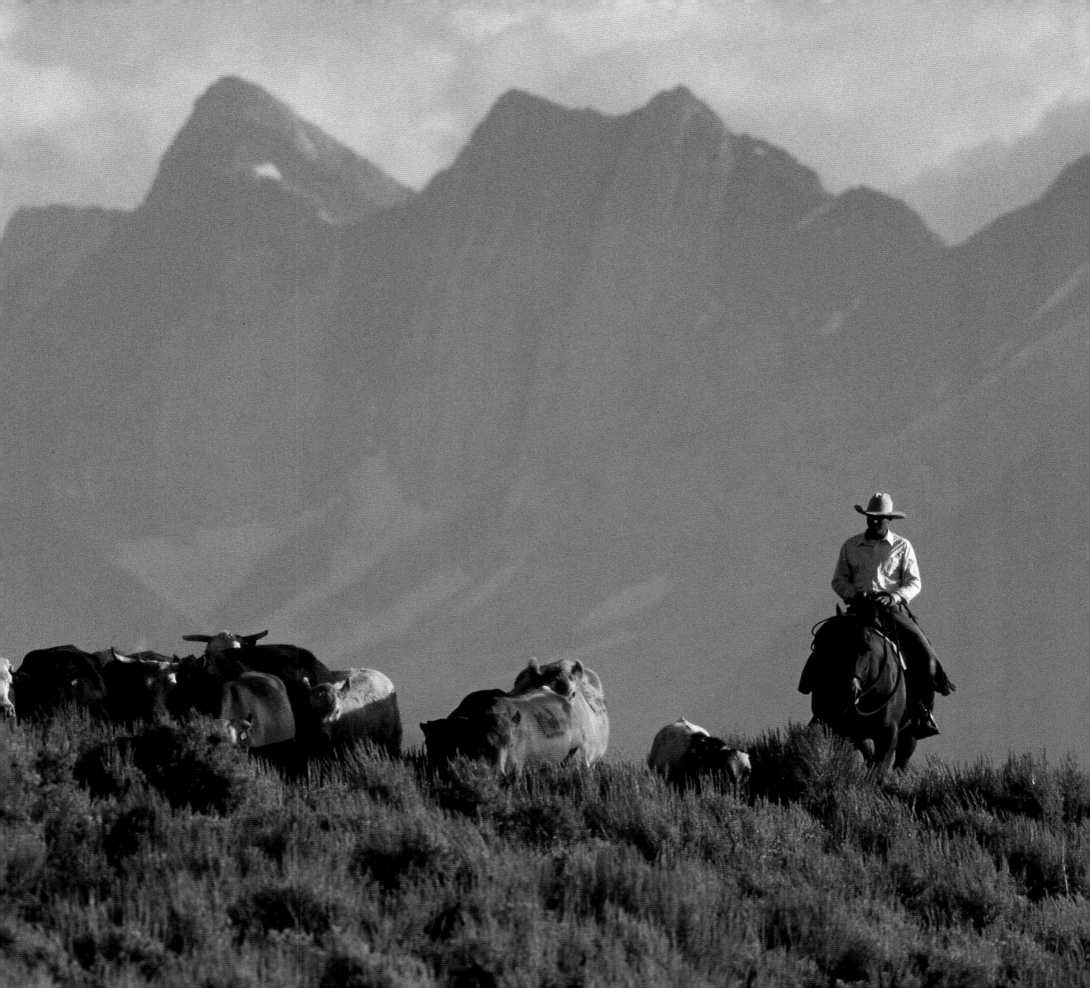

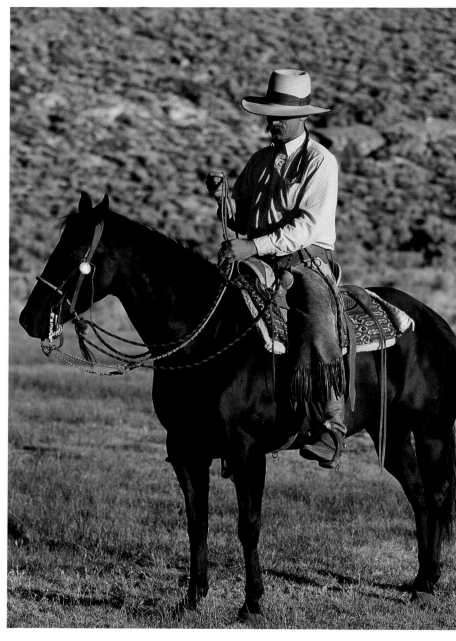

Ricky Link
Woods Livestock Ranch; Owens Valley, California

I'll take my horse, I'll take my rope,
And hit the trail upon a lope,
Say "Adios" to the Alamo
And turn my head to Mexico.

—The Texas Song

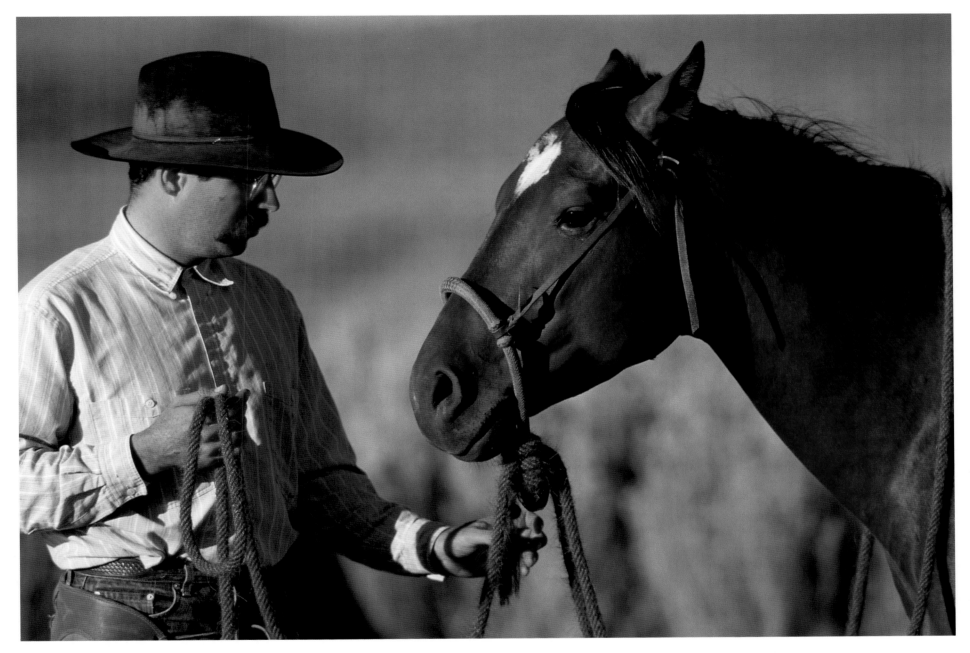

Chris Regali
Woods Livestock Ranch; Owens Valley, California

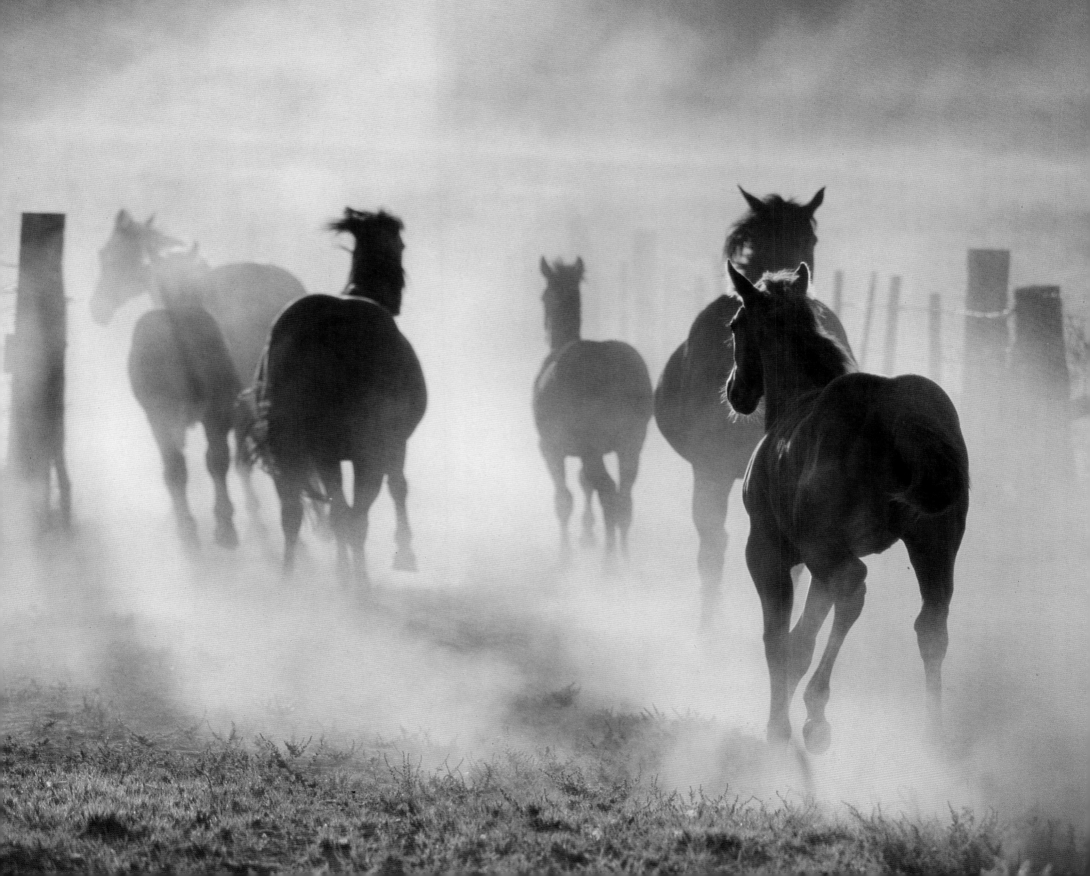

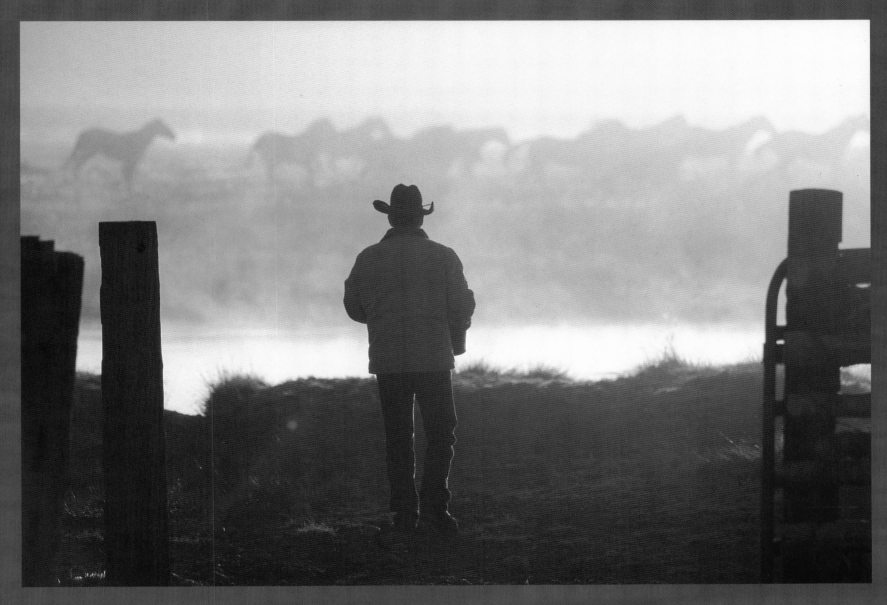

Bringing 'em In
Jim Cashbaugh, Cashbaugh Ranch; Long Valley, California

Turning 'em Out
ribarren Ranch; Bishop, California

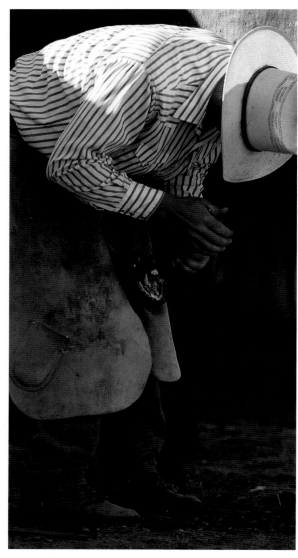

Jeff Yribarren
Yribarren Ranch; Bishop, California

In California, ranching is a family tradition.
Ron and Jeff Yribarren working together on the family ranch.

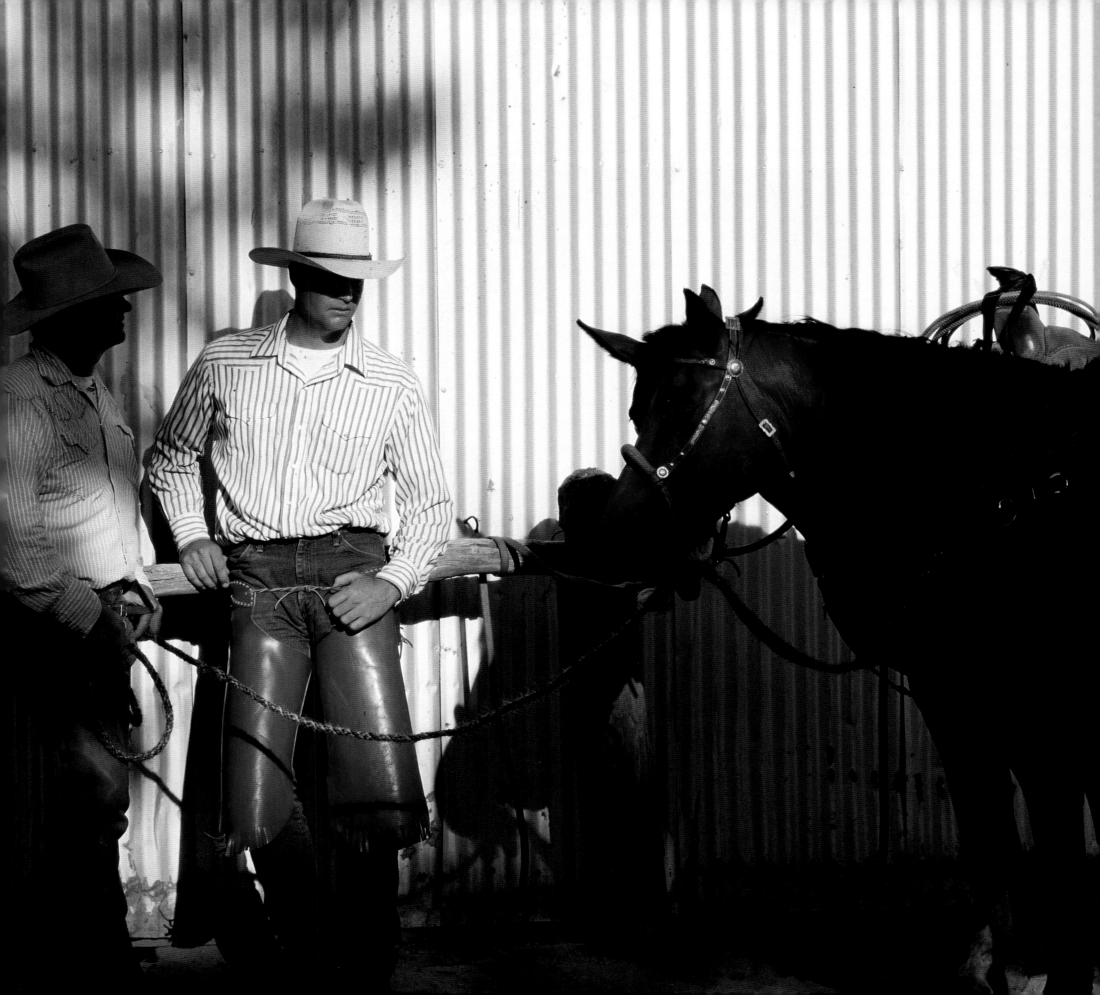

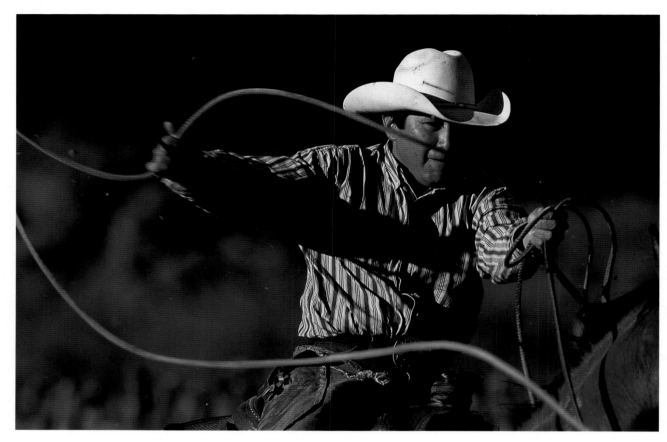

Pullin' the Slack
Jerry Chischillie, Heartz Ranch; Winslow, Arizona

Mount for the chase! Let your lassoes be strong,
Forget not sharp spurs, nor tough buffalo thong

—The White Steed of the Prairies

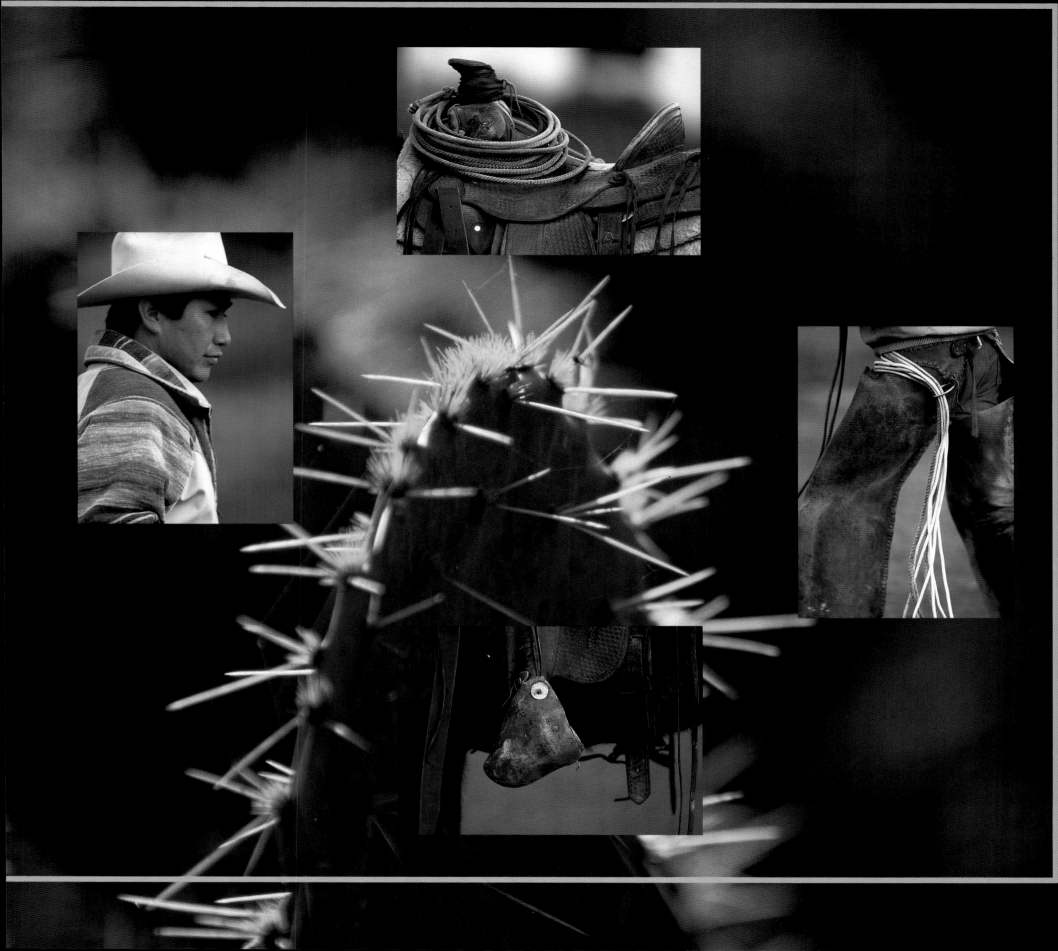

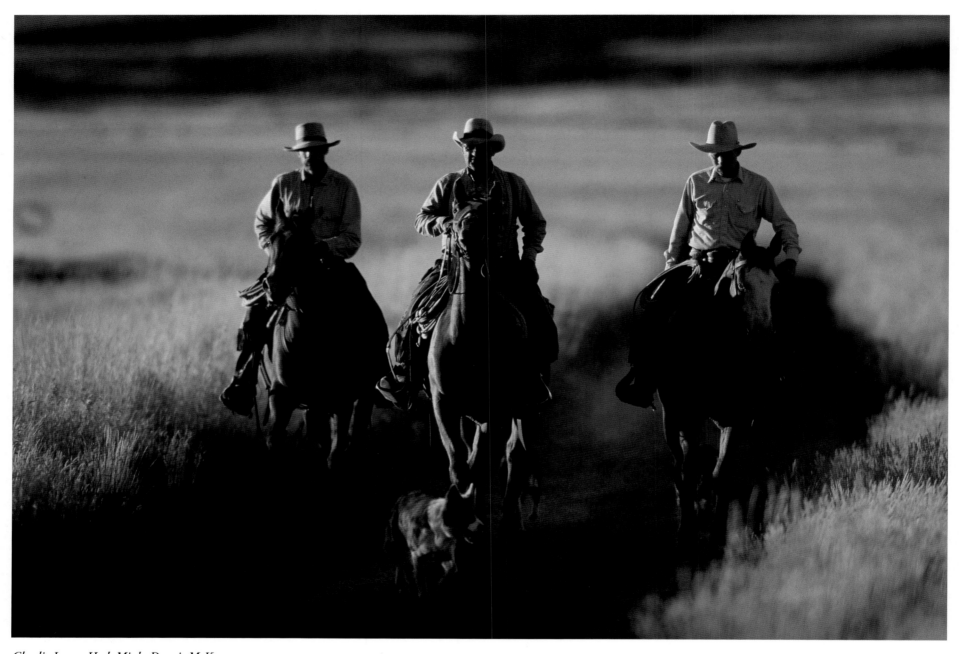

Charlie Lyons, Herb Mink, Dennis McKay
Big Springs Ranch; Bruneau, Idaho

YOU'VE GOT TO THINK FOR YOURSELF

A cowboy his entire life, 69-year-old Herb Mink sums up the cowboy's life in a single word—independence

I've been a cowboy my whole life. I can't remember when I rode my first horse or roped my first cow. The only thing I've ever done different was working at the railroad roundhouse at Huntington, and then on the Brownlee Dam. I worked on the dam for nine months, eight-to-five, five days a week, time-and-a-half if you worked Saturday, double-time if you worked Sunday. That was the only time in my life that I despised going to work.

Doing the same thing every day, you don't get to think for yourself. The boss comes and tells you what to do, and when you're done with that you sit and wait until he tells you to do something else. You don't use your head in no way.

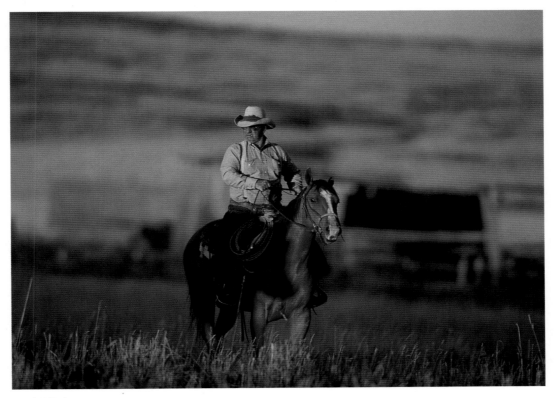

Herb Mink

When you are a cowboy, they give you the cows and the country to run them in. Your cowboss gives you an overall plan of what he wants, but that don't always work. You've got to think for yourself.

When I was 14 years old, Albert Campbell left me at camp with 1,500 steers. He took me out in his car, drove me around the outside edges of the range, and told me to put so many head of steers here, there, and so on. After he took me back to camp I told him I'd do the job as near like he said as I could.

"Wait a minute," he said. "I just gave you an overall picture. I'd rather have a man have 20 ideas of his own and not one of them worth anything than for him to not have any ideas at all."

And that's what an outside cowboy has to do. If he's out in camp by himself, he has to learn to use his head.

When you're in camp with a crew of men and a buckaroo boss, he leads you out every morning and tells you which way to ride. Then you don't have to think so much. That's where loyalty comes in. You need their help and they need yours. Everybody needs some help, even if it isn't anything but a friendly greeting.

It's all right to B.S. sometimes, but you have your mind on what you are doing and your eyes looking for tracks, looking for cows. After a while you learn that you can get out of most of your wrecks by yourself, because you always plan for the worst that can possibly happen. If that don't happen, you've had a good day. You learn to think and to survive.

I've lived in cow camps all my life. I used to have to pitch hay and feed cows in the wintertime, but I love life at the camp. I go to Digshooter, and have to pack-in in the spring on packhorses, stay for two months, come out for three or four days, then go back and stay for six weeks before coming out again for a couple of days. I have to pack-in 23 miles. You can't get a vehicle in there because it's so rocky and rough.

When I go to camp in the spring, I'll haul my horses and my pack outfit as far as we can in a trailer. Then I pack up my packhorses, usually three, and take what stuff I need to take. My extra horses I just tail together, tie each one to the other's tail, so I'm

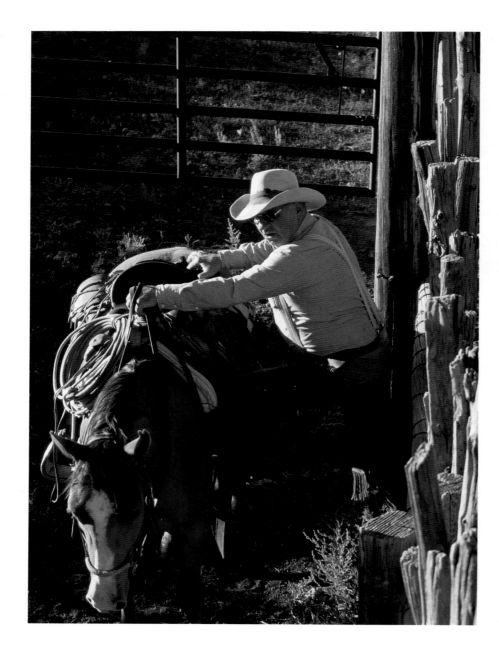

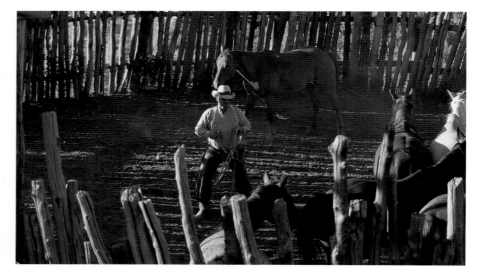

I got into camp just as it got dark. It had snowed all morning and in the afternoon it had quit and started to freeze. With my horse kicking that snow and slush, I had snow and mud frozen all over my boots. I just unpacked, stayed in camp that night, then straightened up the next morning.

I went around checking my horse pasture's fence and got water to the camp the next day, then spent three days packing salt. The salt was already in camp, because we take it in in the fall. Hauling it out to different spots, I can put out nearly a ton of salt in a day.

I'm usually in camp only five days before I ride back out to meet the cattle. I ride out to Blue Creek, which is 16 miles from my camp, and pick up a truck. I load up and drive about 20 miles to where they are trucking in the steers, then spend about three days getting them in to Battle Creek. I have help getting them to Battle Creek, and then a man stays and helps me scatter them out some.

Last year at Digshooter we had 2,000 yearling steers in a country that's probably 15 miles deep and 23 miles wide at the widest spot. Just a lot of open, rocky country. In the summertime I get up about 2:30 or 3 in the morning, saddle my horse and ride out. I take a section each day and move the cows if I have to, and pack salt out to them. When I get through, I come home, but never the same way I went out. I've already seen that country. I come through some other country and maybe I'll see something that means I have to change my plans for the next day.

While you are out you look for sickness, cripples. You look at your grass to see if the cattle need to be moved. If they are all congregated in one spot, you split them up. And when you've got cows and calves, you keep the bulls scattered out.

You do what you think needs to be done to get the most pounds on the cattle in a summer's time. That means you don't overgraze. You can eat grass off once and not hurt it. You can eat it off twice and not hurt it if it's early in the growing season. But any time you let your cattle camp on it and knead the grass into the dirt while it's still growing, then you're hurting the ground.

riding one and have five other horses tailed together.

I lead my kitchen horse—that's the horse I have the eggs on—and pack boxes on the second. The third horse hasn't got much, as a rule, maybe a duffel full of clothes or a couple of sacks of dog food. I have to take in hay and grain as well as canned goods and staples, and then store some over the winter so I don't have so much to pack-in in the spring.

Last year my cowboss went with me to see if I could get across Battle Creek. We went in there blind, had no idea how high the creek was. It can be swollen, and you don't want to cross in the dark. But it turned out the creek was low, so he turned around and went back out.

After the grass matures in the fall and is seed-ripe, you can't eat it too short. Of course you move your cows when they stop doing good, but when the grass is really short after it's all matured and seeded, the cattle stomp the seeds into the ground and the next year you have new plants to start.

When you are out like that and you see a sick cow, you doctor her all by yourself. While you are riding you look at the cows' eyes, their ears, noses, mouths, legs, and body. That will tell you if there's anything wrong with them. You decide what the problem is and give them medicine accordingly. You can't pack all different kinds of medicine, so you use one kind that works best overall for anything you should happen to find. I usually pack penicillin, LA200, and a little pinkeye powder. That takes care of about everything I need. I also pack fencing pliers, a screwdriver, and a pair of binoculars. That's about it.

I was up there almost two months before I saw anybody. I have a radio and call once a week to report in. Out there by myself I feel happy. I get along fine with the cows and my dogs. It's people I have a problem with!

Last year I had a hip operation and they wouldn't let me go to camp afterwards. I had to stay in the valley all summer, because they were afraid I'd hurt my hip. I was unhappy and it was harder on me here in the valley because they were selling off their cows and I was working cows and calves every day. When I was out at camp by myself and my hip started hurting, I'd just butcher for the day, then finish up what needed to be done with the cattle the next.

If anyone asks me how come I punched cows all my life and never owned any myself, I say, "You mean to say that after all these years of staring a cow in the behind I'm dumb enough to want to own one?" Somebody asked me how come I stayed this long. I said, "Well, when I was young I did it for the glory. The girls all liked cowboys. Then I got married and couldn't look at the girls anymore, so I did it for the money. Now I'm so damned old I don't know anything else, so I'm just gonna stay being a cowboy."

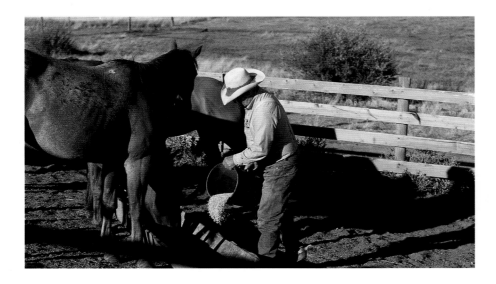

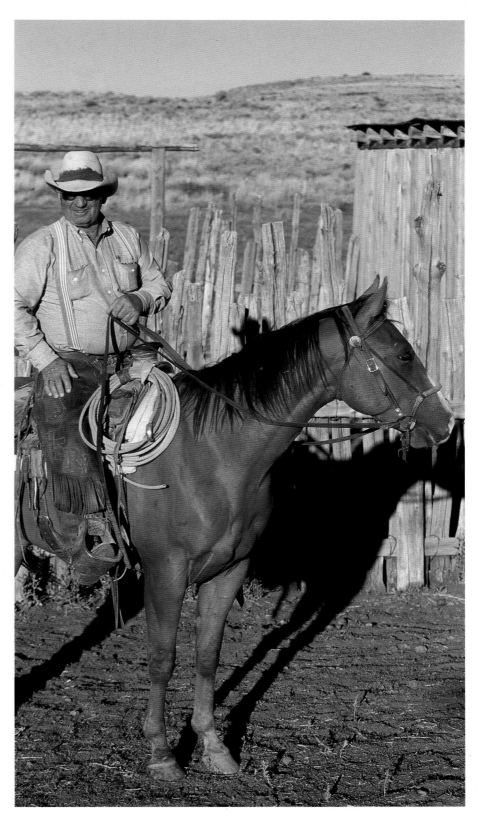

I'VE HAD SOME GOOD DOGS

The cowboy, the horse, and the dog all make a team, says Herb Mink

Old Nicki hardly worked before she was a year old. I owned her mother, and my boy that died was a little guy then, five or six years old, he wanted a pup. So I picked out this one. I kept her and gave the others away. But she was growed up, damn near a year old, and she still hadn't done nothing. You couldn't call her, couldn't send her back. You would go out and she'd just hang back about 50 yards.

Then one day in the fall I was trailing up from the Oxbow Dam, up Pine Creek by the freeway, and three big calves crawled through a fence and went up a hillside a quarter of a mile or so. Nicki just took off on her own. She went up and around them, and she worked them back and through that hole in the fence. She never disturbed the other cattle, never hurried the calves, just worked them in. Then she came back to the back end of the herd and started working them back and forth.

After that, all I had to teach her were the signals, and she turned out to be really something.

One day we were gathering cows over here when I worked for Knox, and I was up on a hillside to get what I thought was a black bull. That bull was damn near a half-a-mile away and I kept sending Nicki. She'd go right to it, then she'd come back. I'd cuss her and send her back. She'd go, she'd look, and I'd holler "Bring it!" She'd stand and look and then she'd come right back.

Finally, Joe Barrett came over and said, "Herb, if I was old Nicki I'd bite you. You're trying to make her bring back a rock!"

I couldn't let Joe get the best of me, so I said, "Well, she used to bring 'em."

And Nicki could bring in the cows. I'd send her and she'd bring everything. She'd never leave. She worked for me for years, and lived just a little more than 13 years. She went with me every day I went, except the last two days she was alive. She died in June and by fall the cows would get to scattering on us. I'd holler, "Get away wide, Nicki. Turn 'em!" Them old cows' heads would all come up and they'd just start drifting in. Nicki had broke them, and even though she'd been gone all summer, she still had them broke.

Nicki hated to bite a cow. Oh, she'd bite them just as hard as she had to—but no more than it took. If it took one bite to stop a cow, that's all she did. She never had to take the second bite. She came as near to being right all the time as any dog I ever saw.

These dogs have to have cow sense. They've got to have aggression, but they've got to have patience, too. They've got to learn not to fight unless they have to.

I had one other dog before Nicki that was almost as good. That dog was named Johnny. In the fall of the year, cows with big calves get to dogfighting, but Johnny could bring one back. He never heeled a cow in his life, but he was hell on their ears and faces. He just cut in and grabbed that old cow by the ear and then he'd run. He'd always run, because she was after him and going the way he wanted her to go. He never ran the wrong way.

It wasn't long before he had them exactly where he wanted them.

I could leave Johnny to hold a herd. I could take a short circle and put some cows where we were gonna rodeo, and I'd just tell him to watch them. Then I'd leave. I'd go make a big circle and he'd just stay there and hold those cows all day. If cowboys came in with cows, he'd just slip out and cut in front of them like he was saying, "You go help Herb. I got 'em, boys."

He'd stay there all day and hold them. I could never make old Nicki do that. She'd stay half an hour or an hour until people began to show up, then she'd have to come and hunt me, help me.

There are always dogs in cow country. Up home, in Hells Canyon, that's really dog country. Everybody has dogs and they got good dogs. In that steep country, you have to have a real good dog because it's so damn steep that you can see some cows over on a ridge and you can see if they're yours or not. You can send that dog over there and he's close enough that you can holler at him. You can have him bring that cow up the ridge while you bring what you've got until the cows finally come together.

A good dog minds and has respect. A horse has to mind, and a cowboy has to mind, too. The cowboy, the horse, and the dog all go together. They make a team.

Roger Peters, Colt Barelman, Jay Hogga *and Chuck William*

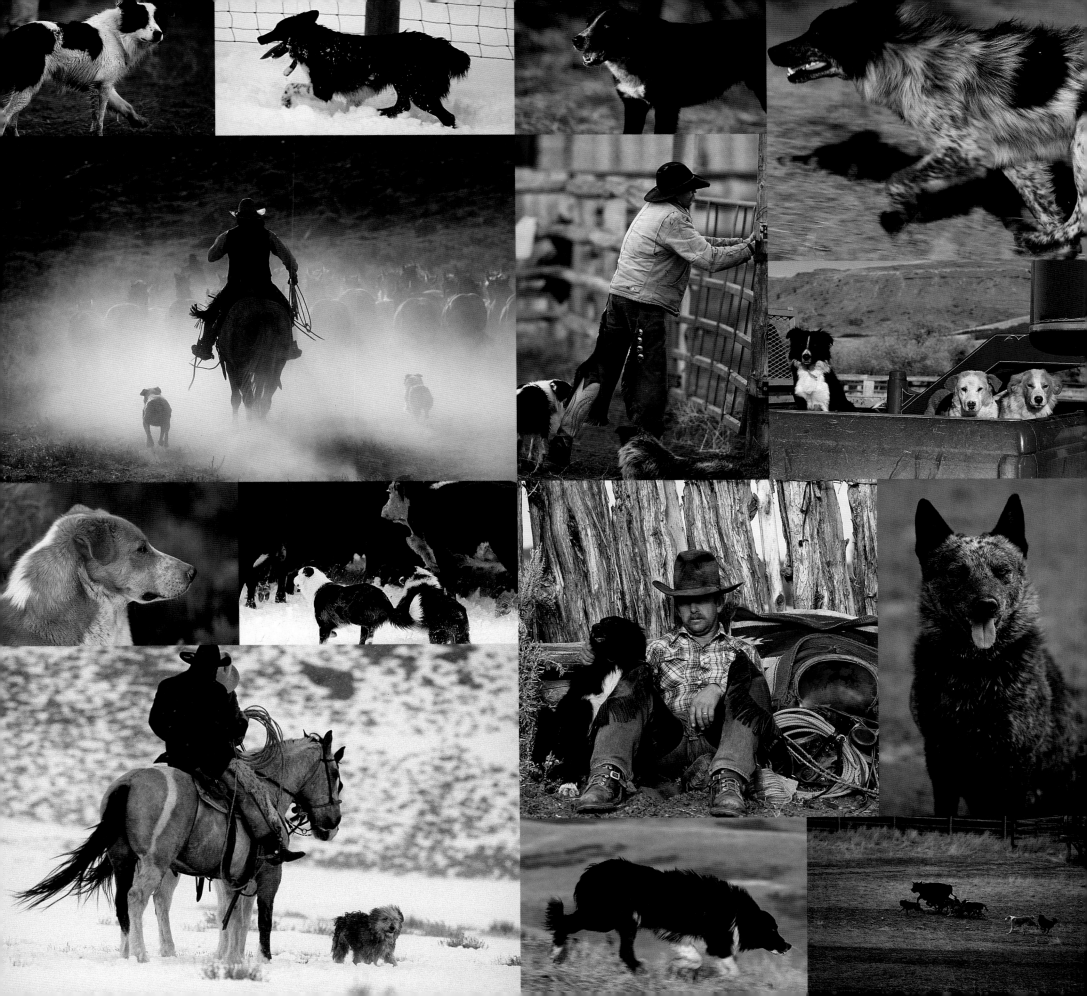

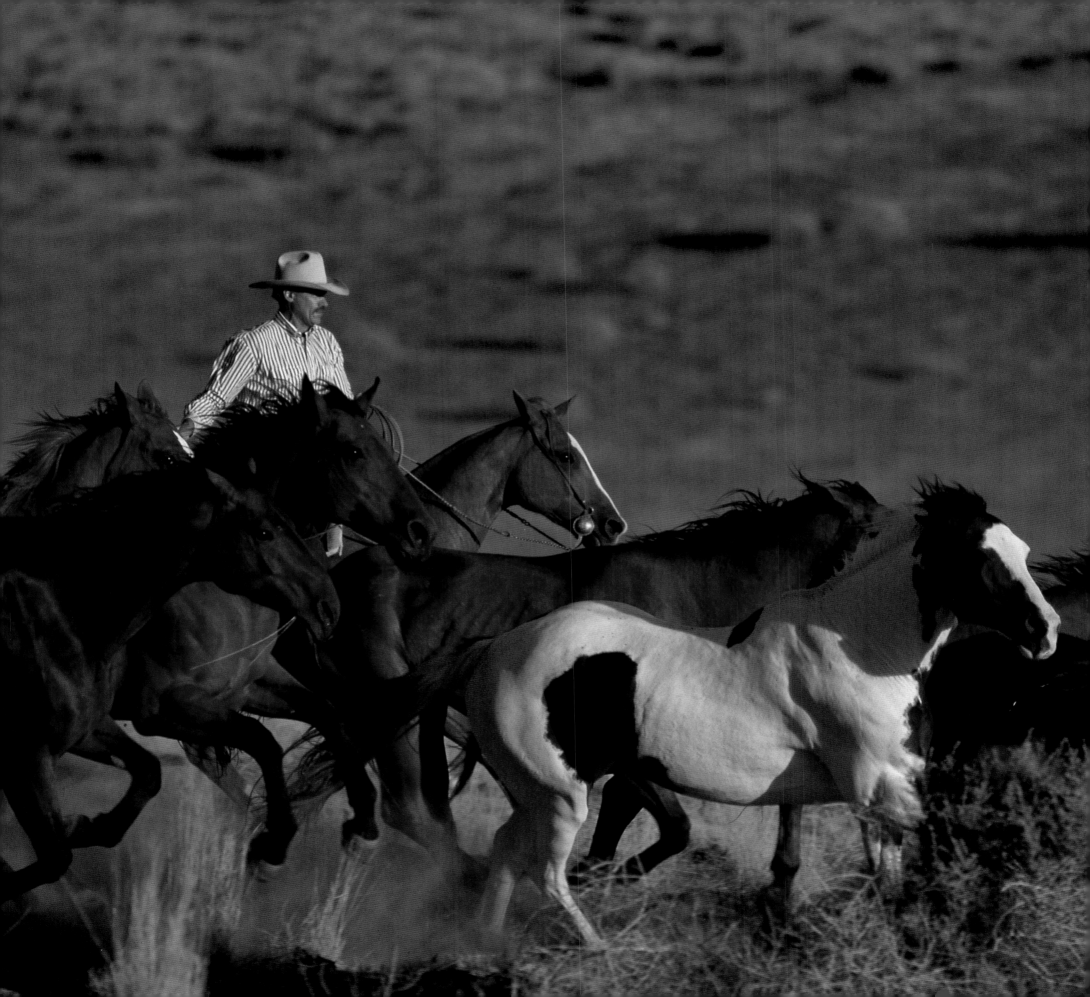

THE COWBOY WAY

Third-generation rancher Chuck Hall talks about life in the Bruneau Valley and what it means to "cowboy up"

I am third-generation right here on this place, and I watched my father scrape and scrimp and go without all the time I was growing up. I was 10 or 12 years old before we got water in the house, and that was about the same time we got a television. I don't think there's too many men my age in this country who don't remember when they didn't have a television, telephone, or running water in the house.

As a young man growing up in this Bruneau valley, this valley was my playground. We're looking at a valley 10 miles long and 2 to 3 miles wide, and I was free to go. The valley was my backyard, and horseback or afoot I could go, it didn't matter where. When I got a little older and got a car it was a little different, but when I was on a horse I was free to go anywhere I wanted.

It was a great life growing up here. I learned to work at an early age, learned responsibility. I had loving, caring parents who taught me right from wrong, and put out a lot of effort to show me the right way. I don't believe that could have happened anywhere but here. I don't think it could have happened in town, even in a small town like Bruneau with 150 people. I don't think I'd have got near the education and the love from the family that I got way out here.

Because we didn't have a television, didn't have a telephone, in the evenings we'd read, play games. There was no communication from the outside

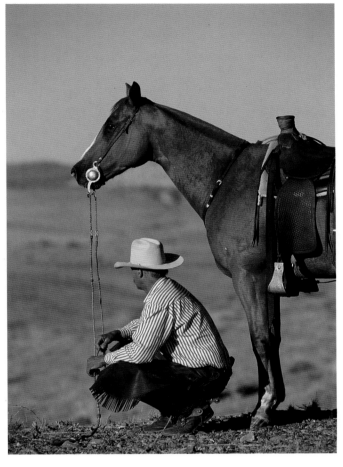

Chuck Hall

world other than the newspaper. We had our own little life out here. That didn't last as long as it probably should have. When we got a television, things changed. We were glued to the tube every evening then, but it was still great.

We never even had a well. We didn't dig a well for this place until probably the early '70s. Up until then there was no need for one. We got water out of the Buckaroo Ditch out here—that was our water supply. Water would run down to the ditch here, and into a little cistern, and it was good water. Forty-five years ago when I was born, there was no pollution. There was a little cow manure in the water maybe, but for the

most part there was nothing. There were no chemicals, nothing to hurt the water, and it was good to drink.

We'd go out with a bucket, dip water out of the cistern and bring it into the house. Mom would wash clothes like that. She'd get water out of the cistern and she'd heat it on the wood stove and pour it into an old, old Maytag wringer machine and wash the clothes.

There's a lot of hot water that runs into that canal. It'll get 20 below here, and that ditch'll stay open.

The closeness I feel for this ranch is because my father didn't have an eight-to-five job. He had a 24-hours-a-day, seven-days-a-week job. Every day he went to work he could take me and my brother along. We went with him everyplace. We had our own little seat on the tractor. We had our own little seat on the hay wagon. We were never out of sight of our parents. I can't count but maybe twice my parents ever got a baby-sitter for us kids. They either took us with them or they didn't go.

I do feel a kinship with the earth—but not as strong as my father does. My father was born in the house he lives in, which makes that pretty sacred ground to him. I don't know anybody else who can say that. I wasn't born in that house. I was three days old before I came to it, so probably my ties with that land and that house are not as good as his. But I feel great ties with this land because I grew up on it. It's where I played, it's where I cried, it's where I laughed. This is a very special place to me. I can't imagine being anywhere else.

I don't know if there's a responsibility, something that I have to do for my ancestors, but I want to carry on here. My grandfather put this together, my dad held it together and improved on it, and hopefully I can, too. Hopefully I can continue in their footsteps. But I've never found it possible just to have one job, I have to have two, always. I'm also the brand inspector for the Department of Law Enforcement's livestock division. Been there 14 years.

Running with the Remuda
Chuck Hall, Hall Ranch; Bruneau, Idaho

Being a cowboy has been most of my life. That's what I wanted to do. I had a choice to do something else and this is what I wanted. I think there is an art to being a cowboy. Not everybody in this world is capable of doing it. Not everybody has the sense, even though there are many people more intelligent than cowboys. A cowboy has to understand cows, understand horses, and be able to think like one or reason like one and get along with one.

To me, the definition of a cowboy is not somebody who wears the hat and boots, but somebody who is honest, who is capable of doing a day's work. Today they could get off their horse and fix a fence, tomorrow they could get off their horse and bale hay.

To me, somebody who's capable of going down in the field and getting a cow is a cowboy, regardless if he's got a big neckerchief around his neck. Quite often, those guys who dress up cowboy style are too intent on proving to the world that they're a cowboy, and they have to show the world that they are with their clothes rather than their ability.

A cowboy always takes a lot of pride in his attire, his clothes, his saddle, his spurs, his boots, anything about him. He even takes pride in the type of horse he rides and the type of cow he follows when he gets on that horse. It all goes to what you like. I've seen some cowboys who never owned a pair of boots.

You can tell by the way a man sits on his horse whether he's a cowboy or not. If a man was wearing a business suit and got on a horse, I could tell right off if he was a cowboy or not. The way he got on, the way he held his reins, the way his feet hung, the way he balanced in the saddle, regardless of his clothes.

I like to dress Western. I like people to know I'm a cowboy. But I don't like the sloppy hat, I don't like the big tough rag around my neck. I choose to be a little more of a cattleman type rather than your basic buckaroo when it comes to my clothes. I still like silver spurs, though, and I still like nice bridles.

I love to brag on being third generation here on this ranch. There's nothing more pleasing to me than being able to say that my father did it, my grandfather did it, and I'm going to do it. If my son were alive, he'd do it. I know he felt the same way. He loved this life, too. It's the cowboy way.

We use the term "cowboy way" in everything we do. It goes right down to the way you cut the meat on your plate. When we do something around here and we don't have a reason we did it, we say it's the cowboy way. That's the only explanation we have for it.

The cowboy way could be how dad did it, how grandpa did it, how I was taught to do it. Maybe I'm not doing it right, but I'm doing it the way dad did it, the way grandpa did it. If it worked for them, it'll probably work for me. That's the cowboy way.

When you walk into a cowboy's house, you feel you're welcome. Stay a night, stay a week. You're hungry, you eat. I think the cowboy way has a lot more to it than a lot of other lifestyles. Anything a cowboy owns is yours if you want it. You better not touch his wife or ride his horse, but if you want to borrow five dollars from him, he'll give it to you. It's a generous feeling, an honesty.

I can't say that the cowboy way is the right way. One of my favorite sayings here is, "If everybody in this world was a cowboy, it'd be a pretty poor place to live." I thank God that there is somebody out there who's willing to run the computers, drive the trucks and sit at the desks. They all make life better for us, even for us cowboys. I'm just glad I'm not one of them.

Here's another little thing that I think about quite often when I'm horseback out here in the desert and I'm following a cow and looking between my horse's ears. I think, why me? What happened that made me a cowboy? What would my life have been like if I'd been born in Pennsylvania or New York and never had the opportunity to do this? Would I feel lonesome, left out? Would I have a problem with my life?

I can't imagine living a life other than the one I live. How many people in the United States would like to be where I am when I'm sitting on that yellow horse going down through the brush and rocks? How many people in this nation would trade places with me without even thinking about it?

Perhaps the spirit of the cowboy is a lot of things. To me, one aspect of that spirit could be, all winter long we work and we feed cows. We're here every day picking up bales and breaking them open for the cows. Then, finally in the spring you have green grass and you get that first new calf born and his mother's licking him and everything's OK. That makes all the work you did all fall and winter worthwhile. That tells me we made it through the winter and we're gonna see another summer. And there's a good feeling about that.

"Cowboy up" means "tend to business" to me. It means put out a little more effort, look at what you're doing and get it right. No whining. Here's what we gotta do, let's do it. You can put it off, but if you put it off the job's still there. Let's cowboy up and get it done. I don't care if we're fixing fence, baling hay, stacking hay, shoeing a bad horse—cowboy up and shoe him.

Let's say I got a six-year-old colt down here. For the last four years he's been rode 30 times altogether. He's standing there looking at you, and you get on him, and you've got to get a day's work out of that colt. You got to cowboy up if you're going to make it, because he's gonna buck you off if you don't stay ahead of him. To me that means you better cowboy up. Pay attention.

There's an unwritten book, a code of the West. To me it doesn't mean any more than just common courtesy for your fellow rider or for your boss. You ride up to a gate, you get off and open the gate. You don't argue about who's going to open it or who's going to close it. If there's a tough end, you take the tough end. If you're riding with a good man, he's gonna take the tough end next time. It's just common courtesy among cowboys.

Respect comes from how you grow up, your whole upbringing. It has nothing to do with being a cowboy. The code of the West should apply anywhere, not just to cowboys.

When my son was alive, I bought him a colt for his 14th birthday. That colt was a handful when he was just a yearling, and we kept him around here for another year before I started riding him. Jack wasn't tough enough then to ride him, especially this colt, so I rode him probably 60 times, and every day that colt and I got to hating each other a little bit worse.

One day I rode him out in the Grassview area, gathering cows. There was me, Jack, and three or four more high school boys, all 15, 16 or 17. Some of them should have been riding this colt and I should have been riding an old horse, being as I was the old man of the crowd.

I'd made a pretty good circle and thought the colt was aired out pretty good, but I brought a little bunch of cows into the road and he looked up and here comes my son with a bunch of cows. He looked off this way and here come Matt Tindle with a bunch and here comes Kit Bachman with a bunch over here. The colt looked around at all these cowboys and cows and all this action happening and he got scared, got to bucking with me, and I couldn't ride him. He was way too much horse for me, and he bucked me off right there.

Those three boys thought it was the silliest thing they'd ever seen—the old man get aired off right there in the rocks. I think it was Matt Tindle who caught the horse and brought him back. He just handed me the McCarty and rode off. I thought that was kind of odd. The cowboy way is to wait around, see if your partner can get back up on that colt, see if you can help him. But Matt was young and he didn't know you were supposed to do that.

So here came my son, and he said, "You all right, dad?" "Yeah, I'm fine," I said. I got back on the colt, patted him a little bit, calmed him down. Then I told Jack, "This colt wants to go some more and we're gonna go another circle." Jack asked, "You want me to go, dad?" I said "No, son. You can't keep up with where I'm going and what I'm gonna do," and me and that colt made another pretty good two-hour circle out there. When I got back he was OK.

But the kids sure thought that was pretty funny to see the old man bucked off.

I expect a lot out of a horse. First off, I expect him to stand so I can get on. I'm not going to follow him around and I don't expect a horse to argue with me. If I ask him to jump off Bruneau Canyon and that's what I want him to do, that's what I expect him to do. Of course I wouldn't do that, but worse than anything I hate for a horse to argue with me. He doesn't have to be a good bridle horse and he doesn't have to be the prettiest horse, but I want a horse that doesn't argue with me.

I want a horse to have a little cow sense. You know, turn with the cow a little. And I want to be able to rope on him. If I didn't rope, or if I was fast enough to catch a cow afoot, I wouldn't need a horse. But that's why I get on a horse—to rope.

If any cowboy's worth his salt at all, he's gonna rope. Everybody ropes. That's the reason that every cowboy gets on a horse. That's what it's all about. Until I was 20 years old, I thought that's what cows were for—to rope.

I know I take for granted how good I have it. I was gone 10 years from this valley, and until I came back I didn't realize how good I really had it here. I lived in Boise, I lived in Emmett for a while. I lived in Meridian and Star and Eagle. I worked at feed lots, shoeing horses and things. I never left the cowboy lifestyle, agriculture, but it was certainly a different life there than it is here.

I hope the cowboy lifestyle never dies. And as far as I'm concerned, it never will. We'll never find a better way to work livestock than horseback. There's been motorcycles and four-wheelers, jeeps and helicopters and everything else tried, but there's no substitute for a good horse. And you have to have a cowboy. You have to have somebody who knows how to ride that horse and get the most out of him to get the job done.

I hate to see the fence closin' up the range
And all this filling in the trail with people that
is strange.

—*The Bronc Peeler's Song*

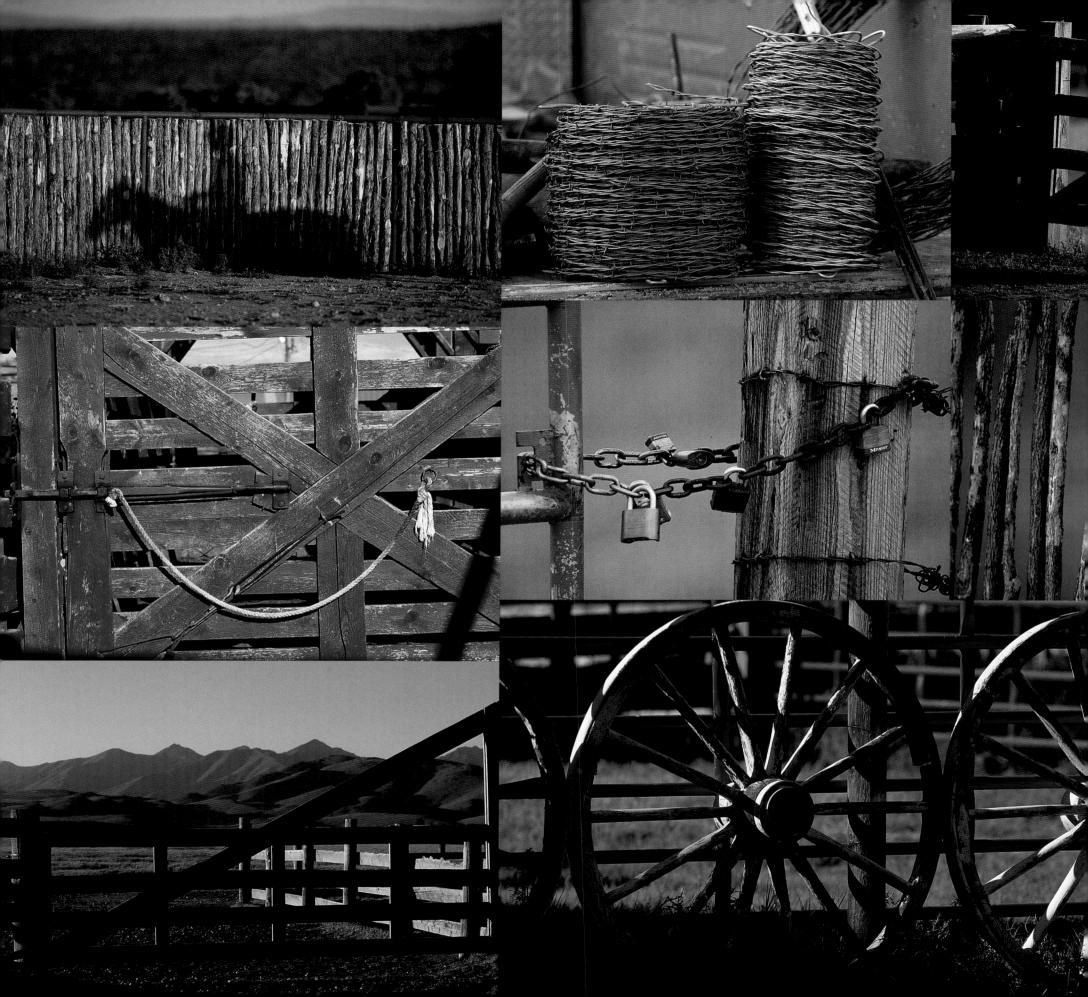

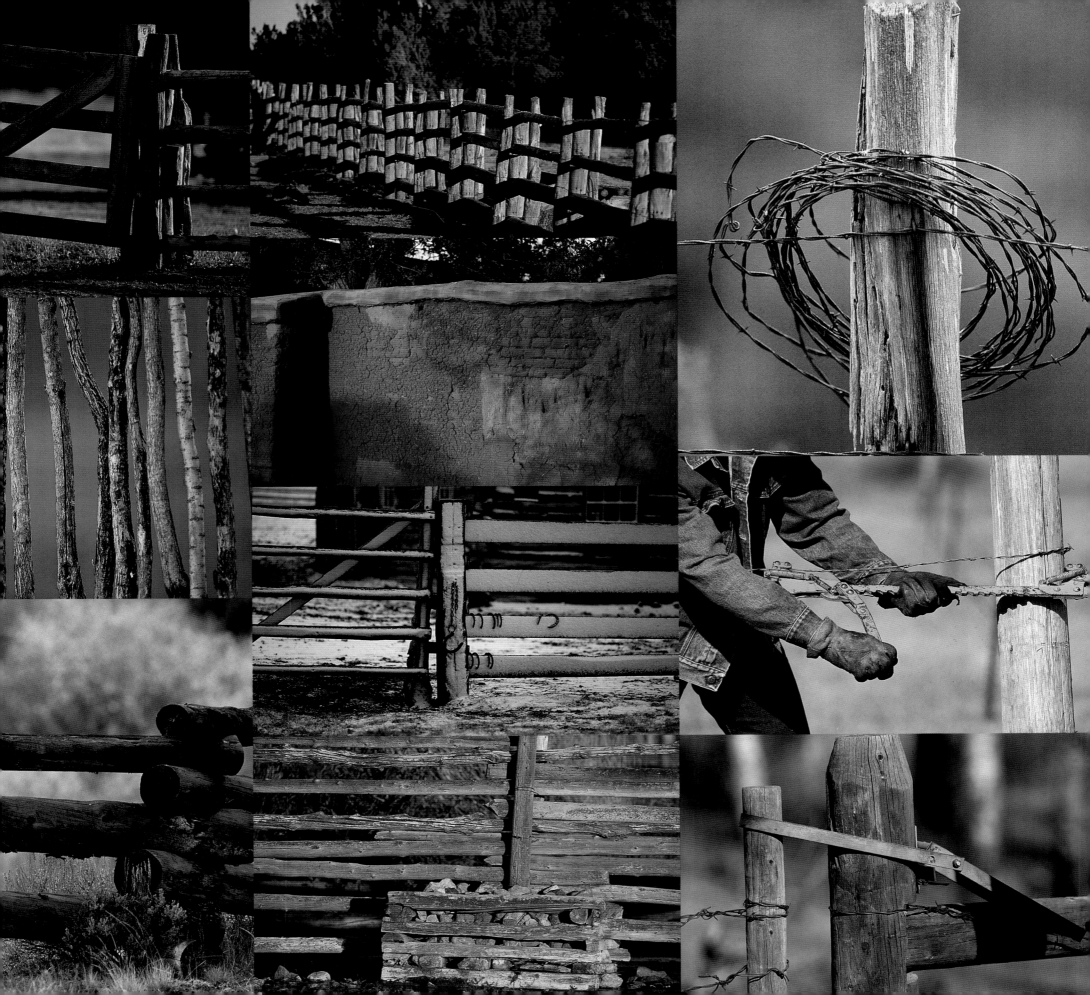

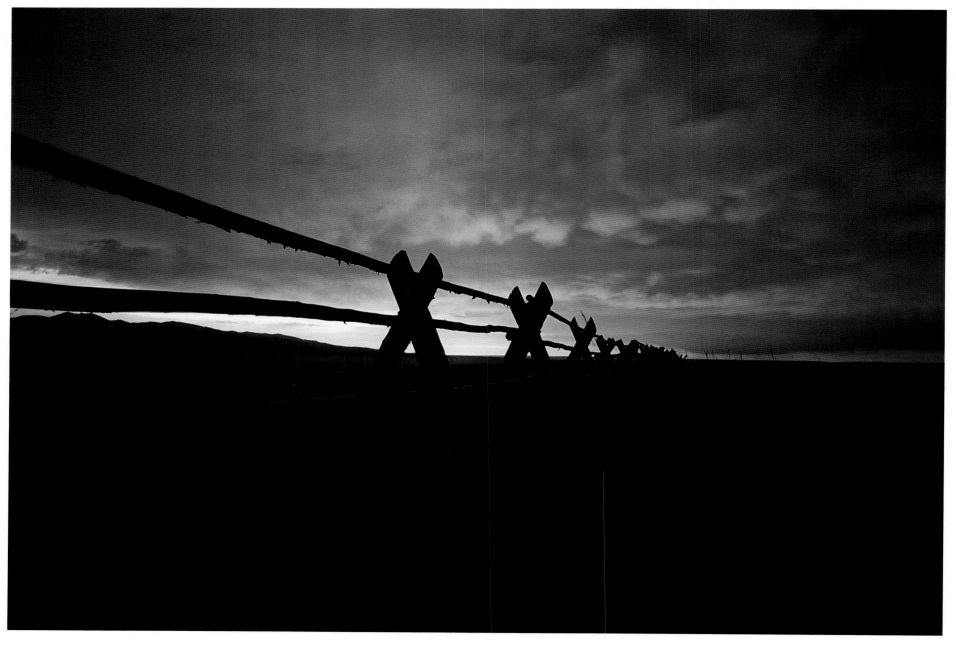

Sheridan Ranch; Island Park, Idaho

Previous pag
Dead Horse Ranch, New Mexico; Tee's Ranch, Arizon
Bar Horseshoe Ranch, Idaho; VV Ranch, Texa
Hall Ranch, Idaho; Flat Top Ranch, Idah

Gate Latc
Dragging Y Ranch; Grant, Montan

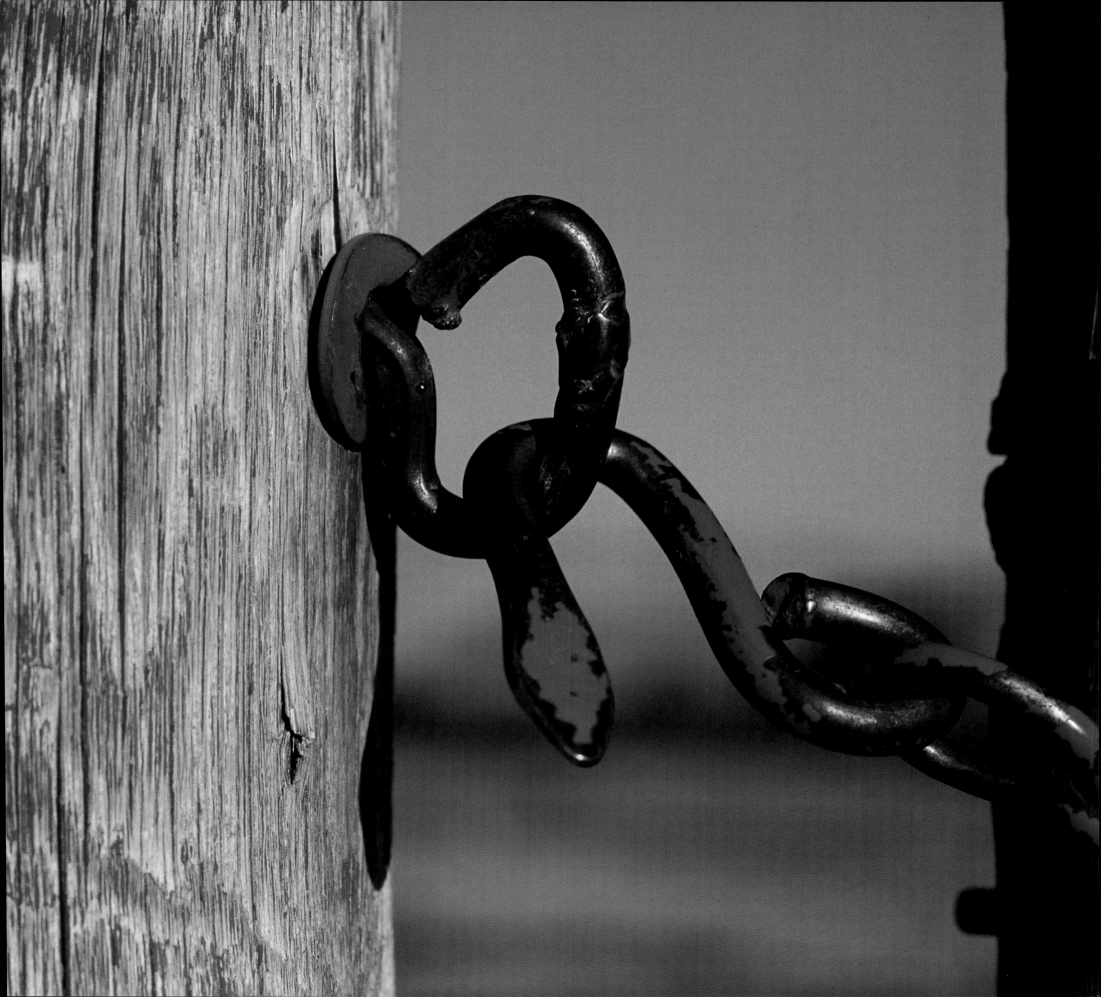

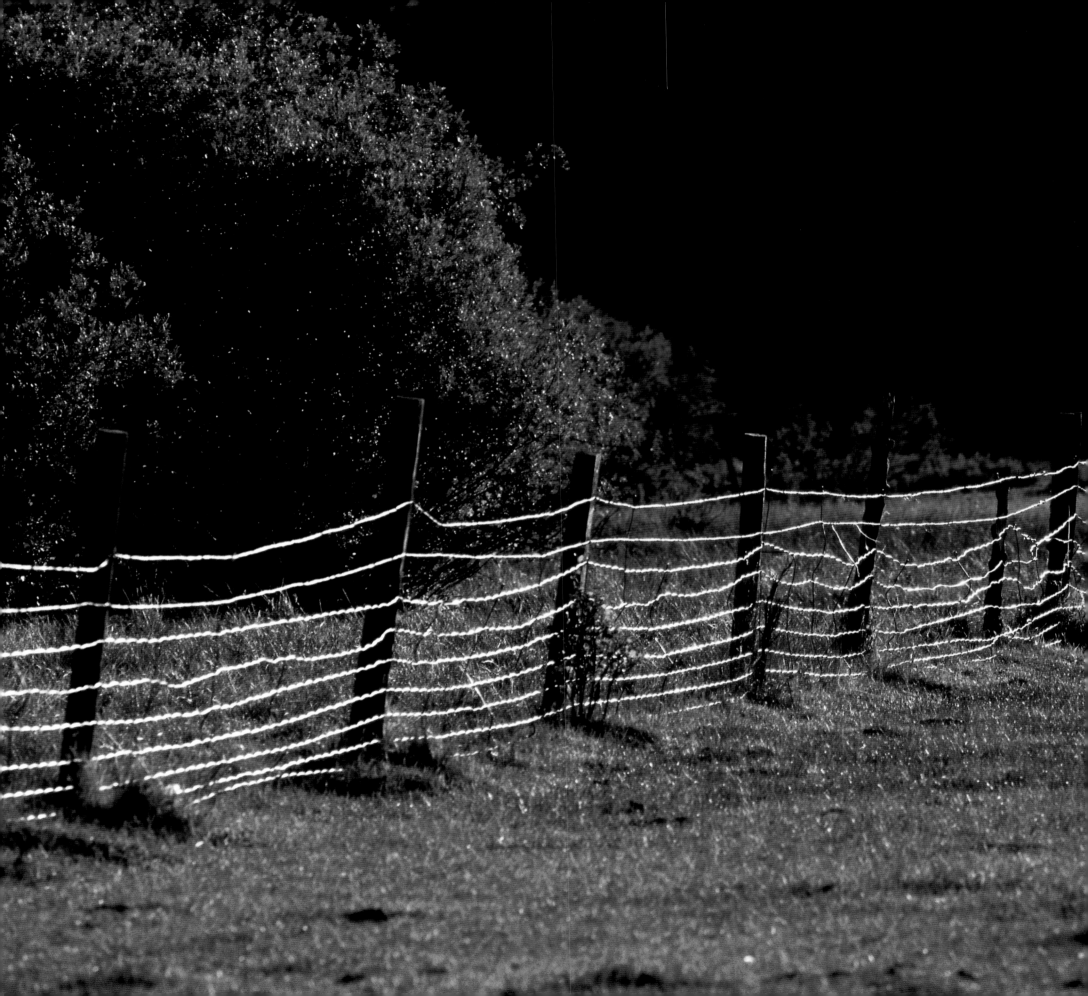

THE LAIDLAW FENCE

By John and Diane Peavey

A 4,000-acre meadow lies at the heart of Flat Top Sheep Company Ranch in South Central Idaho. This abundant grazing land is surrounded by rolling sagebrush and grass-covered hillside and basalt rock ridges. But its immediate borders are defined by an imposing fence built by the original ranch owner, Jim Laidlaw, in 1920. It was an extraordinary undertaking at the time and remains so today.

Laidlaw was a Scotsman and a pioneer in the sheep business, developing the Panama breed of white-faced ewes and introducing the black-faced Suffolk bucks into Idaho. He was not about to watch his prized animals fall prey to marauding coyotes, so he designed and built an enclosure to protect them.

The most notable feature of the fence is its massive Douglas-fir corner posts, each one two to three feet in diameter. The ends were lightly burned to form a charcoal seal to protect them from rotting. Then these huge corner posts were sunk deep into the earth with Jim Laidlaw coaching "dig 'er a little deeper, boys."

What is less obvious about the structure are the fourteen strands of wire strung between these posts. There are four barbed wires, two planted underground to keep the coyotes from digging beneath the fence and two strung along the top. These fortify the ten spring-steel wires running horizontally between. Wooden posts and metal stays at regular intervals hold these in place.

The sixteen-mile fence cost $1,000 a mile to build, which was an enormous amount at that time. And three quarters of a century later, it needs only a little repair, only an occasional staple.

Neighbors still admire its workmanship and strength. And they still comment on the scope of the project, amusing themselves with the idea that, in the end, Jim Laidlaw probably fenced in about as many coyotes as he fenced out.

A portion of the Laidlaw Fence, Flat Top
Sheep Company, Idaho

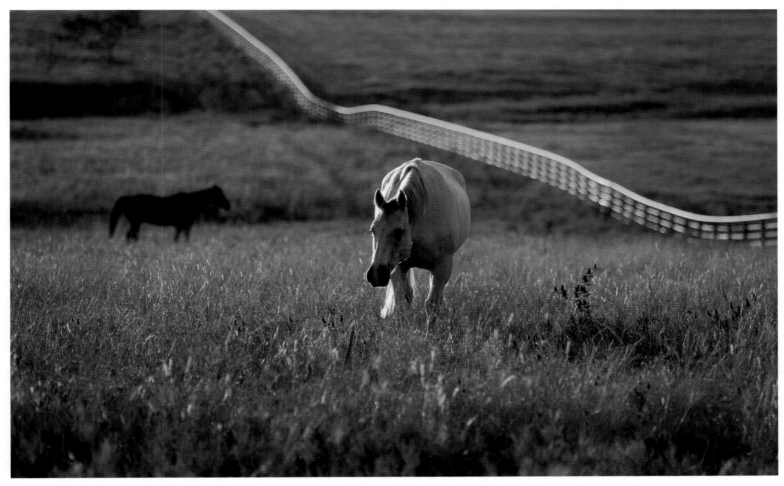

Old Frosty
Saunders VV Ranch; Weatherford, Texas

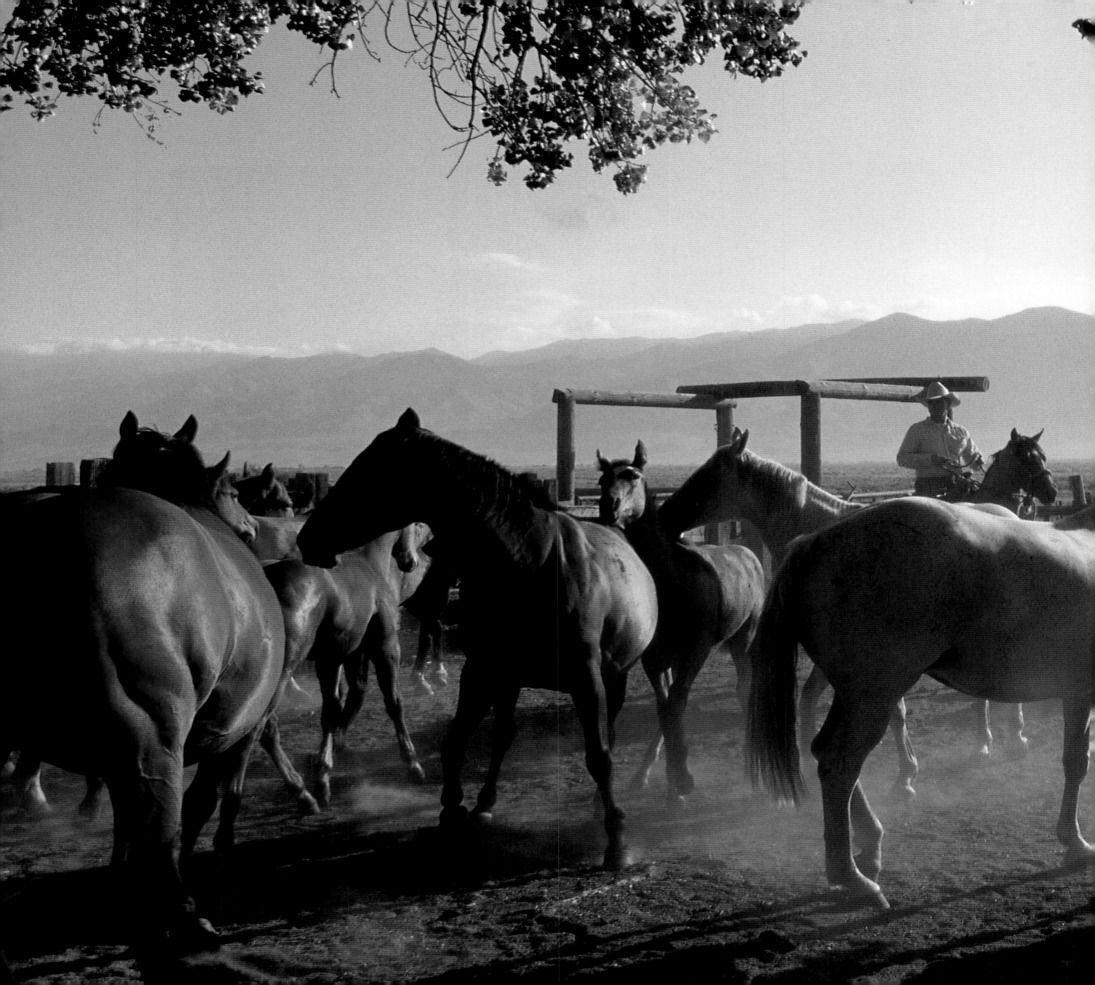

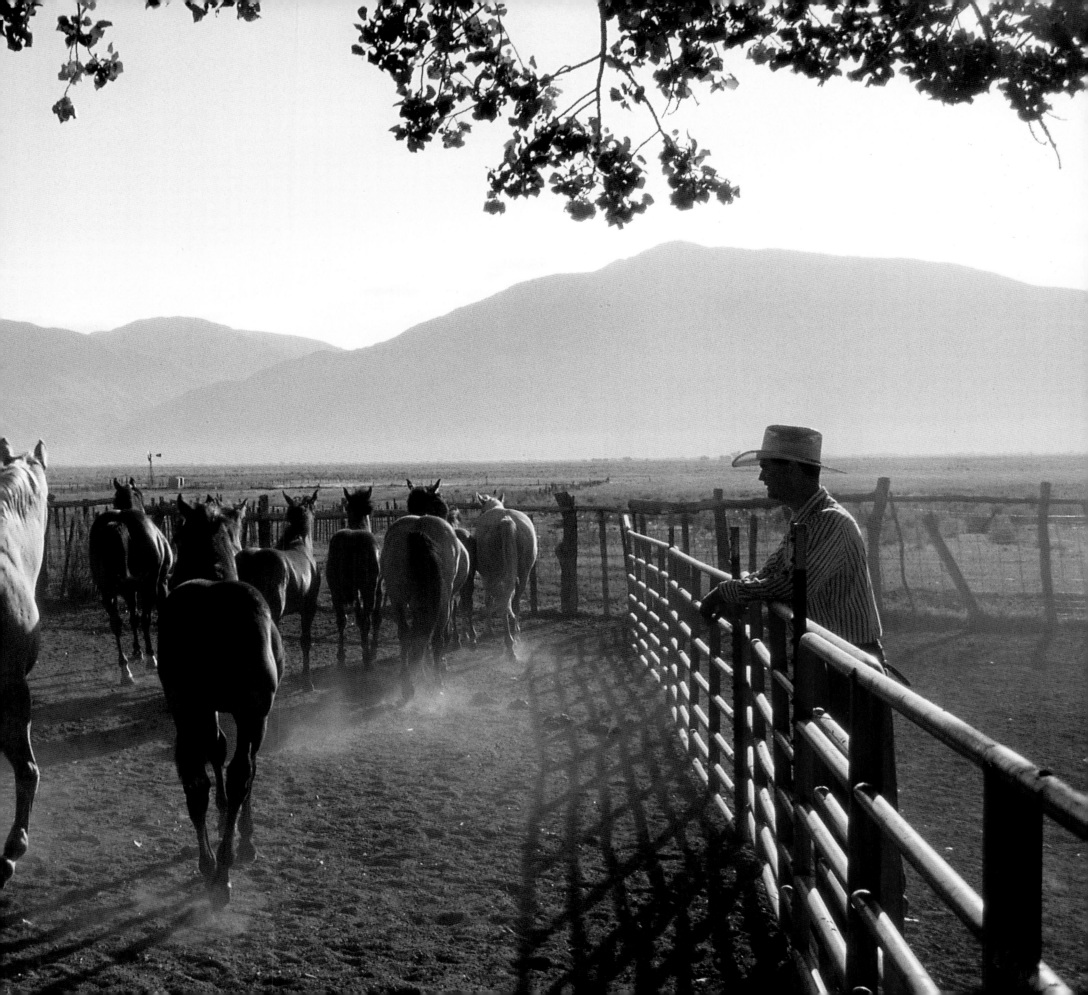

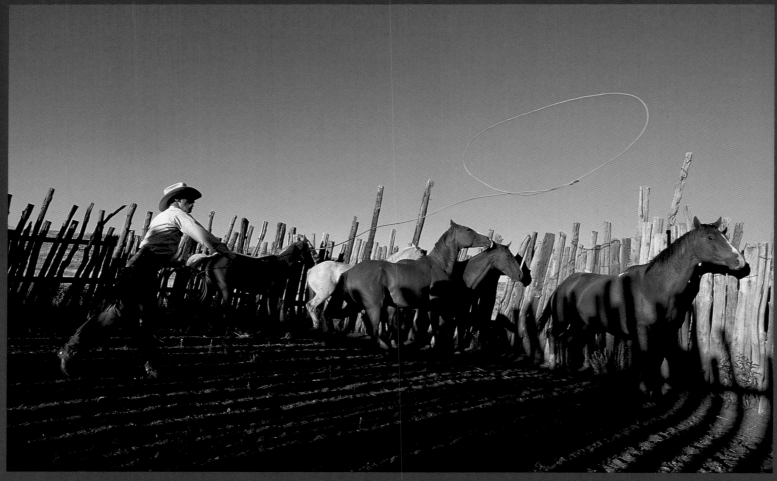

Dennis McKay
Big Springs Ranch; Bruneau, Idaho

Previous Pag
Ron and Jeff Yribarren; Bishop, Californi

Butch Smal
Small Ranch; Small, Idah

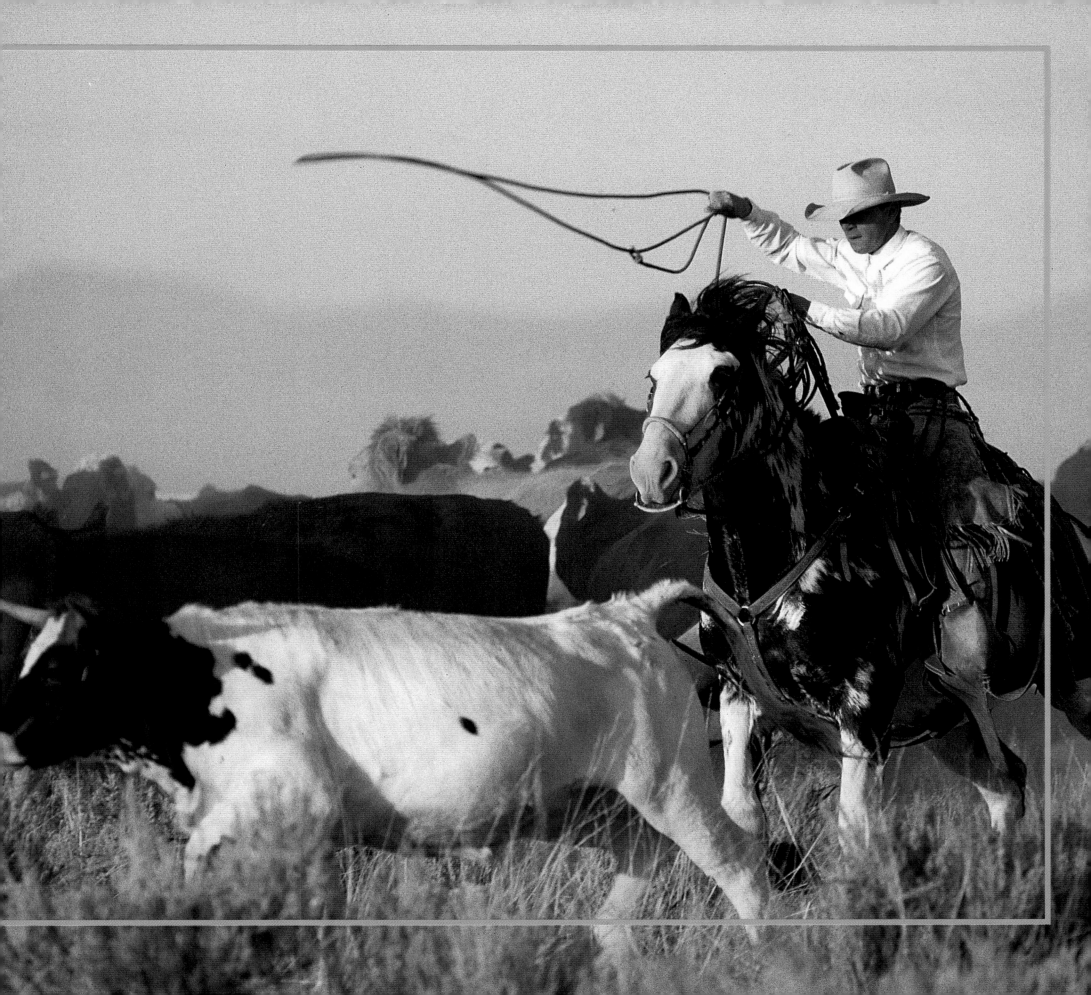

A GOOD HORSE
AND A LOT OF LUCK

Never expect to make money at a roping, says Nevada cowboy Ira Walker

I grew up on a ranch right here in Owyhee, and started packing a rope as soon as I was walking. My dad, George Walker, cowboyed all his life. He's worked for some pretty big cow outfits, and when he was younger he ran cows here on the reservation, too. He roped quite a bit when he was younger, and he's still a pretty good hand with a horse.

When I was growing up there were a lot of guys who were good ropers, but they never went anywhere. They just stayed here on the reservation and roped. My dad was a good roper. Raymond Blackhat was an old guy who used to rope really good. There's been so many from this reservation, guys who are talented whether it came to roping or riding bucking horses. There's a certain legend about the guys from Owyhee, Nevada.

For the most part, I support myself with my rodeo winnings and jackpot winnings. Oh, I've got a few head of cows, and then I day work for the Petan Ranch when I can.

I rope with a bunch of different guys along the way. Like last year I roped with Barry Johnson quite a bit, and the year before I roped with Marlo Eldridge. At a jackpot rop-ing it's easy to just show up and pick up a heeler. You can get there and see who's there and kinda just get worked around to where you can get some partners. You rope with a lot of different guys. At a rodeo, you've got to be pre-entered in order to compete.

I've won the Wilderness Circuit of the PRCA (Professional Rodeo Cowboys Association) twice, and I won the Amateur Idaho Cowboy's Association one year. I've won a little at places like San Antonio, Texas, and Yuma, Arizona, and places like that. I've also done pretty good at the Bob Feist Invitational in Reno, which is a pretty big roping.

I don't think you can expect to make money when you go to a roping. It just depends on the way things are going to happen. Sometimes there's good days, and sometimes there are bad days, so it's just hard to say. One year at Tucson, Arizona, I won the first go-round and it was for like $2,500 per man. Then one year at Reno I won the first go-round and that was $3,000 per man. At the smaller PRCA rodeos, you can win $600 for first place, but then the entry fees aren't as high, either. At Reno the entry fees are $300 per person, but at a little rodeo it's $60 per man.

At a local rodeo, like here at Elko, you can probably win $700. They get a lot of

backing by the community and there's added money.

I'm gone to ropings quite a bit. I'll leave here in May and be gone three or four days out of the week. Then I come home, get some stuff done if I can, and leave again the next weekend. At a lot of the bigger rodeos in the summer, like at Reno, the Bob Feist Rodeo is on a Monday, then the slack is Tuesday, Wednesday and Thursday. You might be there all week if you draw up wrong.

You enter and tell them when you need to be there, but it don't always work out that way. You might be up there, say, Saturday night for the first performance, and then not come back until the next Saturday night at the last performance.

Amateur rodeos are pretty much two days or so, and you can get to them pretty easy. At the pro rodeos, you gotta call and be pre-entered two weeks before you get there, and you never know what you're going to do. You can call and tell them when you want to be up, and they can kind of run it through the computer. That way, most of the time you can get in the night you need to be there. But then you can get fouled up and have to go different nights, and that changes your schedule. If you're going to both the pro rodeos and amateur rodeos, you gotta kind of work around that.

Your horse is important in roping. You've got to be able to ride and know your horse before you can rope. There are a lot of guys who are average ropers but who ride good horses, and they still win. The horse is at least 70 percent of the team, and maybe more. Then luck is a big part of it. I think in team roping, at the bigger and better rodeos, the horse is probably 70 to 80 percent of the team, the roper is 10 percent, and luck is the rest.

A good roping horse is hard to find, because if you find one, the guy who owns him wants a lot of money for him or doesn't want to sell him. A lot of the better team ropers nowadays will find a good horse that fits them, and they'll keep him as long as they can. My horse is 15 this year. I got him when he was 10. He's never been hurt, and he was never hauled to too many rodeos or too many ropings. I use him out in the brush quite a bit because I think it helps him.

I goof around with a few of the younger horses I've got now, but the horses I ride

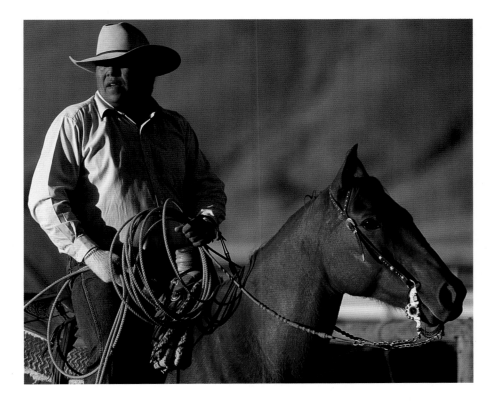

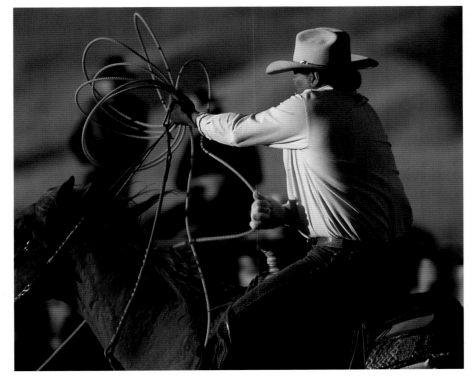

Ira Walker, Walker Ranch; Owyhee, Nevada

I bought trained. In the summertime around here, we can practice at one or two places and take a younger horse and play and try to get him going, but in this part of the country it's hard to do because a lot of the guys don't have time to do it. It's a lot easier for a guy to send a horse to a trainer if he thinks he's got one that is going to make a good team roping horse.

The cost of a good roping horse depends a lot on the horse. I've seen guys get $20,000 for a good horse. I'd get $5,000 for the horse I've got right now. If a guy's lucky, he can get one for $3,000 to $3,500, and it would be a pretty nice horse. But there's also times when you can get a horse for almost nothing and he turns out to be a pretty good horse. A guy who's first starting roping should get a horse that knows more than he does.

Team roping starts out with two guys, a header and a heeler. The header is going to rope the steer around the neck or the horns. Once he gets him caught, he needs to turn him in an "L" sort of direction so the heeler can catch the steer by both hind feet. He can catch the steer by one hind foot, but that means a 5-second penalty. Once the heeler catches, they stretch the cow out on the ground.

Team roping is a fast event. The fastest time wins, same as in any other sport. For instance, at the National Finals 3.8 seconds was the fast run. At an amateur rodeo, your 5- and 6-second runs are pretty good. At the average pro rodeo, a 6-second run will win you quite a bit.

Your time depends on the arena, as well as how quick you can rope. At rodeos they've got what's called a "barrier," a string stretched in front of the ropers, and they've got different "score lines" on the cattle. The score line is a head-start for the steer. For instance, at Reno they've got a 20-foot score line, which is quite a ways out there. At an amateur rodeo, the score line is pretty short. You can go right behind the steer, dang near. Whichever it is, you've got to let the steer clear the chute before you get started, or you'll break the barrier. That's a 10-second penalty.

There are a lot of things to take into consideration at a roping—the steer you draw, ground conditions, even the time that's winning the rodeo. It's a lot easier for me if I know that the rodeo is pretty tough. It makes me try to be a little more aggressive on things. It makes you hustle more when you know the times are fast.

In the summer, I practice every day if I can. When I'm on the road, I've got some friends who have practice arenas, and I'll try to rope every day. I practice while standing on the ground, too. I put a dummy up and I'll rope it every day if I can. I think it keeps you sharp.

There are differences between roping gear and cowboy gear. The ropes are a lot shorter in team roping than those the cowboys use. Your head ropes are 30 feet long, and the heel ropes are 35 feet long. Then on your saddle horn you use rubber, something a lot of cowboys would never put on their saddle horns. On your cowboy horse, you've got reins and romals or McCartys. The team ropers just have a roping rein that doesn't get in the way of things.

Roping saddles are different, too. Team roping saddles have smaller saddle horns than your regular buckaroo saddles. A lot of the buckaroo saddles got tin or wooden stirrups, whereas the team roping saddles have rawhide-covered stirrups.

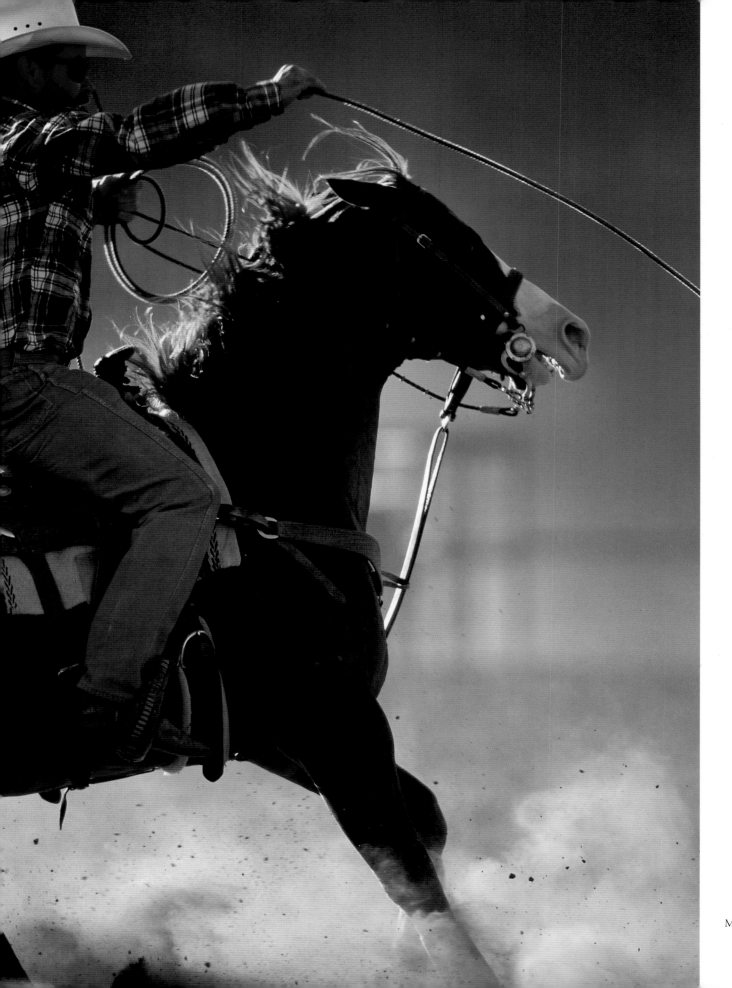

The biggest part of your team roping horses are not very well broke, but they are trained for a certain purpose and that's team roping. They are not broke like your good buckaroo horses. I rarely see a team roping horse that doesn't have a tie-down. It's just part of the team roping deal.

In order to win nowadays, your horse has to have size and quickness. Most team roping horses are pretty automatic. From when he leaves the box, a heading horse will rate the steer and run to it as hard as it can. Running up to a steer and then leading him off is just a normal move for that horse.

The sport of team roping has really took off. Team roping is everywhere. It's in Florida, Georgia, back East, even in Hawaii. It doesn't matter how old a roper is. There's guys out there who can rope real good and who are 50 and 60 years old. Sure, a lot of the younger kids can outrope an older guy, but the majority of the older ropers hold their own.

What do I like most about roping? Winning. It makes a guy feel pretty good when he goes and wins big money in a short time. It's better than a job.

Mark Gomes, Estancia Ranch, Paso Robles, California

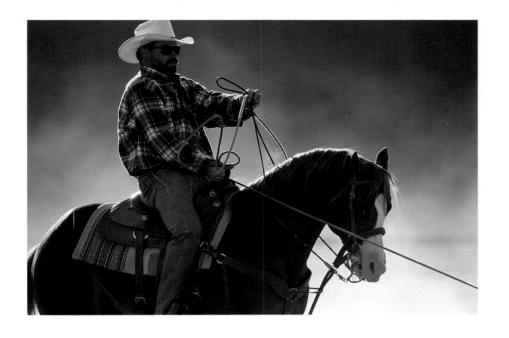

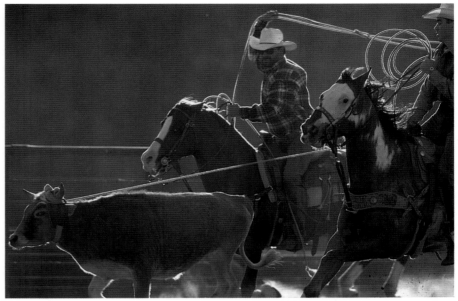

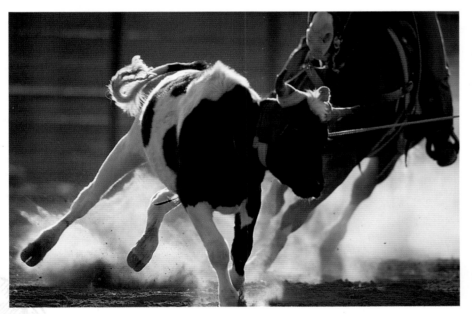

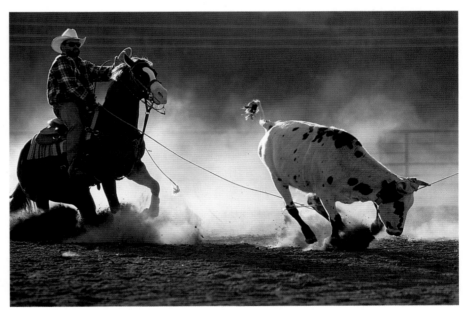

Mark Gomes and Dugan Kelly, Estancia Ranch; Paso Robles, California

THE ART OF ROPING

Spider Teller never had to practice roping. It came to him naturally.

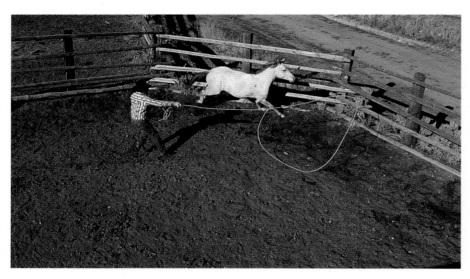

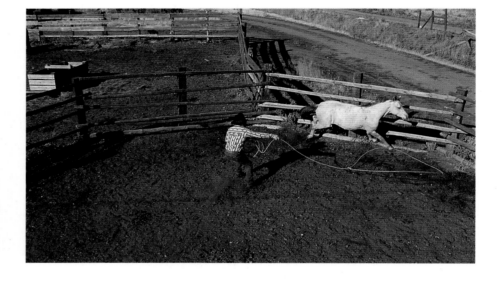

Spider Teller throws a Fancy Four Foot Loop

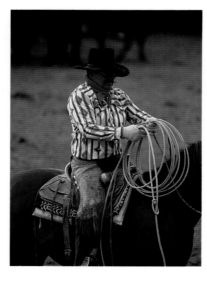

From what I used to hear about my grandfather, he used to have lots of cattle and was one hell of a roper using a reata. My uncles were all ropers, too. But the way I got started, I'd say I was maybe 13 or 14 and I met this old man named Bert Brown. He owned the old 45 Ranch down by the Owyhee River. Somehow I got hooked up with him and I used to go down to his place off and on to do odd jobs.

We didn't rope that much, and it seems to me that when I did start roping it just came natural. It was just something that I did. As I got older, maybe 16 or so, I met Willis Packer and got started with him riding colts. I didn't know too much about colts at the time, but he was a pretty good hand with horses.

Then I hooked up with Randy Bunch, the buckaroo boss at the Petan Company. This guy was one hell of a hand. He could rope and he could turn a horse around. He taught me how to do things, and it all came natural to me.

When I was about 17, I worked at the Petan Company. In the summertimes, from April to September or so, I lived out there mostly on the desert with the wagon. We'd winter back on the Petan at a place called the Maricho. We stayed there in cabins all winter, just checking the feed grounds.

I never did practice roping. The only time I practiced was when I had to rope something. It was an everyday thing to rope, but when I was growing up, ropes were kinda hard to come by. You used hand-me-downs or whatever someone threw away. When we were kids, we mostly used grass ropes. You didn't see nylon. Whatever somebody threw away, you picked up, soaked it in water to stiffen it, and used it.

My grandfather used to have a lot of reatas lying around that were broke, and I used a lot of them. They weren't very long, but that's what I'd use.

There is an art to roping. You gotta rope proper, otherwise things just ain't gonna work. To me, proper roping is trying to throw a good loop. I see guys so many times just go up and throw. There has to be timing in there. If you're going to throw at a calf that's running, you gotta watch that calf and throw at the right time—then you pick him right out of the air. Guys who just throw their rope just hit the ground and the rope just crumbles up.

And there's a lot of things about handling a rope and how you handle cattle. Like if you catch one for somebody, you can't just stand there. I've seen guys in a pen who would rope something and just stand, and whatever they roped would run around

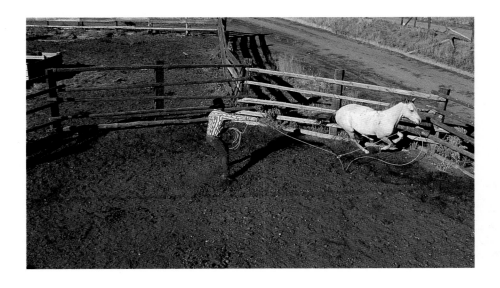

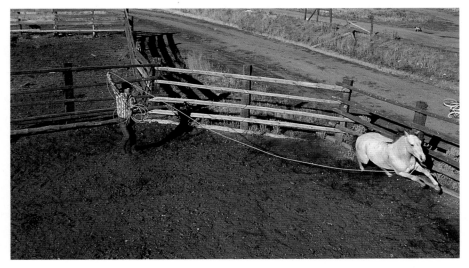

and around. How is a heeler going to catch up to that thing running around and around? You gotta catch that cow, get him in a good place and drag him. You drag him just fast enough to where he is hopping and the heeler's got a good chance to pick up the heels.

And if you're heeling you have to have timing, too. If you just throw, you won't catch anything. You gotta watch how that cow is jumping, then time it in your mind. It's like instinct, learning to throw so that you get two legs every time.

I've watched a lot of guys rope, some real fancy ropers, and I've always tried different ways of catching.

When a horse is running really fast and you're bringing him around, you're swinging your loop and then you throw it at the ground hard. The rope goes down flat and then you give it a little twist so it turns over. It's kinda like a trap.

I used to practice fancy loops a lot. There's all kinds of them. Like when you are heeling calves, there's one called the coolie shot. If a calf's going away, you throw the loop right on top of the back and it comes around and takes both hind legs.

A fancy loop is one that will just blow a guy's

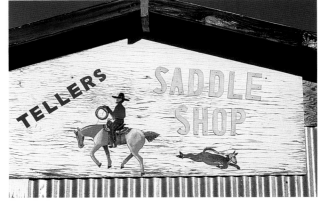

mind. You get a bunch of guys together who think they can rope and you throw a fancy loop a couple of times—it'll blow their minds quick. You let a calf run by you and throw your rope hard as you can at the ground, and it comes back up and you throat-latch them.

Another thing I burned guys on was the reata. See, a reata is a really fast rope. We would get to roping calves, and the calves are wild, and these guys would think I was a heck of a roper. Every time a calf would run by me going 100 miles an hour, man, I'd just throw and head for the fire. Two hind legs every time. They thought I was really something.

When you throw your rope, say with your right hand, you're picking up the rope with that hand, and that's the hand that's going to your horn. When you feel a tug, you know you've got it, and then you go to your horn. As you're going to your horn you can feel the rope running through your hand. The rope running through your hand is the coils, and that's what goes around your saddle horn.

Most of all I just like to throw the fancy loops and blow their minds.

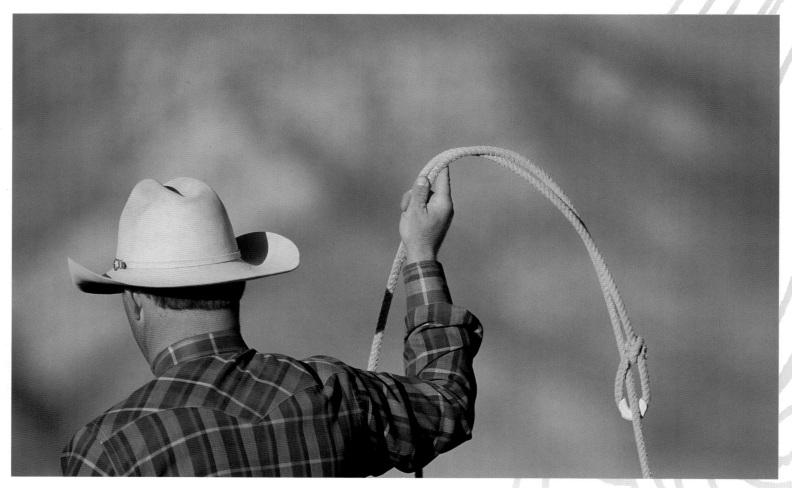

I'm Ready
Bob Marriott; Diamond G Rodeo Company, Elk Ridge, Utah

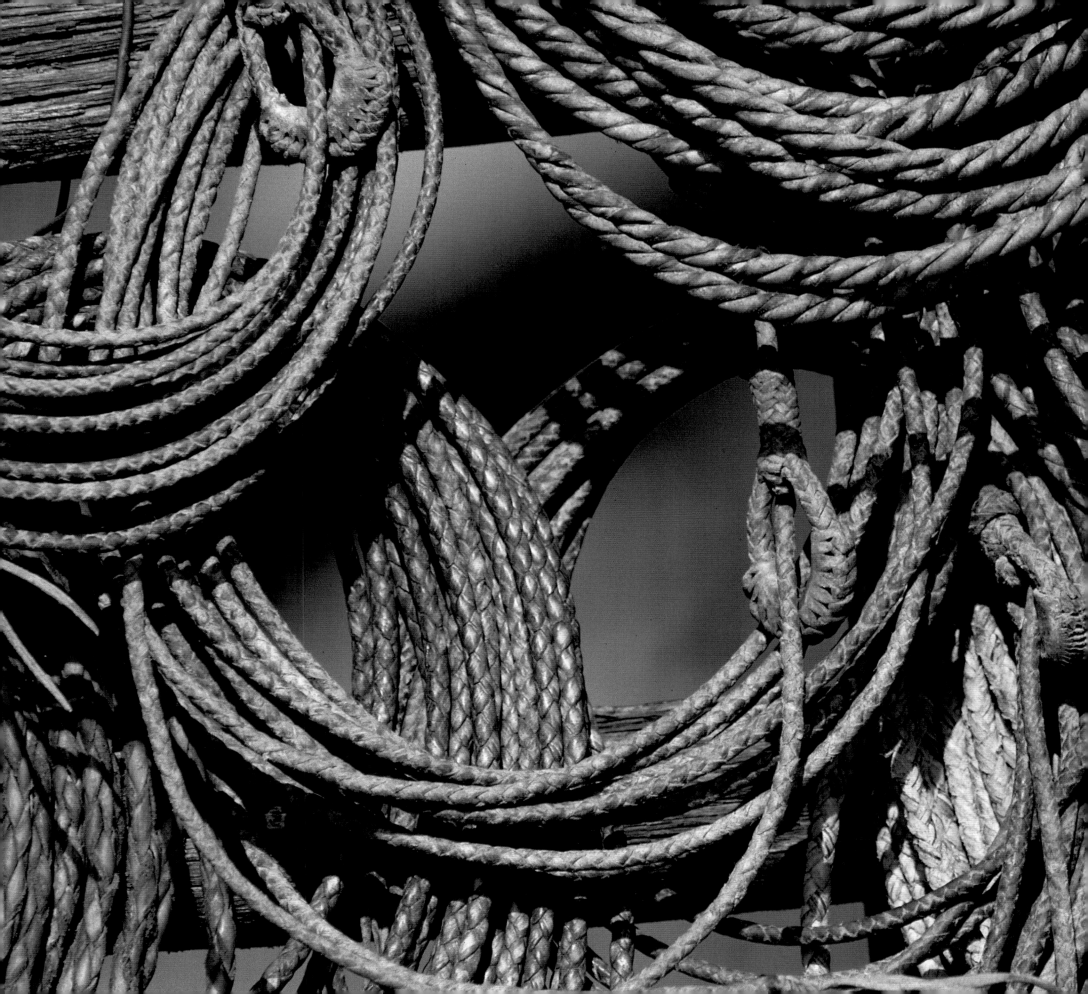

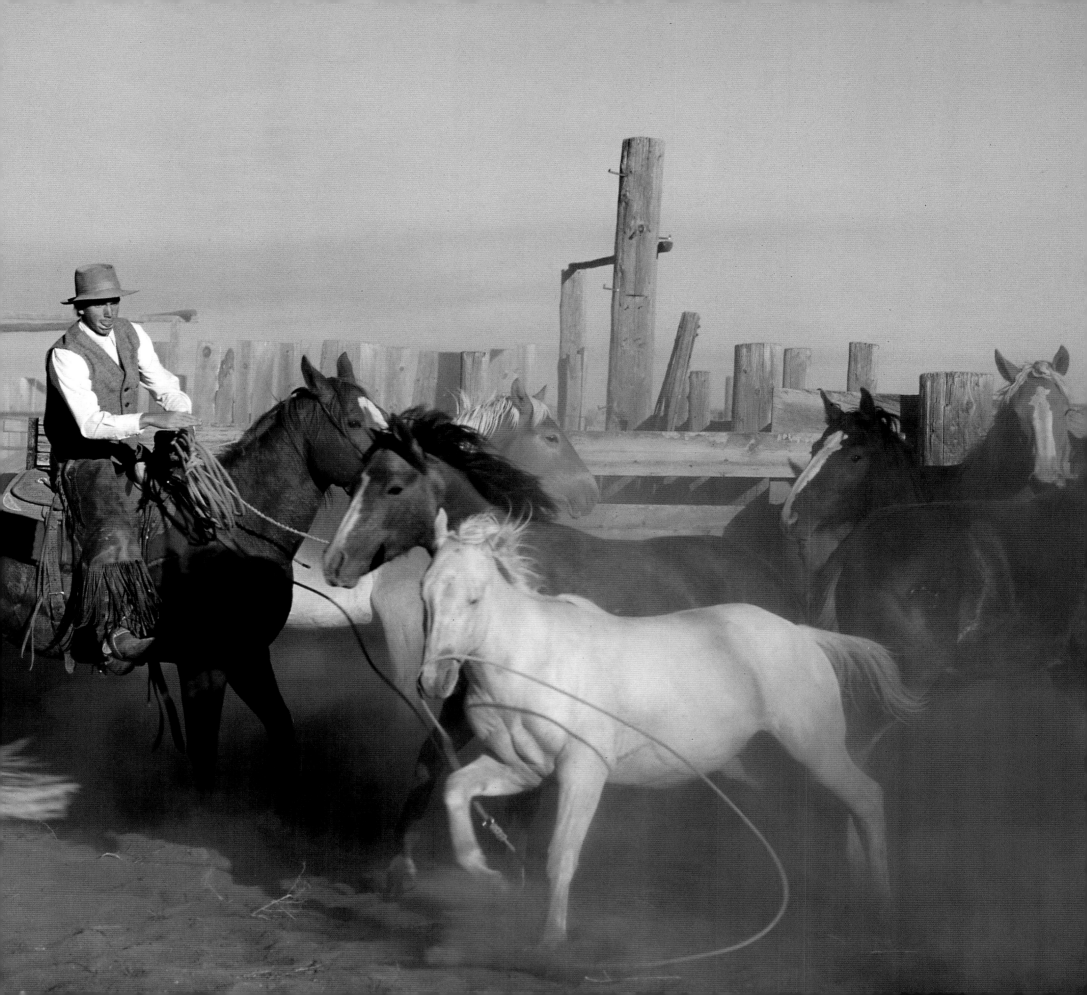

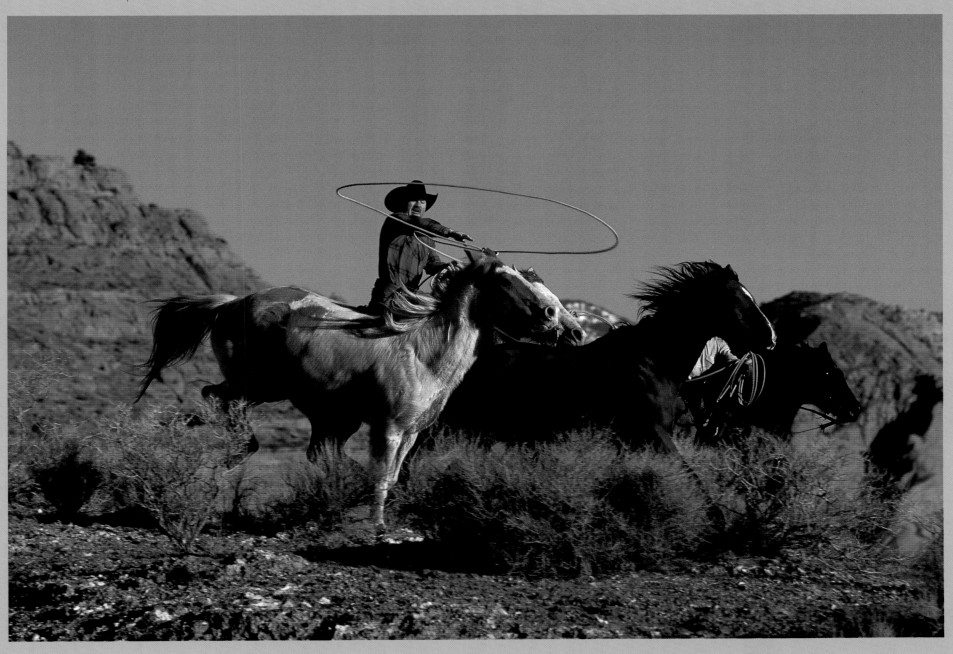

Lewis Feild
Diamond G Ranch; Elk Ridge, Utah

Conner Jacobs
Jacobs Ranch; Dubois, Idaho

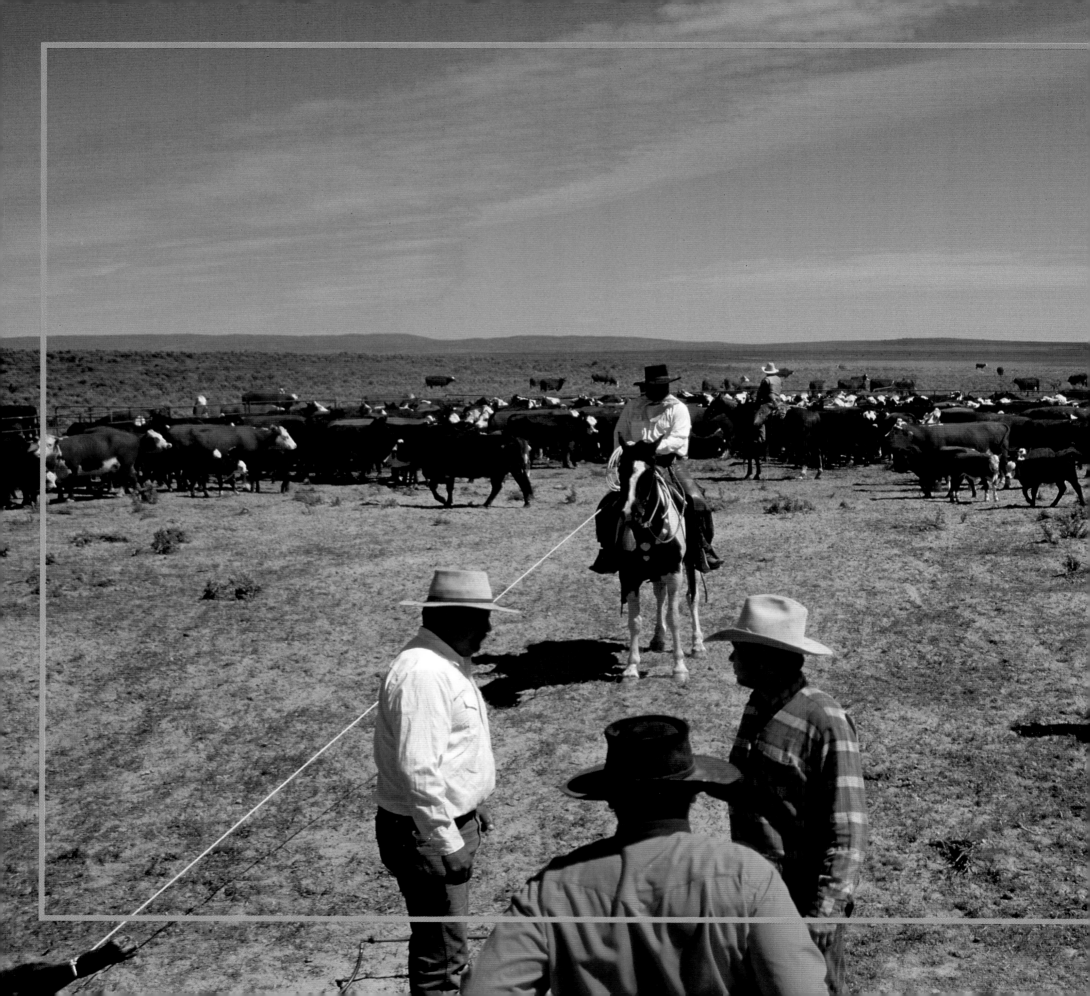

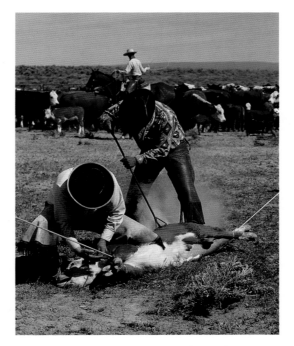

T.J. Thompson, Thad Johnson, Norbert Gibson
YP Ranch; Tuscarora, Nevada

They'll ride into the branding pen,
A rope within their hands,
And catch them by each forefoot
and bring them to the sands.

—The Buffalo Skinner

Nathan Kelly, John Jackson, Michael Virgil, Dave Thompson, Woody Harvey, Norbert Gibson
YP Ranch; Tuscarora, Nevada

BUSTIN' BRONCS

Just part of a day's work for Chad Williams

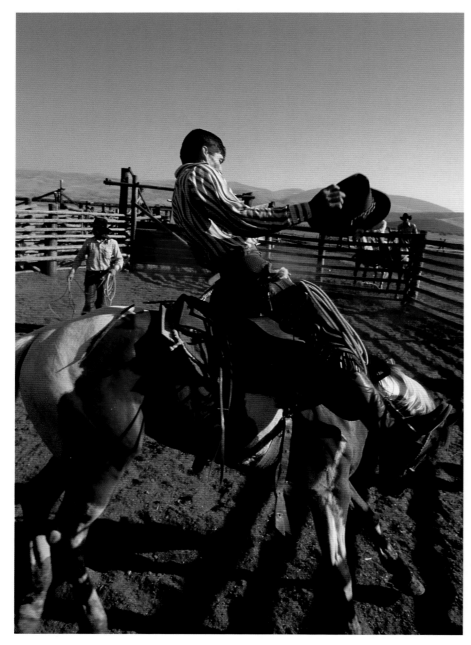

Chad Williams
Dragging Y Ranch; Grant, Montana

As long as I can remember I've been riding horses. I was born and raised on a ranch in Hamer, Idaho, and I was around horses all the time. That's how I learned about them. All through high school I started horses for people in the area in order to make a little extra money.

I learned the basics of starting horses from my father, and I still use a lot of the things he taught me. But from there, most of the things I learned have been from experience, just from one horse to another and learning from my mistakes. And of course you can learn a lot of things by talking to other people and watching what they do.

At the Dragging Y Ranch, me and Mark Telford were in charge of a string of horses, and between the two of us we probably had about 20 head. It was our responsibility to get those horses started. Some of them had been started already, and we were just supposed to ride and train them some more.

We weren't told to get a horse so far along. Basically we were given the horses and then we used them for ranch work. In the meantime, they were being broke. We broke those horses enough so that we could get work done on them, and so that someone else could get work done on them when we were done with them.

The horses I got when I was there were three- and four-year-olds, and I don't believe they were halter broke. When they were run in, they had been running free on the mountain with a herd up there in the pasture. We broke horses on that ranch in the old style. The horses that they gave us were the horses that we rode, and we had to break them quickly or at least be able to get something done on them in order to get our work done. We would ride them for four or five months, then either turn them out or give them to somebody else to ride.

If a horse isn't halter broke, I'll run him in the round corral, play with him a little bit, get the halter on him and tie him to a snubbing post. One thing that I do is get an inner tube and tie the inner tube to the post, and then I tie the halter, the lead rope to the inner tube. That way it has a little give. I leave a horse tied for about 12 hours, and afterwards the horse is normally broke to lead. Some of them take a couple of times, others lead really well after the first 12 hours.

The next day I run them back into the round corral, just run them around and rope them a few times. I rope them on the head, rope them on the back feet and such. I rope the back feet and get them used to the ropes so they don't kick at it. Then I get

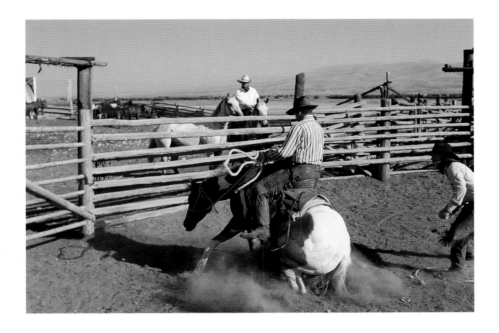

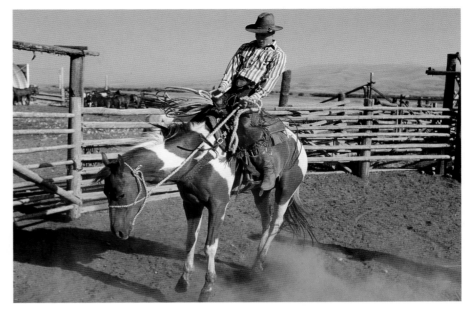

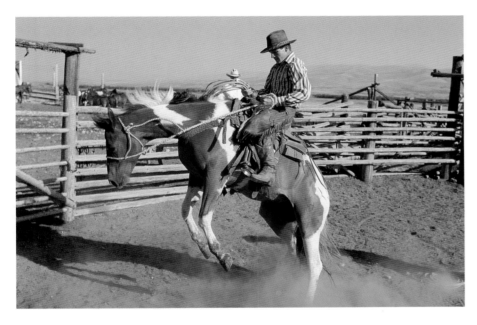

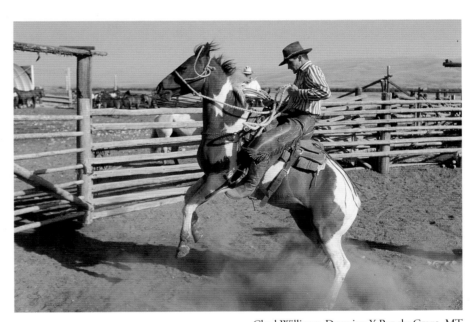

Chad Williams, Dragging Y Ranch; Grant, MT

them haltered, tie them to a post and rope a back left foot because that is the side you saddle on. Then I stretch them out so if they are standing still they are on all four feet, but if they move they are standing on three feet.

Right there I saddle them. I'll saddle them while they are tied up, still stretched out, and I get on and off of them a lot of times until they get used to it. Then, depending on the horse, I may turn him loose and ride him around. I stick a snaffle bit in his mouth and ride him around a little bit in the round corral. What I do all depends on the horse.

The purpose of hazing them with a rope is that I don't want them to run away from me when I take them outside the pen. One reason I rope a back foot is because through that back foot I can teach them to stop. I'll have them going around the corral and say "whoa." If they don't stop, I'll pull on that back leg. Eventually they will always give to

that back leg. Pretty soon I'll just touch that back leg and they will stop. I use voice commands while I'm working with the rope, and that saves me when I go out the very first time—my horses are stopping when I tell them to. Also, if they get caught in wire or have some other wreck, the horse is going to think that it is nothing new, and if I say "whoa" he will stop.

From day one, the way I train a horse is I'll just stick my spurs in them, just in the front conch. I won't hammer them. I won't kick them hard, but I will just hit them and push more and more, so that it is kind of gradual. Be nice at first with your voice, then a little bit on the bit, then a little spur, a little more and a little more. Eventually, the horse is going to have to make a choice about whether he wants more pain or whether he wants to stop.

Of course, after he stops I make everything good. I let my spurs go immediately so that he knows that stopping is good. He gets a reward.

I also use my body weight to communicate. I have said "whoa" first of all, and my body weight is shifted as your body naturally would be when a horse comes to a stop. That shift is also a warning. By sitting a certain way in the saddle, you are communicating to the horse what you want him to do.

I like some horses more than others, and that has to do with the connection and communication process that I have with them. If a horse was reacting right, I would break them to lead in one day, ride them in the pen the next day, and the next day I would take them outside.

When you first start a horse, it's not a surprise if it bucks. But it is not very often that I find a horse that bucks hard and bucks a lot. If a horse bucks the first couple of times that I get on him, that is pretty normal.

I did have a horse that surprised me once. That was the wildest horse I ever fooled with. He was probably six or seven years old, and he ran away. I am saying ran away—he was at a point where I was out of control. But I didn't panic because I knew how good his feet were and that he wasn't going to fall down. He had been a wild horse in the mountains and he had good feet. I felt completely safe—if you can feel safe while your horse is running away. I got a handle on him eventually, but that is why I normally won't leave the pen unless I am pretty confident that I am going to be okay.

If a horse is running away, a big, strong horse, I grab one rein, whichever arm is stronger, and try to get him going in a circle. I wouldn't want to jerk real hard because I might throw him off balance and he would fall on me. You get him going in smaller and smaller circles until you get a handle on him. You have to keep the communication going with a horse. If they are running away hard, their mind goes somewhere else instead of paying attention to you.

I believe that a horse has the power to reason. You can have one horse that you do exactly the same thing on every day, and another horse that you do exactly the same thing on, and one horse will learn what you are doing and the other won't. My dad had a horse one time that got stuck in fence. That horse just waited until we showed up and let him go. I thought that was reasoning, because another horse would have hurt himself trying to get out.

A horse reaches physical maturity at five or six years old, depending on the horse.

But I don't think you can start training a horse too young, as long as he's big enough to pack you. I have started a lot of two-year-olds that are pretty small, but don't like to do it because when I get to a point where the horse is tired enough that he is ready to learn, he is too tired to do anything. Three or four years old is where I like to start them.

Those old Texas guys, they always start five-year-old horses. My dad said that when he came from Colorado, he wouldn't start a horse until it was five, six or seven years old. He said they would just run them in a pen and manhandle them, throw a saddle on them and ride and hope they didn't fall off. Those horses bucked hard and beat those cowboys to death, and by the time you got them broke they were 10 or 12 years old and over the hill practically.

If you start a horse when they are three or four, by the time they are six or seven, in their prime, they are nice, broke horses.

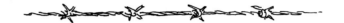

YOU NEVER STOP TRAINING THEM

Helena, Montana horseman Curt Pate
has his own way of getting a horse on the payroll

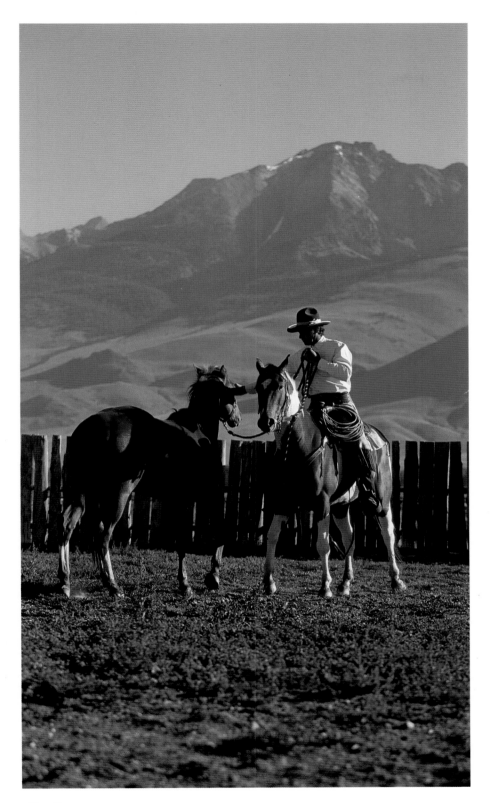

Curt Pate
Freeing up the horse's feet and getting him used to seeing someone above him.

I've always been interested in horses and cattle and the things you can do with them. I got my first rope from a great saddlemaker named Dan Buck when I was four years old and just continued on from there.

I've tried all the old methods of training horses and that's pretty fun and wild, but now I've come to the style of trainers like Ray Hunt or Tom Dorrance. I think if I was a horse, that would be the style I'd like to have put to me so that I could learn the things that humans want. The philosophy of this is, when you walk into a round pen or into a corral with a horse, instead of having in mind that you're going to conquer the horse and train him, it would be like coming in and teaching your best friend something. If you were trying to help a friend of yours learn something, you might go at it with the same approach.

If you're going to ride a horse for the first time, or you're starting a colt, the goal is to be able to get him where you can saddle him and ride him, and so you go through all the steps in a way that the horse can accept and not have to deal with fear and pain. I try to do everything that's beneficial for the horse, but also we need to get something done. We can't work on them for three years and never have them earn their keep. We want to get them on the payroll as quick as we can, with the least amount of stress on the horse.

Whether you are training a horse for ranch work, roping and doctoring cattle, or to go to a show ring, the basics are all the same. A horse will go anywhere if it's trained properly.

The purpose of the first 30 days of training is to get the horse gentle and trusting. I always tell people I'm not promising anything as far as a fancy rein. The main purpose is just to get the horse safe and gentle and trusting of you. Anything else you get after that is a bonus.

The one thing that you always want to remember is that everything we do with our horses, whether we're feeding them, riding them, or turning them loose, we're always training them. From the first minute in the pen with a horse you are building trust and trying to keep it. A lot of times we think we're training our horse only when we're in the round pen or in the arena or riding them, but I think we're training our horses all

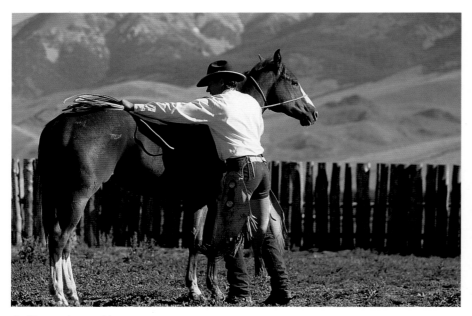

Sacking out horse with rope.

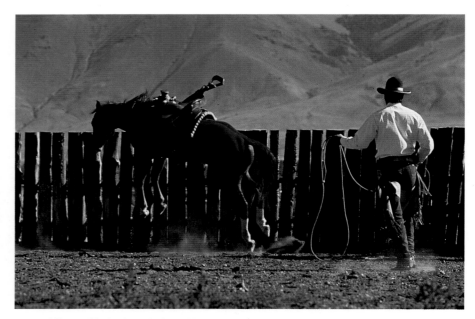

First saddling. If he bucks with the saddle, it is ok—it doesn't mean he will buck when he is ridden.

Getting on for the first time.

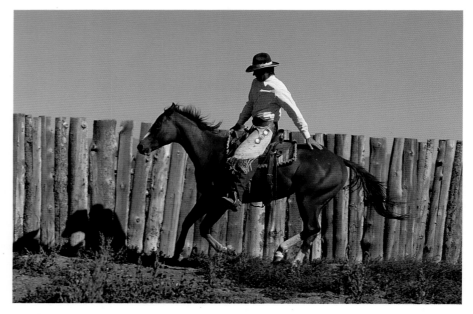

Comforting the horse while allowing him to travel in a natural manner leaves him no reason to buck.

the time, even when we're just walking through the pasture.

I feel that a horse never stops learning. You never take him out of training. Some horses that are ridden for five or six years by the great horsemen, they're still learning every day. You are always teaching them more, just like we never quit learning in our jobs. We are always learning more.

The amount of time it takes to train a horse depends on the horse's personality. A lot of times a horse that hasn't been touched or messed with by a person will come around a lot quicker than one that's been messed with and learned bad manners around humans.

I try to figure out each horse the first time I'm in the pen with him. The first thing you do is get him to move around and you watch his expression. The horse will kind of tell you what he needs or what he's going to have to have done to him in order to get your saddle on him. Some horses, it doesn't take anything. You just go ahead and put your saddle on him right away. Some horses it takes two hours to get them to where you can put the saddle on.

You can start 15 horses in the same day, and there will be 15 different ways in which they need to be approached. You know what they've had done to them previously—you know some of them have never been touched and they are pretty wild and scared and so you go at them a little slower and do not scare them as much. But if the horse has been bottle-fed or something, then he's going to be real pushy and want to run over the top of you, so you have to take a different approach to get him to have a little more respect for you.

I don't think there should be any time limit set on anything when training horses because they don't carry a watch. If it takes three hours to get to where you can pet him, the horse doesn't care. We shouldn't care either. If it takes us three hours to get where we can pet a horse down the neck, then that's what it takes. We shouldn't try to make it go faster. The next horse might be one you can walk right up to and pet him, and he might be the one that you can saddle right then. The one that takes three hours to pet, it's going to take quite a bit longer to get him saddled.

When starting a horse, I like to use a 50-foot round pen that's real safe. I want the horse to be able to move out because I want a walk, trot and lope in both directions. I want to be able to bring the horse from a lope back to a trot. I'll start working on that right away, and when I'm riding this will all transfer.

I do this training from the ground—put the pressure on. We're talking the predator/prey thing. If the lion comes to the horse, the horse is going to move away. So I'm going to be the lion. I'm going to get some movement out of the horse, and as soon as I do, then I'll back off. The horse learns that when I push on him, that means to go. So then you pick up a trot and then a lope and you also want to be able to bring him back from a lope to a trot, down to a walk.

And all this time the horse is getting gentler and gentler. You get to where you can get your hands on them and pat them and make it so it's not so scary for them. Then you might use a rope or a slicker or something to kind of rub them—sack 'em out. The thing is to not apply too much pressure to where they get scared. You want to apply enough pressure to where it bothers them, and then back off and get them so they can tolerate what you are doing. Instead of making them take it, like just slinging the slicker all over them, you just ball it up in your hand and rub them all over with it. Then you let a little more and a little more out of your hand. You build the horse's confidence. Pretty soon you can be throwing your slicker all over them, or your rope or whatever. Then you go ahead and saddle them and get them to where they can do all the transitions—walk, trot, and lope—both ways with the saddle, looking like they are running out in the pasture and the saddle isn't bothering them a bit.

Then you want to get above them so that when you get in the saddle for the first time, they know it's not something preying on them. And you also want to get the horse to changing eyes. A horse always looks at you with one eye. If you're behind him and he has you in his left eye, and then you switch over to where he has to find you with his right eye, there's a moment there when the horse loses you and it's like you've left for hours then come back and it really scares him. It's like somebody's attacking him, and a lot of times if you are on his back that'll make him buck.

When you first approach a horse or first ride him you say, "OK horse, here's our deal. This is everything you're going to have to take with me riding, whether I'm roping or playing polo." If I'm going to be playing polo on a horse, I want to get him used to a polo mallet the first thing. You're saying, "Here's all this stuff that you're going to have to get used to in our life together. If you can take that, then it's going to be a good life, but I'm not going to shove it down your throat."

That's the main thing. I think a lot of times what we get into is, if you're going to swing a rope on a horse you don't have to whirl it as fast as you can the first time. You ought to slow down and do just a little bit. Pretty soon you can go all the way around with your hand instead of just a little ways, and then you'll be throwing your rope and it won't bother the horse one little bit. But if you start out whirling as fast as you can first thing, it's really going to scare the horse and he'll get a phobia built up about what you are doing.

Sometimes I'll rope a horse first thing if I think that'll help him. A lot of times doing this will save a lot of time and a lot of running for the horse. I don't want him too tired. If he's shot before I get my hands on him, then I've got to quit. The horse is too tired to go on. So I try to get him real gentle without running him around much.

The rope is like an extension of your arm, and you use it to help your horse to stay in there with you. I wouldn't tie him up or anything, but the rope just kind of helps you keep him with you and makes things happen a lot faster. The purpose is to allow the horse to build trust in you and to show him that you're not going to hurt him and don't mean him any harm.

As long as we treat horses right, I don't think they want to do any wrong. If we'll just look at things through their eyes and try to see why they are doing something instead of thinking they are trying to do wrong, they can be true friends. As long as we just do things for them to help their comfort zone, they'll make it through for us. If we just allow them to search through things and find out what's right and what's wrong as far as what we consider right or wrong, and if we respect them, I think they'll respect us and learn.

I think a horse just wants to get along and get back to that hay pile as quick as he can. I think he wants to be friends. I don't think he wants to fight through life. If horses learn that we will be decent to them, they'll be decent to us. Horses just want to be left alone and do their thing, and they'll do their job for us to earn their keep. If we just leave them alone, they'll try to please us all the time.

Every horse has a purpose. He doesn't have to be a ranch horse. He can be a show horse or a very young kid's horse. Everything has to have a job in life, whether it's a person or a horse. But because horses are at our mercy—we feed them, we tell them what they have to do—we should be good to them. An old horse that is just someone's friend has as good a purpose as the horse that's going to go in a world championship reining.

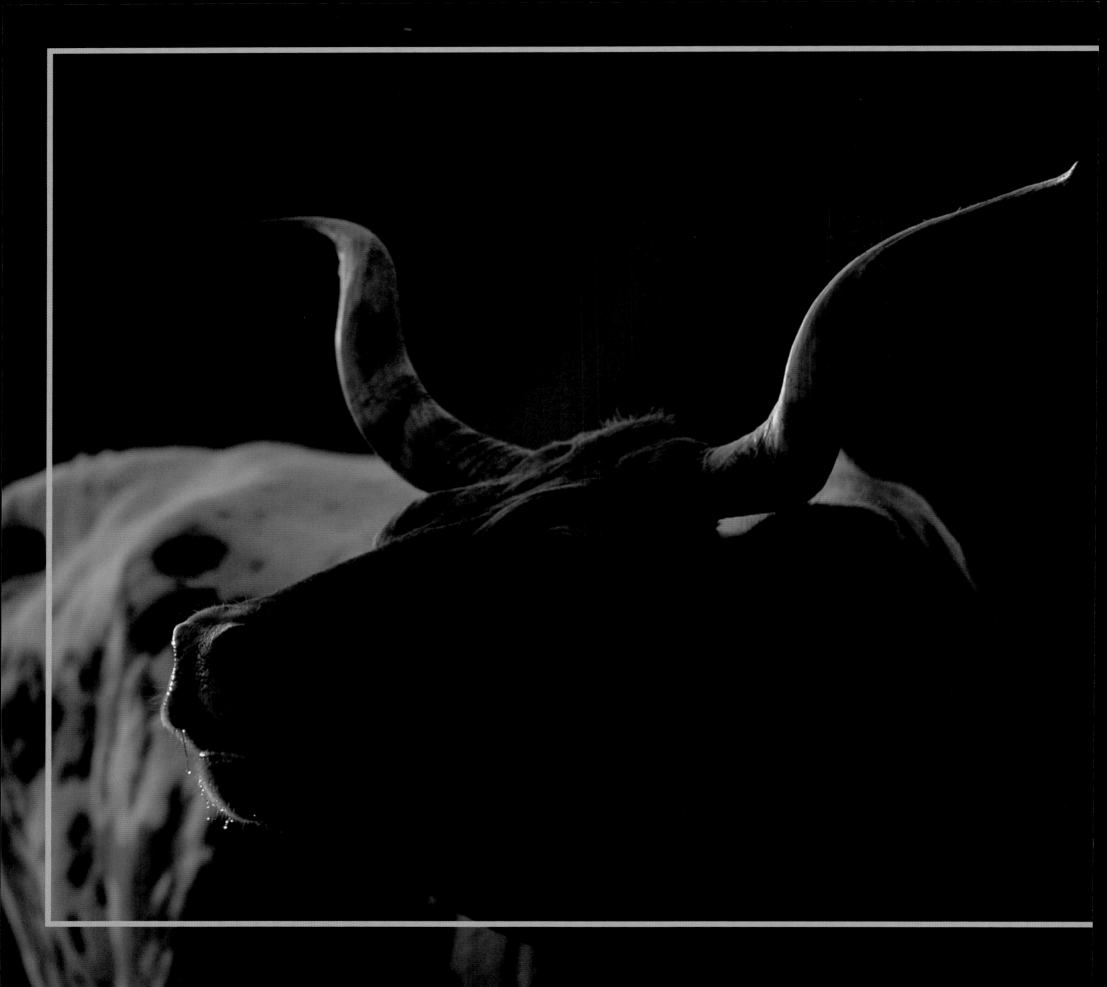

BLAZING NEW TRAILS

Texas cattleman Tom B. Saunders IV talks about the history and development of the cattle industry

During the middle 1500s, Spain sent explorers to the New World. Accompanying them were cattle and horses. The horses were used for transporting both men and supplies during exploration of the Americas, while the cattle were brought for sustenance.

As these conquistadors ventured into what would later become the southern end of Texas, they encountered hardships in the form of violent storms, drought, bad water and Indian attacks. The result was that cattle were run off, strayed, or lagged behind the traveling herds because of injury or sickness. These animals were the seeds of the Texas cattle industry.

For 300 years, until Texas achieved independence from Mexico, more cattle were brought in, more escaped captivity, and the cattle that survived in the wild multiplied into huge herds. These were the cattle that became known as Texas Longhorns.

Longhorns proved efficient grazers and capable of sustaining themselves easily in the harsh environment. They were prolific and with their massive horns were capable of protecting their calves from predators. Eventually they became immune to diseases that plagued domestic cattle, and through natural selection they became one of the most highly adaptable and self-sustaining breeds known.

At the beginning of the 19th century, Texas overflowed with cattle. Herds were estimated in the hundreds of thousands. However, there was no market for all this beef. There were more cattle in the state than there were people, and beef was free for the taking. Following the Civil War, however, the railroad pushed into Kansas, and Texas ranchers recognized a unique opportunity to sell their cattle. So began the great trail driving period, which lasted from 1866 into the late 1800s. Some reports estimated that 10 million head of Longhorns went up the trail to shipping points in Kansas.

The last quarter of the 19th century saw another significant change. With the invention of barbed wire, the cattle industry evolved from open range and free-ranging Longhorns to fenced ranches. This change was disliked by many ranchers and cowboys who had moved freely with their herds much as the buffalo had done, taking advantage of the better grass and water that was available in different parts of the country at different times of the year. By the late 1890s, most of the range had been fenced. With fences, ranchers could better utilize their land, better manage their herds, and work and market their cattle more efficiently.

The railroads played an important role in opening up new markets for Texas cattle. But as the demand for beef increased in the heavily populated areas of the Northeastern

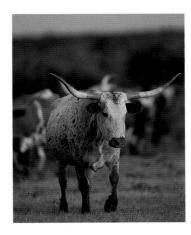

United States, the demand for better-quality beef increased as well. Realizing that they could make greater profits with high-quality beef, ranchers began improving their cattle through selective breeding.

In the late 1870s and early 1880s, foreign investors came to this country and purchased large amounts of grassland in cattle country. With them came some of their native cattle, such as the Hereford and Angus. These English breeds were heavier, more muscled animals that produced larger amounts of better-quality meat than did the rangy native Longhorn. These breeds adapted to their new environment well, and ranchers began crossing them on the Longhorns and thereby increasing the quality of their herds.

Today, ranchers continue fine-tuning the genetics of their herds, producing cattle that not only meet the needs of the marketplace, but that reproduce well, raise healthy calves, and can withstand the rigors of life on the range in differing parts of the country.

For example, R. A. (Rob) Brown, Jr., is a modern West Texas rancher whose family has been in the cattle business for close to a hundred years. He has endeavored to improve the quality of the beef that he raises much as his ancestors did. Traditionally, the R. A. Brown Ranch was a Hereford operation, but in the mid-1960s Rob and his dad began crossbreeding their Hereford cattle with Brown Swiss in order to increase the milking ability of their cows.

This cross worked well and greatly increased the weaning weights of their calves. However, the resulting calves lacked the muscling and beefiness of the Herefords. Rob began looking for a breed that had both milking ability and beefiness, and in the late 1960s found what he wanted in the Simmental breed.

Experimenting with this breed, he began crossbreeding Simmental cattle with Brahman bulls. The resulting cattle became so popular that a new breed was formed called Simbrah.

Around the middle of the 1980s the trend for bigger cattle had reached extremes, but not being married to any one breed, Rob continued to try to produce the right seed stock to meet the needs of cattle producers across the country. He continues doing so today.

The cattle industry has seen many changes—from open range to fenced ranches, from the days of driving grass-fat Longhorns up the trail to the trucking of grain-fattened cattle to market. Regardless of the changes, cattlemen such as R. A. Brown continue to open new and better trails to the future.

Texas Longhorns
Donnell Ranch; Fowlerton, Texas

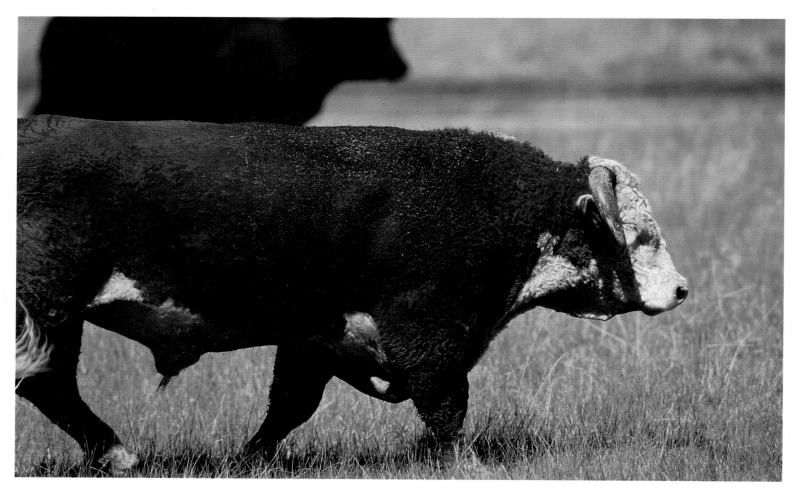

Hereford Bull
Cashbaugh Ranch; Owens Valley, California

California cross-breed cattl
Cashbaugh Ranch; Owens Valley, Californ

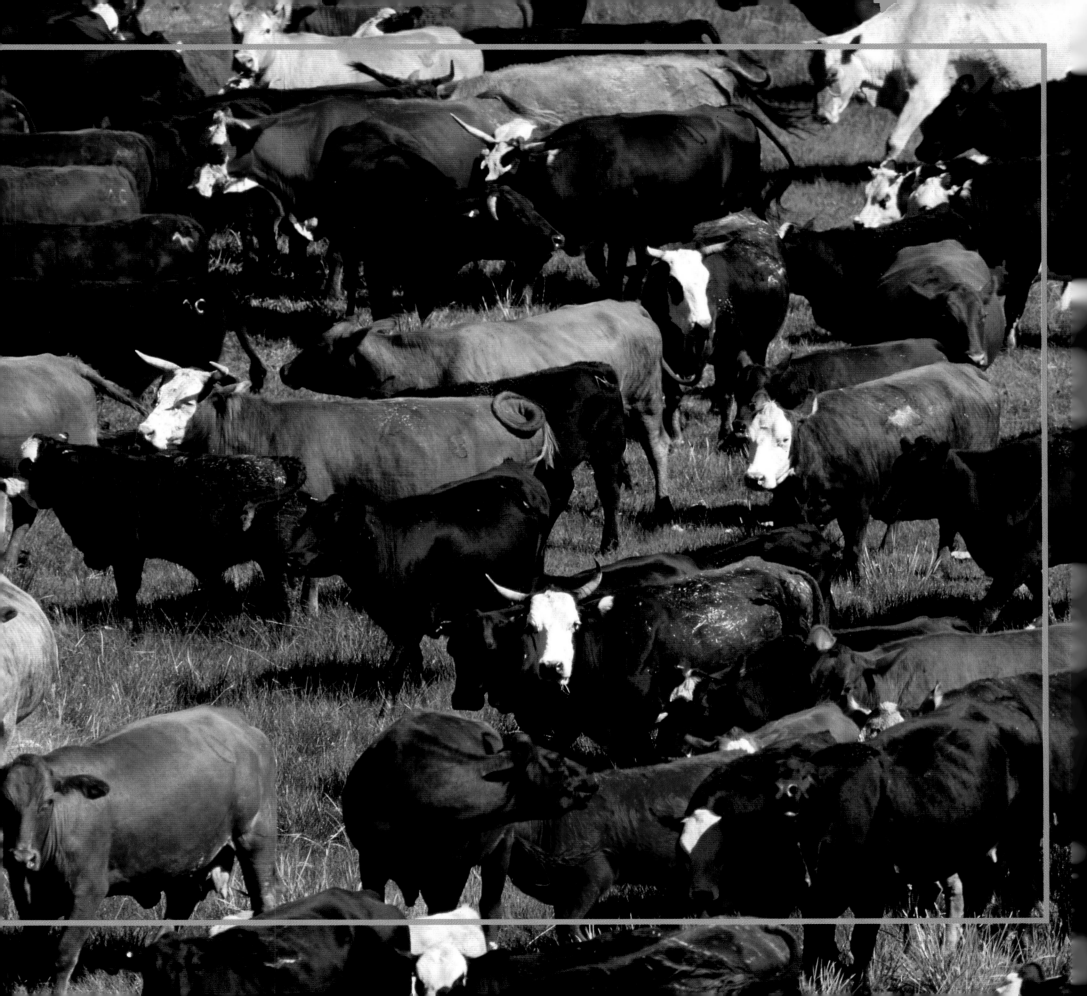

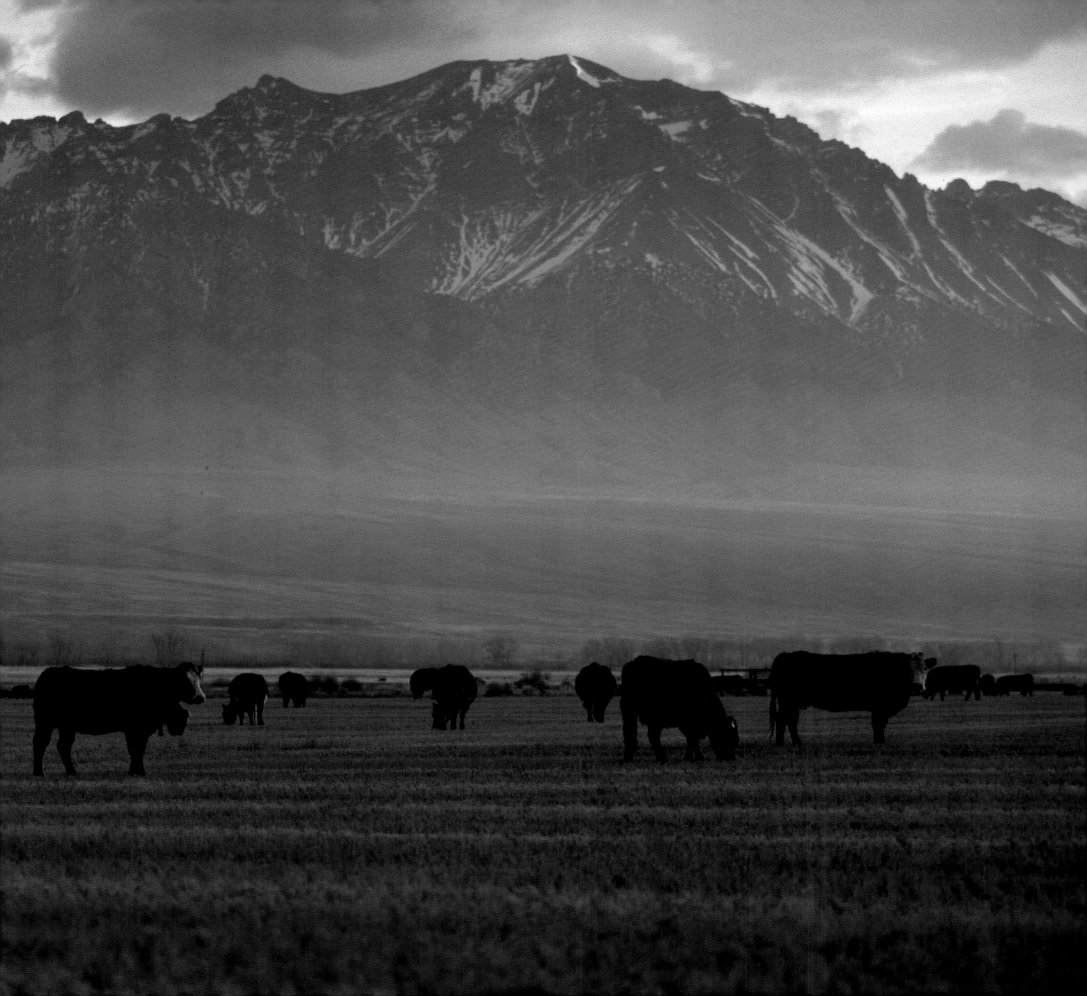

Black Baldy Calf

Next morning at daybreak
in a circle we ride,
we round up the doggies,
take down the rawhide.

—*The Pecos Puncher*

Cross-breed cattle, Bar 13 Ranch; Mackay, Idaho

Southwest Texas Cattle

Gray Brahma Bull

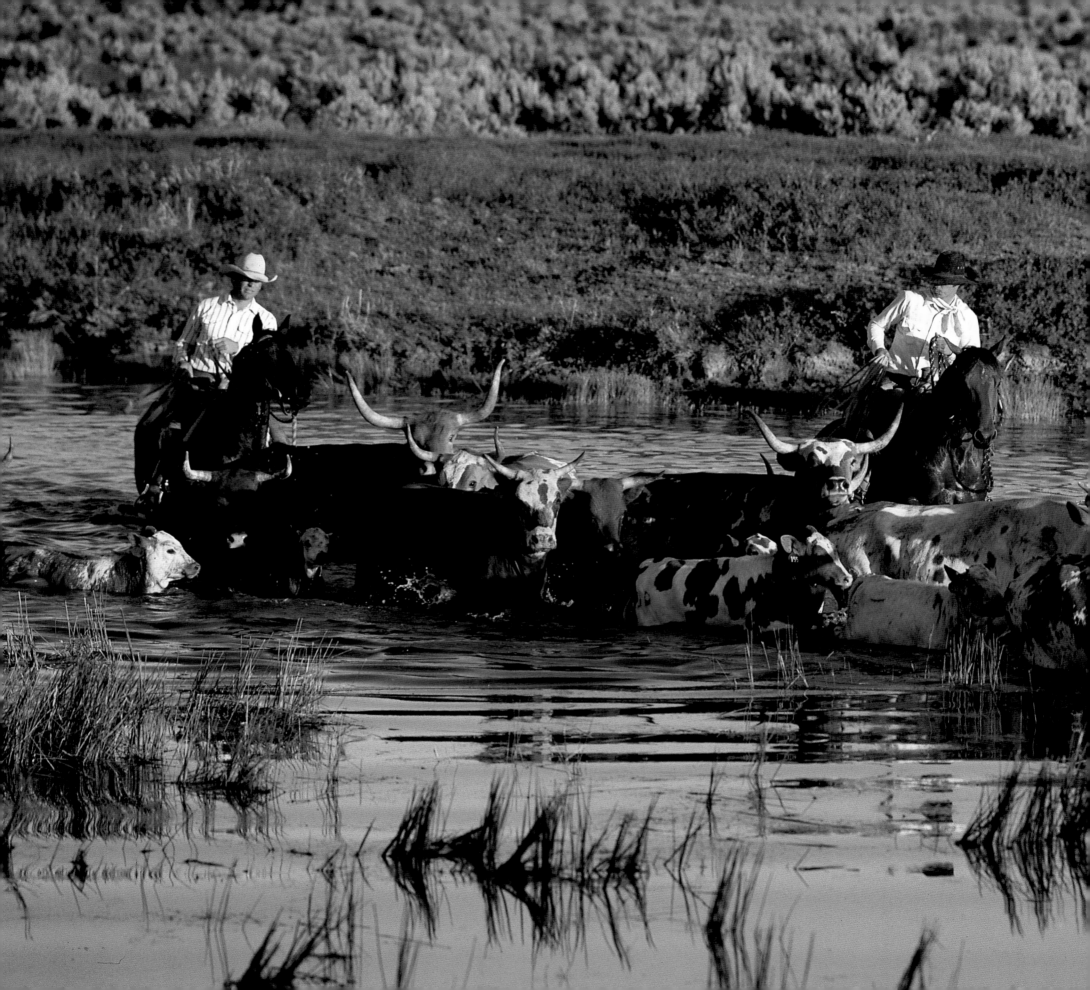

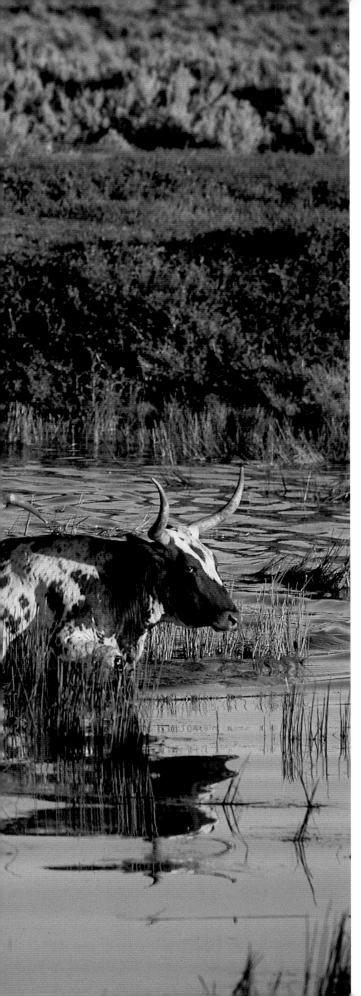

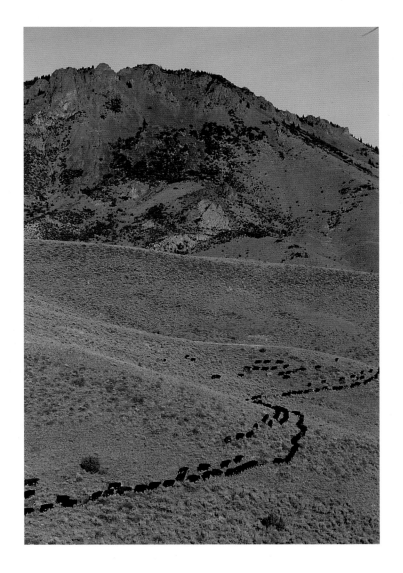

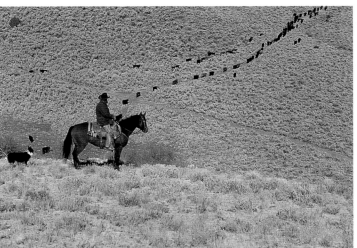

Moving the Cattle to the Winter Ranch
Mike Seal, Antelope Valley Ranch; Moore, Idaho

J2 Brown & Jim Barton
Square Lake, Idaho

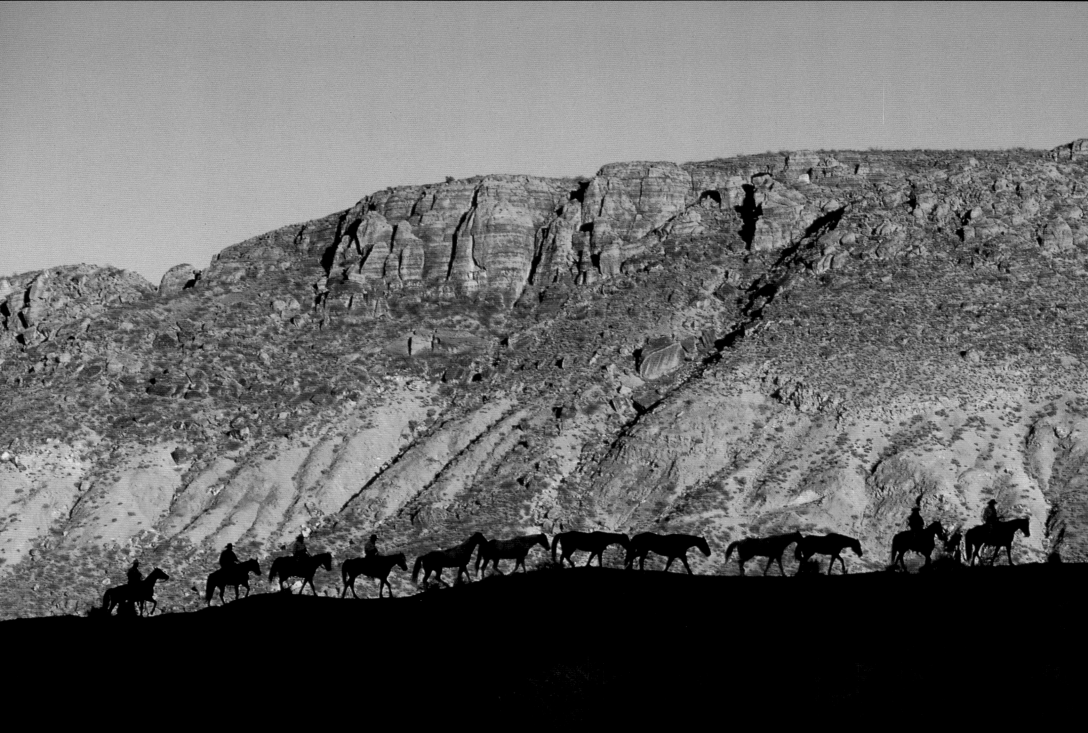

RED ROCK AND THE WESTERN LANDSCAPE

By Buckeye Blake

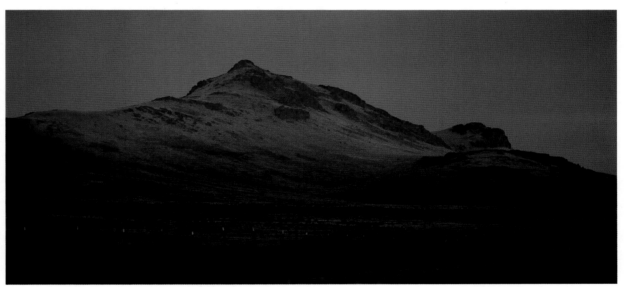

Foothills of the Big Lost Range; Mackay, Idaho

The red earth—sorrel, red roan, red ochre, pipestone, like rust, red oxide, a flat finish, dry looking. An old brick is just the right color. Indian red. This color symbolizes the West. It also symbolizes blood—life blood, energy, vitality and strength. Some Native Americans believed that once you gain wisdom, you are set on the right path, called "the good red road." This color is used as a symbol of power, like a visual vitamin. Other strong colors are yellow ochre, sage and turquoise. Used in various combinations, these colors create the feeling of the West. This book was designed with a conscious effort using such colors to produce a stronger sensation and develop a closer relationship to the subject. This approach, I believe, opens the door to such a grand theatre: the American West.

Buckeye Blake 96

Riding the Ridge
Lewis Feild, Veronica Feild, Sam Eliott, Jess Thomas,
Bob Marriott, Shannon Wilson; Southern Utah

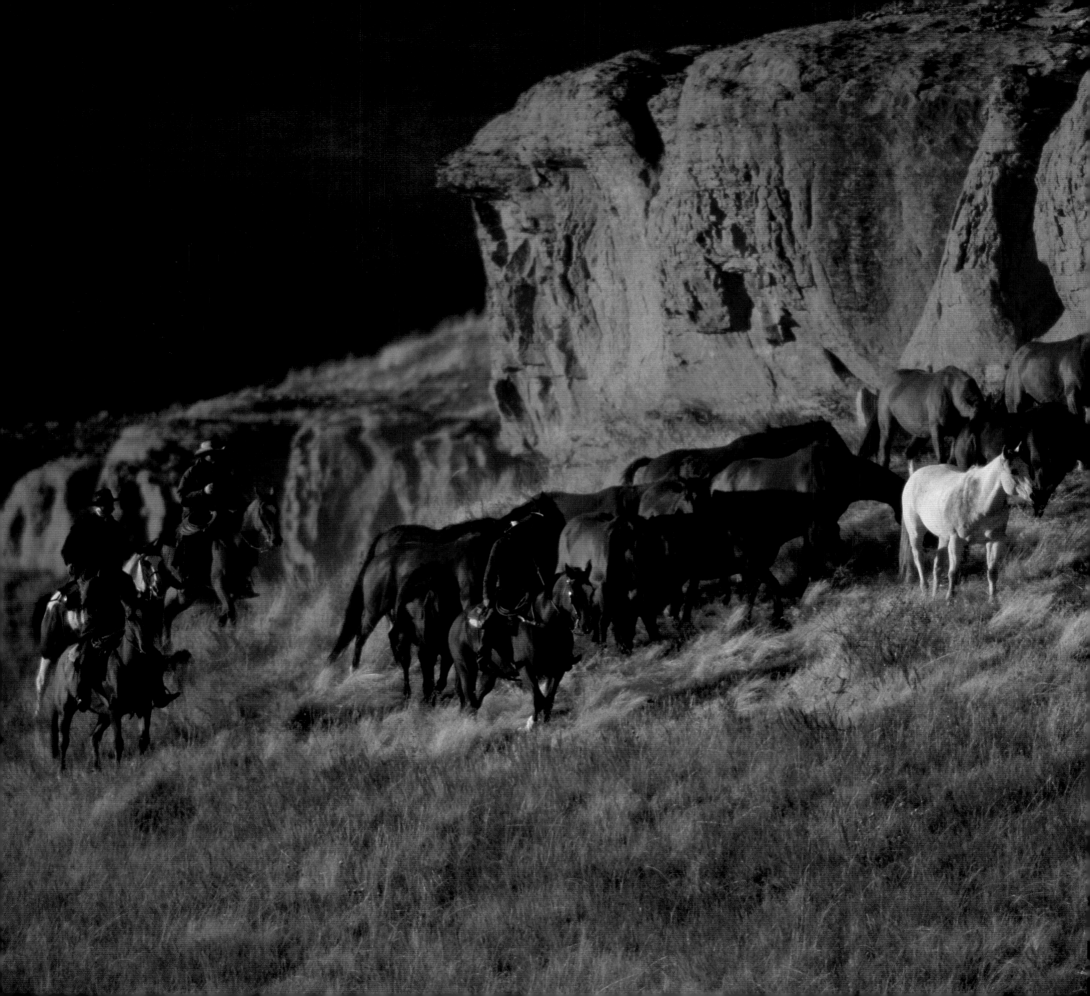

The afternoon shadows are
starting to lean
As the herd gathers into
an evening ravine.

—The Corral

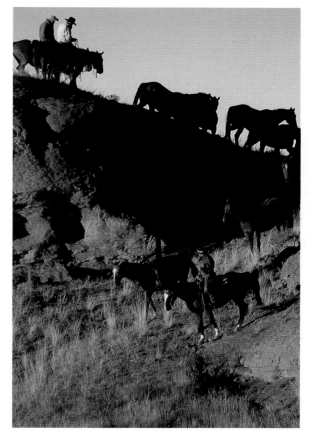

Shane Hoopes, J2 Brown, Brad Mitchell, & Pat Tomlin
Sunlight Ranch; Wyola, Montana

Shane Hoopes, J2 Brown, Brad Mitchell, & Pat Tomlin
Sunlight Ranch; Wyola, Montana

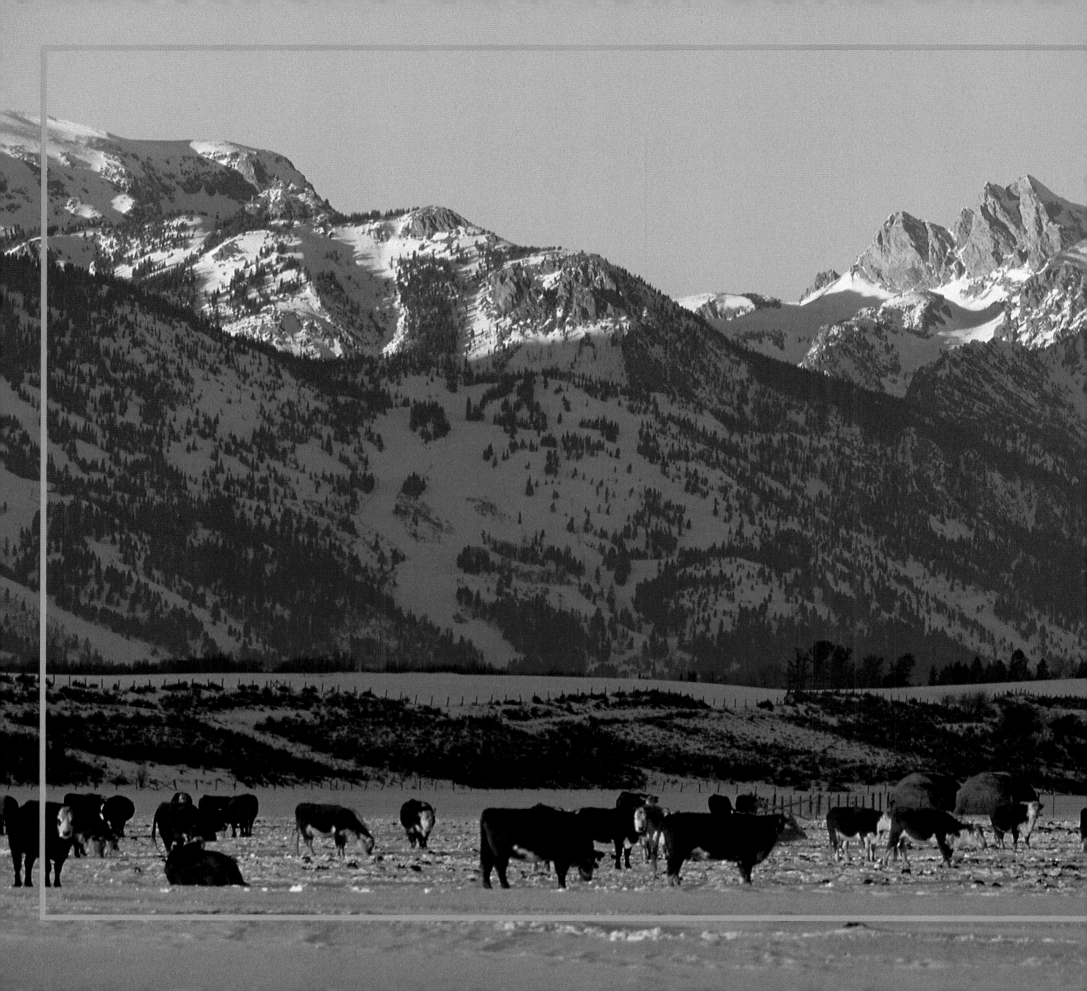

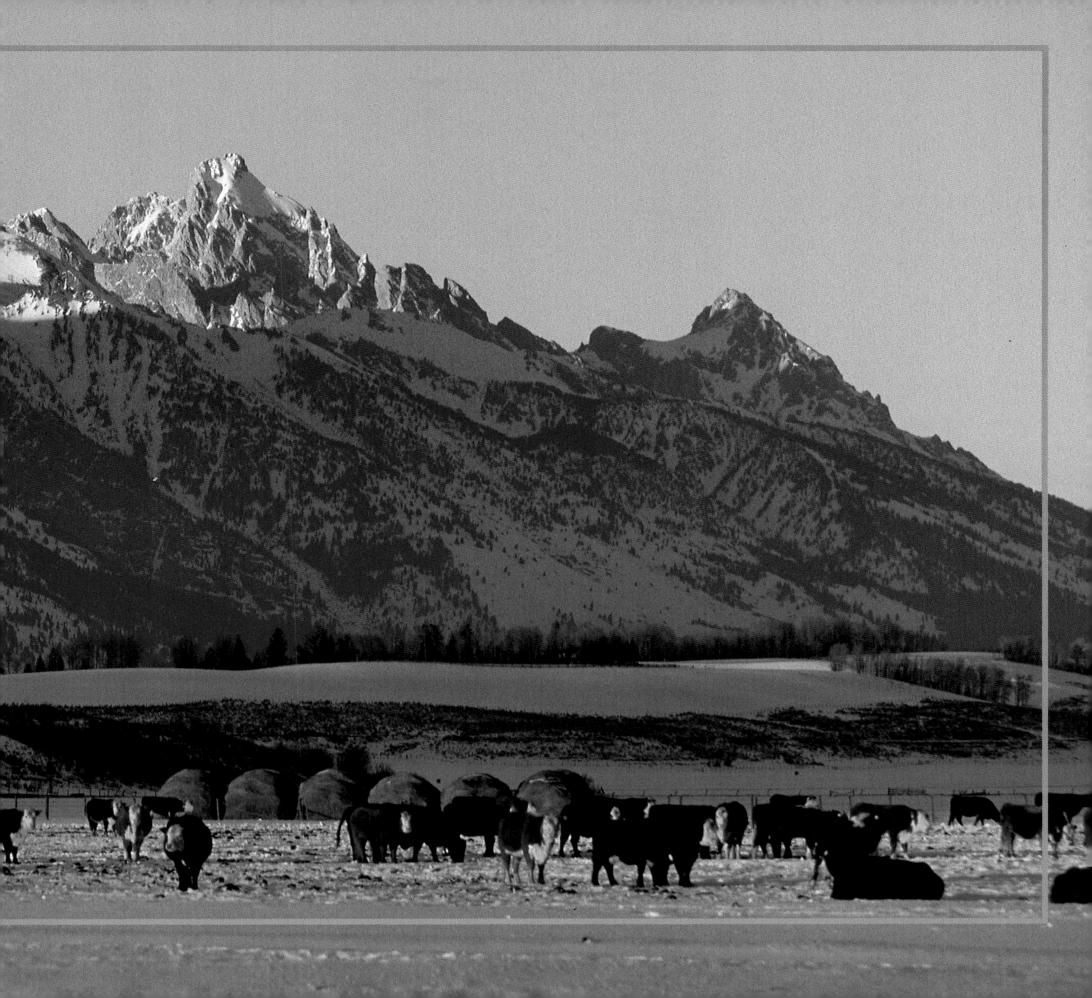

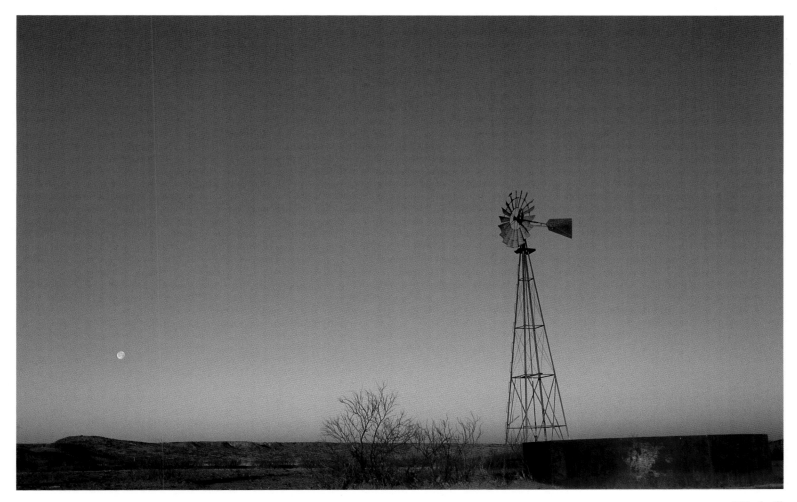

Windmill
LX Ranch; Amarillo, Texas

*"The Comanches held back the settlement of Texas about eighty years,
the windmill sped it all up about eighty years."*

—David R. Stoecklein

indmill
ıth Texas

evious Page: Walton Ranch
ckson Hole, Wyoming

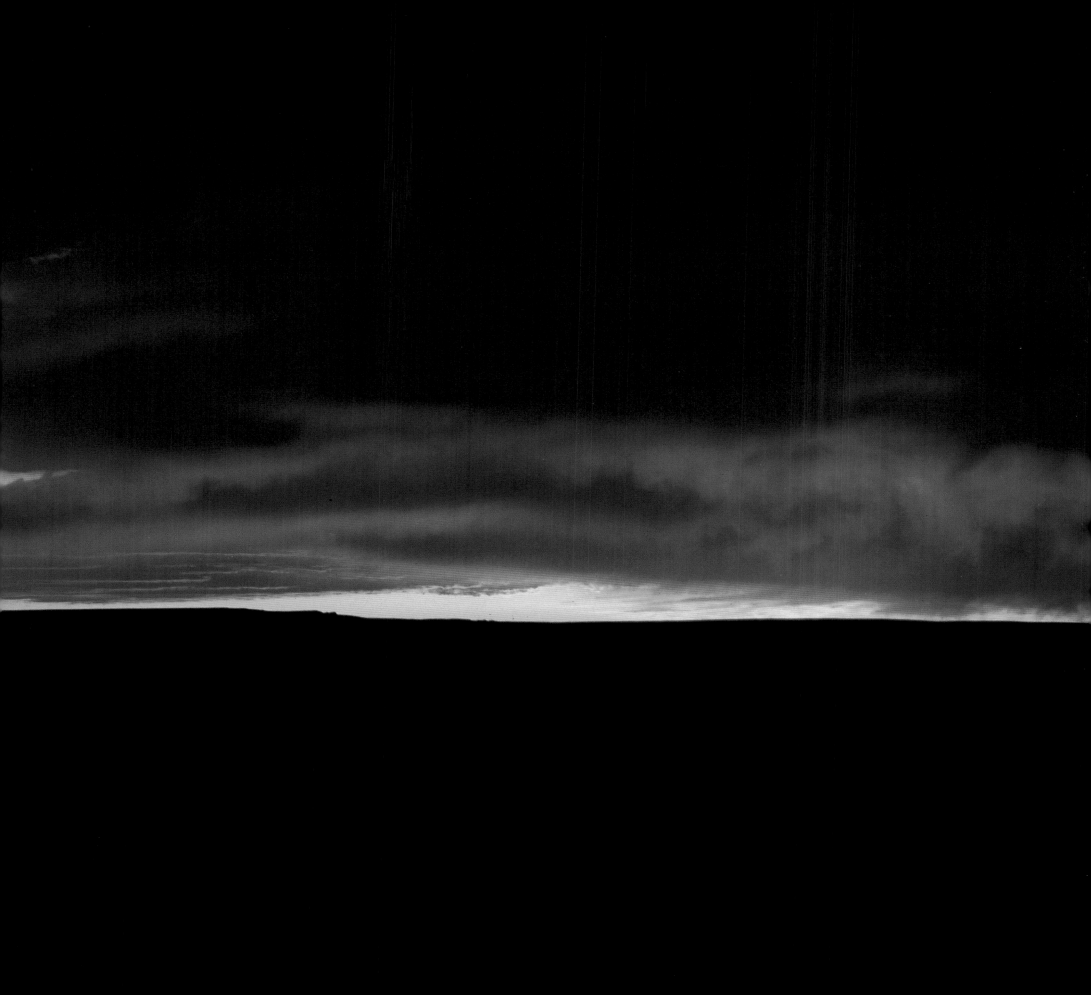

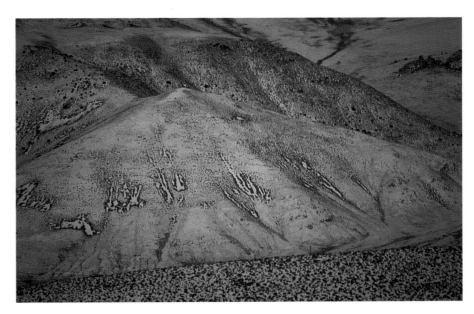

Foothills
Big Lost Range; Mackay, Idaho

Sunrise, West Texas

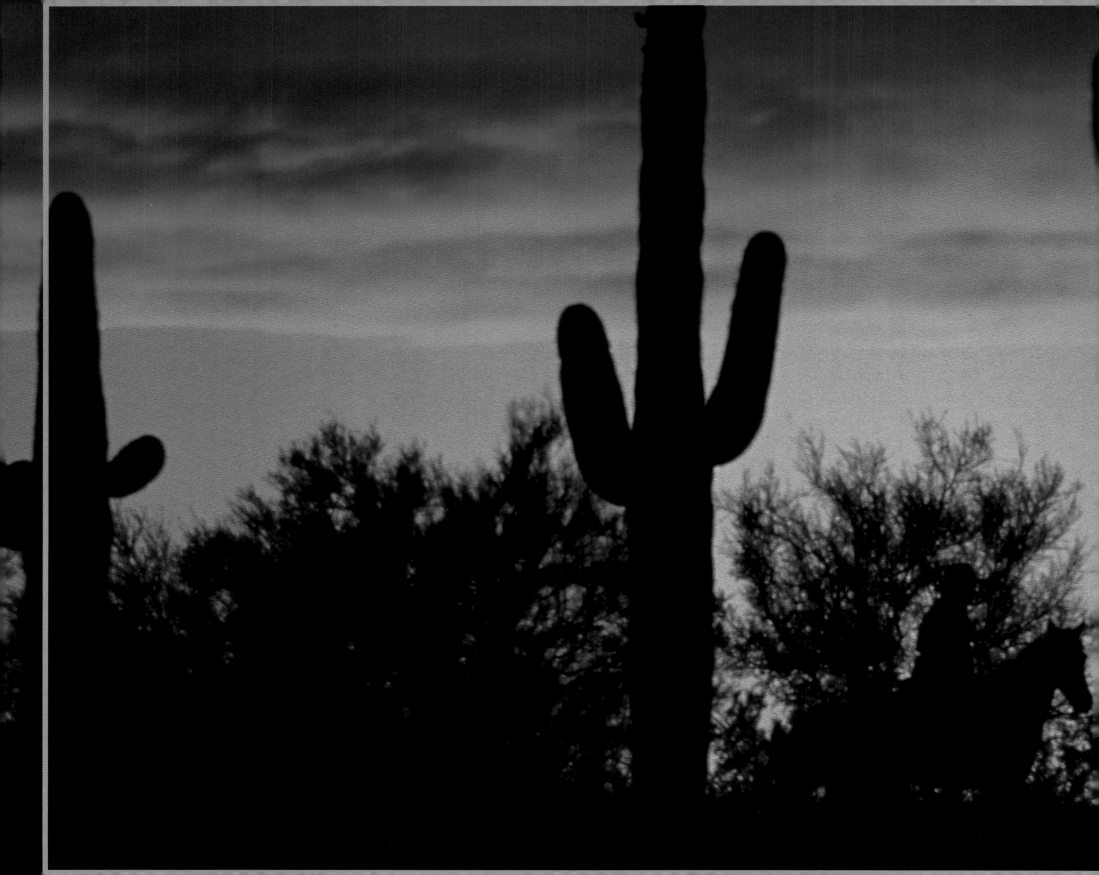

"*Just throw my old hide
in the cactus
out where the desert
wind moans
for I wanted to die
in the desert
where the buzzards would peck
at my bones.*"

—*I wanted to die in the desert*

Riding in the Saguaros
Debbie DeWitt; New River, Arizona

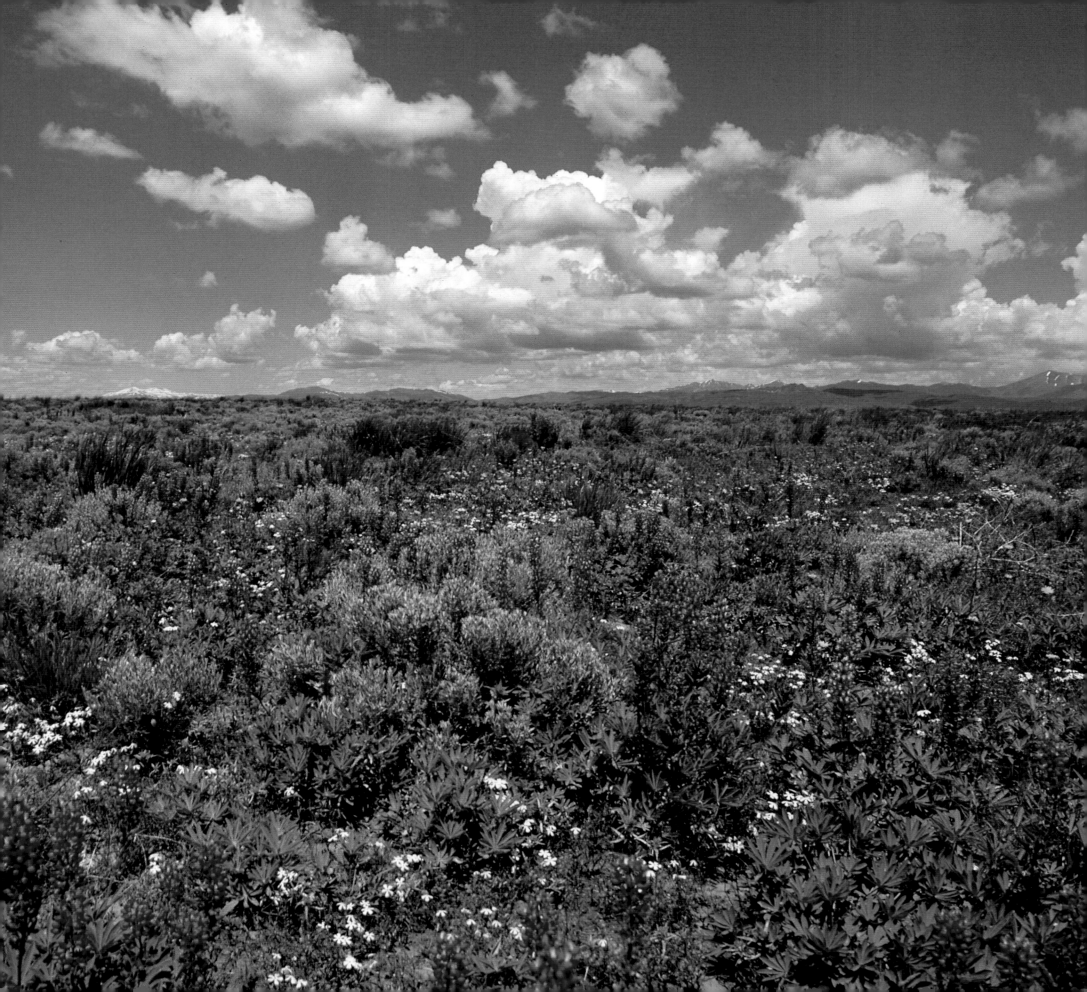

SAGEBRUSH

By Scott Preston

If it gave better shade at lunchtime, sagebrush would be the state tree of cowboy country. Considering it as a bush or shrub doesn't really give full justice to the impact of its influence on the Western imagination, on the minds that work the landscapes where sage forests the hills as far as a man can ride in a day.

Of course, sagebrush gets taken for granted. It is the state flower of Nevada, an honor that may have had as much to do with a basic shortage of other choices as with the romance of the wide open spaces where sagebrush blooms supreme.

Sagebrush isn't often tooled into leather as a design on saddles, belts or boots. It isn't embroidered or stitched on many fancy shirts or skirts, and silversmiths haven't seized upon its ragged bonsai bouquets as a pattern for their hammered jewelry. Roses and swooping verdant vines are the preferred flora of the artisans of the vast dry places of the West, icons of water and exotic colors to wear like talismans of civilization left on the other side of the Mississippi.

But when a loved one is stranded in school or with business somewhere East of where his heart resides, it's a pinch of sage that goes into the envelopes bringing letters from home, bringing a burst of fragrance that fills a room with a scent of dry blue sky and clear miles to the horizon.

The most sacred plants are often the most common. Under ideal conditions, tall sagebrush can reach a height of eight feet. In more hostile environments, it can barely reach a walking man's knees. It doesn't compete particularly well with grasses or other shrubs, yet it has evolved remarkable tolerances to summer drought and heat and winter snow and cold. It is the first plant in the songs and poems of cowboys, and the basic healing herb of native medicine. And it's one of the first plants to disappear as towns expand and houses extend into the ranges of the Old West. Where sagebrush thrives, the cattleman survives.

...ring time on
...e Camas Prairie; Fairfield, Idaho

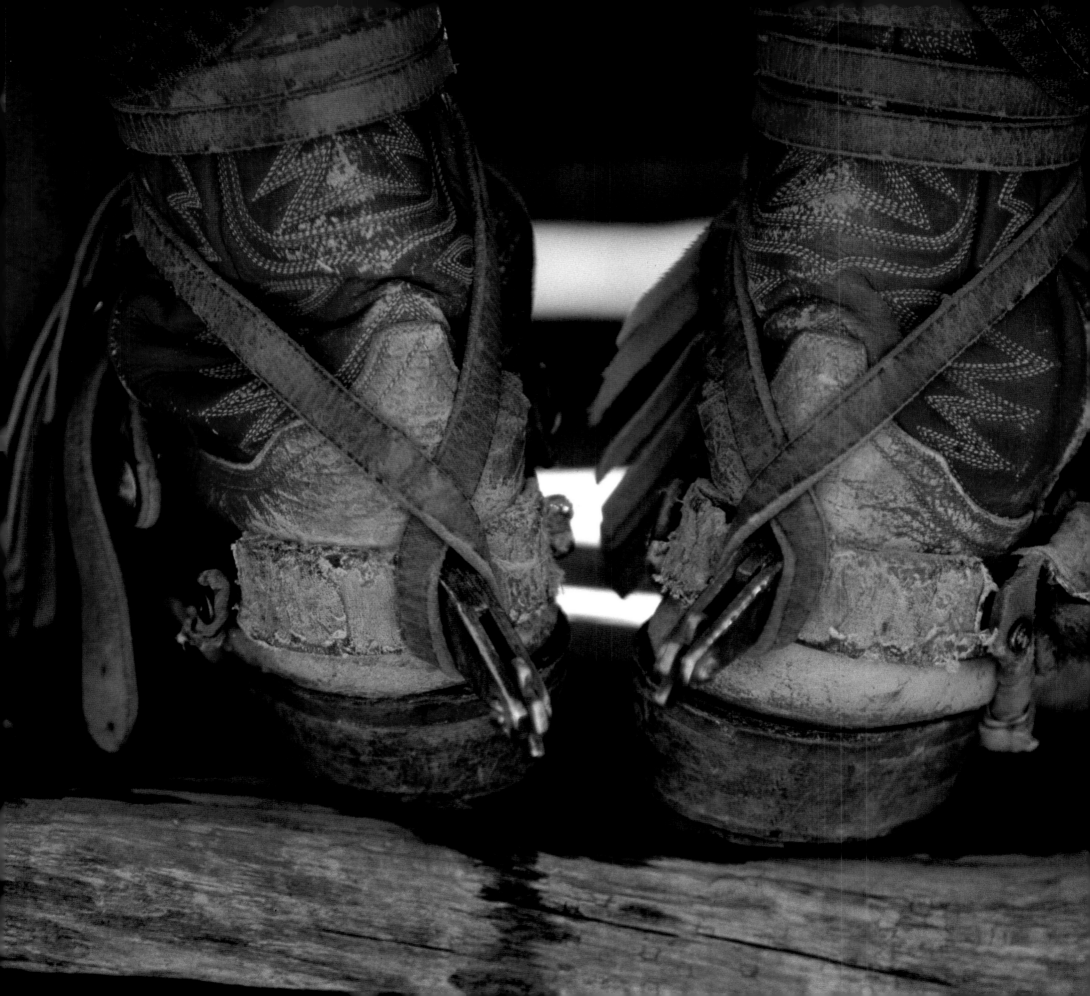

LOTS OF HOURS, LOTS OF MILES

Million-dollar cowboy Lewis Feild talks about the sport of rodeo.

Rodeoing is my way to carry on my family's tradition. I come from a ranching background, and it's been my heritage all my life. I think rodeo is a way to show the world what the West was like, and in certain cases what the West is still like. Rodeo is a means to carry the ranching tradition to the cities where people don't have the opportunity to get on a ranch and see what really goes on there.

I started riding calves at the Oakley, Utah Fourth of July rodeo when I was seven years old. They'd have a junior rodeo with calf riding, but I'd ride at home on the farm too. I'd ride the calves, sheep, pigs, anything I could crawl on.

I started rodeoing seriously in high school. I remember working on a mink farm after school for 35 cents an hour to earn enough money to buy a pair of spurs for riding bulls. After high school, I went to college and competed in intercollegiate rodeos. In the summertime I entered a few amateur and open rodeos around Utah and Idaho.

Rodeo is probably the most individualistic sport in the world. If a world champion tennis player walks onto the court, it doesn't matter who he's going to play tennis with that day. It's all up to him. But a rodeo cowboy goes into the arena and he still has to draw the right animal. A champion has no advantage whatsoever over the worst guy on the circuit.

There's danger at a rodeo, but there's probably more injuries at the lower, non-professional level than there is in professional rodeo because those guys at the top are pro athletes. They know what they are doing. But rodeo is physically demanding.

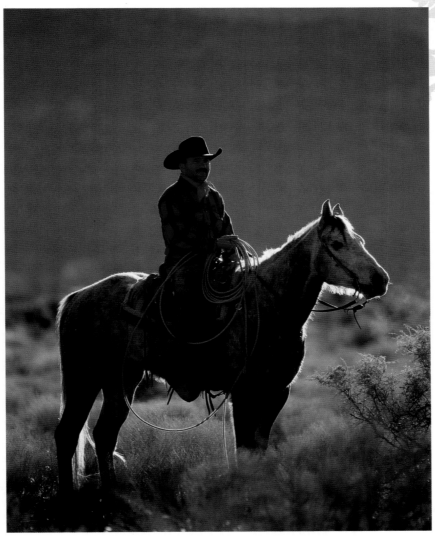

Lewis Feild

There's guys who get hurt all the time. In my career I never did get hurt badly enough to where I couldn't compete. I had some cracked ribs and maybe some little bones broken in my hand, stuff like that, but nothing like torn up knees.

During the summer when I was in college I'd work a part-time job and go rodeoing on the weekends. I turned professional when I was 23. That's kind of old. Most guys, if they become successful, turn pro right out of college when they are 20 or 21. I was pretty dominant in the amateur rodeos. Then a guy named Duane Sorenson actually gave me a handful of $100 bills and told me to go to the Denver rodeo and not come back until the Houston rodeo was over. That was my rookie year when I won Rookie of the Year in bareback riding.

To be a champion in rodeo there's not room for many mistakes. In a year's time you'll probably compete on 150 animals, maybe 200 counting the National Finals. With that many animals you don't have room to screw up.

I didn't make it to the National Finals that year, but I think I would have if I had gone to a few more rodeos. It wasn't my goal at the time. I just went and I made money and was comfortable with what I was doing. But I could see that if I kept it up, I could probably make the National Finals the next year. So I competed and made it from 1981 to 1991, for 11 consecutive seasons. In the meantime, I won the World Champion All-Around Cowboy in 1985, 1986 and 1987. I won the World Champion Bareback Rider in 1985 and 1986. I won the Bill Linderman Award, which is for work-

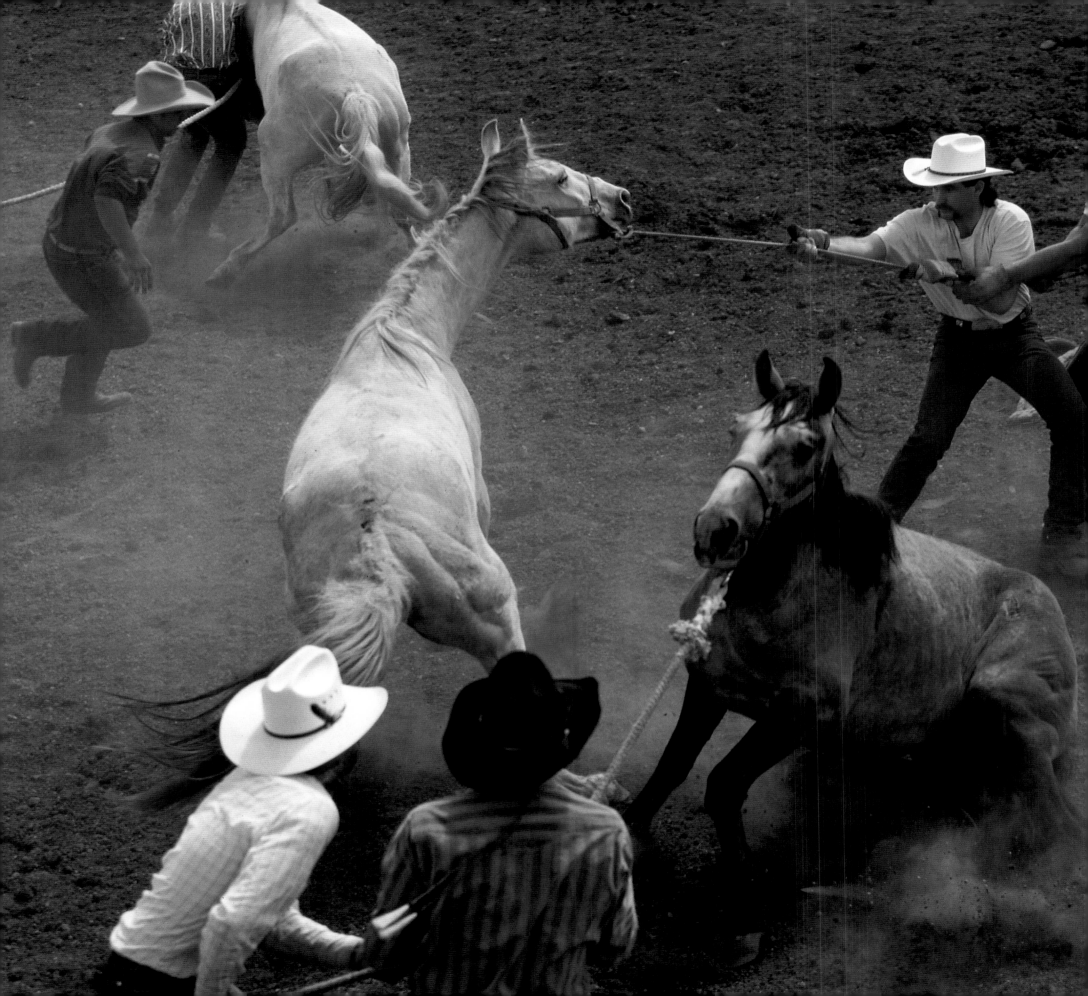

ing three events or more, a thousand minimum in each event, and they have to be a combination of timed events and roughstock events. It's a very coveted award, and I won it three times.

I retired in 1991 when I was 35, the third cowboy to go over the $1 million mark in lifetime professional earnings, and I was the first one in rough stock to do that. I was inducted into the Denver Hall of Fame, and the Pro Rodeo Cowboy Hall of Champions in Colorado Springs a year after I retired.

Rodeo is an individual sport. I mean, baseball or some of the other sports are individual to a point, but you're on your own in the rodeo arena before, during, and after the event. You pay to ride and if you win you get paid. If you don't win you don't get anything. You know you have got to be at your best or better at that particular moment if you're going to win first, but you're not thinking about your score. You're just concentrating on your technique and style and the way you are riding, trying to not make any mistakes. You try to be in total control while at the same time almost looking like you're on the edge of being out of control.

Rodeo cowboys have to be as fit as a football player or basketball player. To compete on that level almost daily, riding a bareback or a saddle bronc or a bull, your body takes an awful beating. Everybody has their own style or technique for getting in shape. In my case, flexibility was the key to staying fit, staying where I didn't get hurt all the time.

I think there's a difference between a rodeo cowboy and a ranch cowboy. It used to be the rodeo cowboys were also ranch cowboys. The guy could go out and move a bunch of cattle to the next pasture or the next canyon, and there are still a lot of cowboys who can do that. But there are probably fewer ranch cowboys who are rodeoing these days, because there are fewer ranches.

Now there's rodeo schools around the country, where guys learn how to ride bulls or broncs. Instead of learning how to do these things on the ranch, they're learning how to do these things in rodeo schools. But they're still rodeo cowboys and they're very good at what they do. Maybe some of them couldn't go out and move cattle or fix the fence, some of the things a ranch cow-

boy has to do, but they're in tune with the competition of the rodeo arena.

Most of all, rodeo is people, good people. They are Western people who have a lot of respect for the land, the animals on it, and their neighbors who live and work there.

Bronc Rider
Mackay Rodeo; Mackay, Idaho

Wild Horse Race
Mackay, Idaho

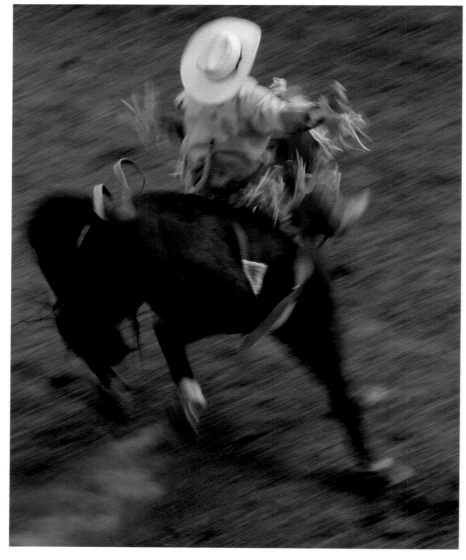

Mackay Rodeo
Mackay, Idaho

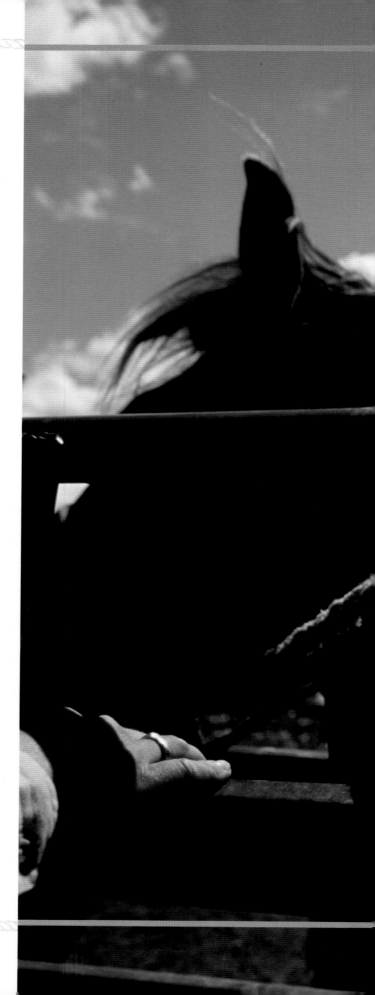

Mackay Rodeo
Mackay, Idaho

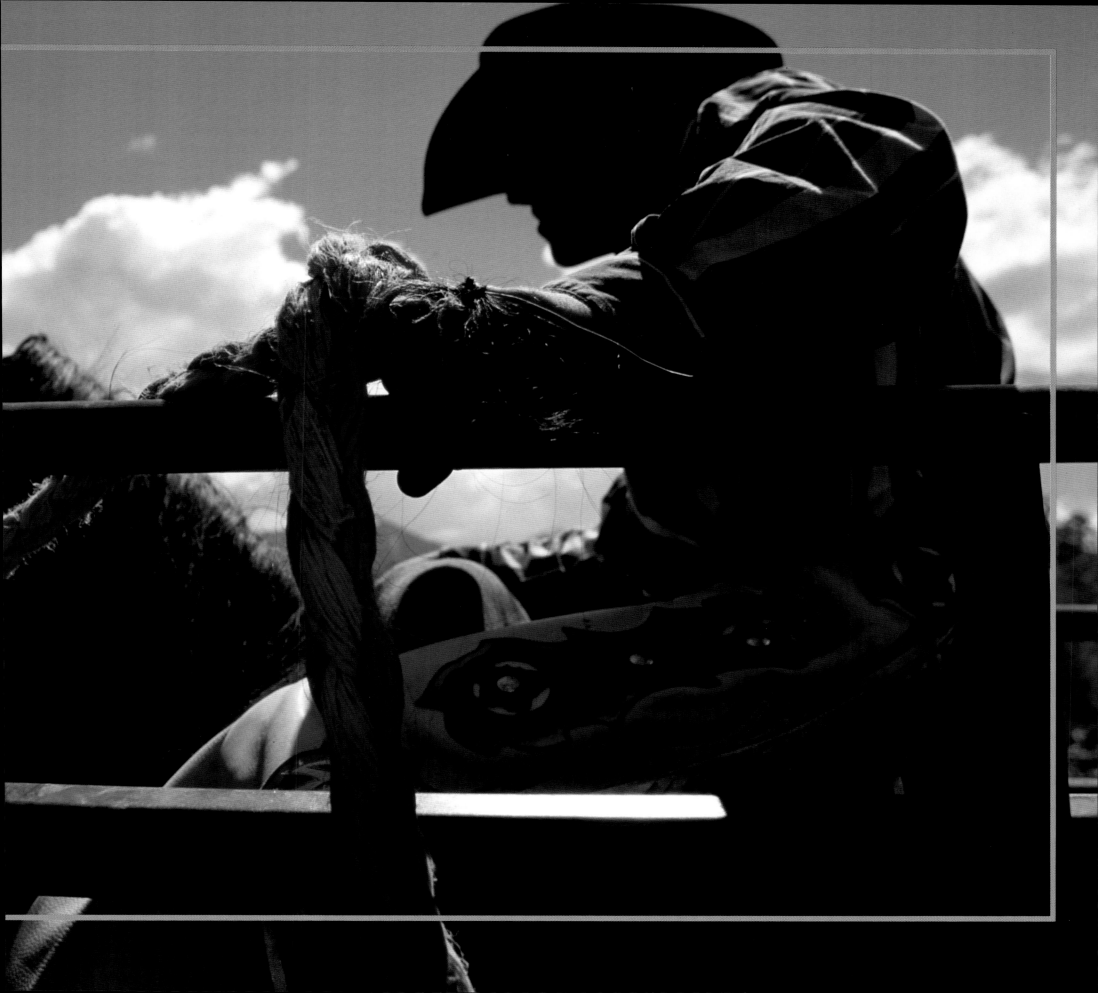

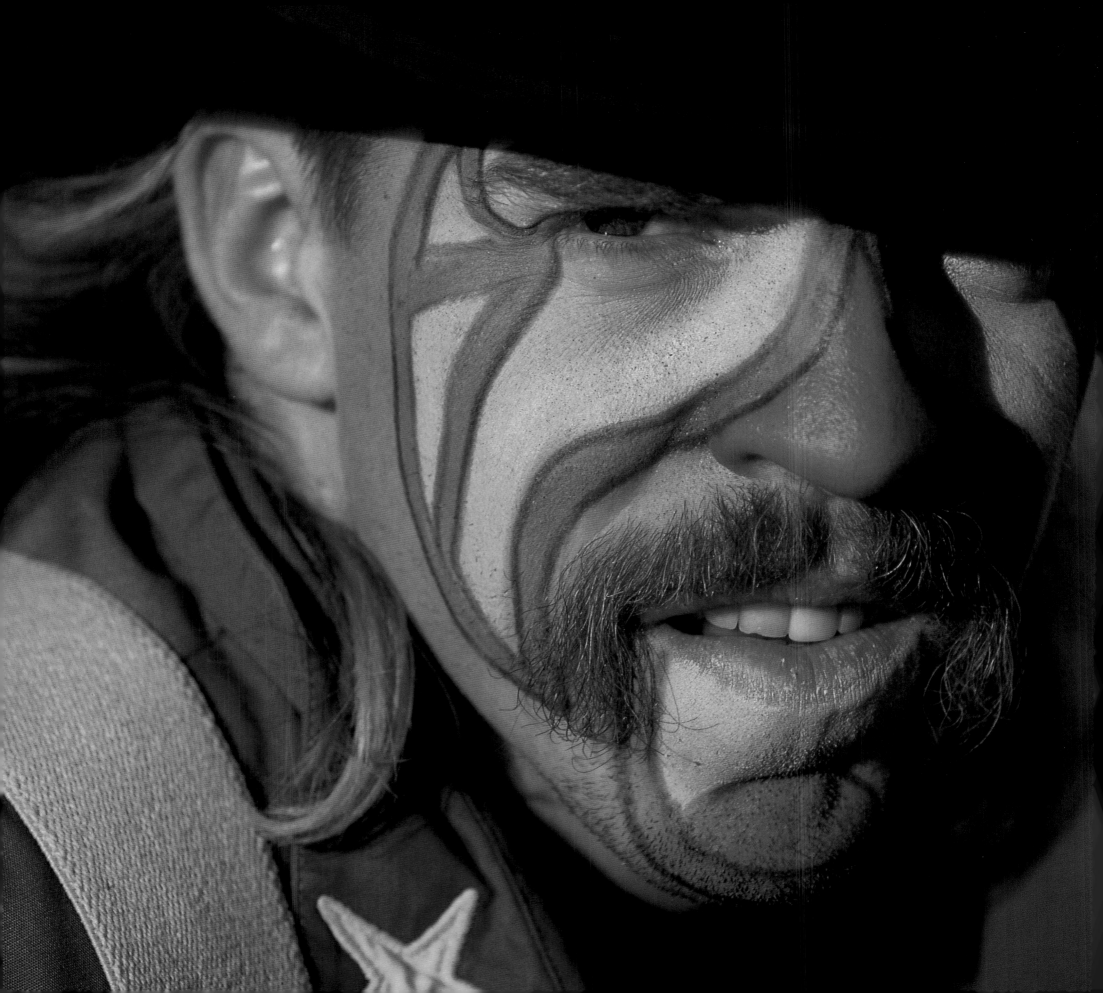

★ THE ★ BULLFIGHTER

The bullfighter's job is to make sure the bull rider makes it to the next rodeo

Everybody thinks the rodeo clown is the guy who protects the cowboy from the bull, but that's the job of the bullfighter. The rodeo clown is the guy in the barrel or who maybe does the dog act or entertains the crowd between events. The bullfighter is the guy who's putting his body between the bull and the cowboy to protect the cowboy after his competition.

When there are bulls in the arena, the bullfighter is out there with a specific duty. He's the one who's going to protect the cowboy from the bull after the cowboy gets bucked off or gets off the bull voluntarily. The bullfighter takes the bull's attention away from the cowboy so that the cowboy can get away.

It would be hard to have bull riding without the bullfighter. If they weren't there, there wouldn't be many guys wanting to ride bulls. The riders know that there are lots of times when they get done riding the bull that they are going to get chased. The bullfighter saves the cowboy from getting mauled, saves him from getting banged around. There have been guys that got killed riding bulls, but there are a lot more times when the bullfighter saved the rider from getting killed.

Bullfighters are very good athletes. They are good on their feet. They have the instinct to know in what direction the bull is going and what they've got to do to physically get their body between the bull and the rider in order to keep the bull's attention and give the rider enough time to get to his feet and get up a fence or something.

Some bullfighters are showmen who entertain the crowd and do some funny stuff. Others are out there strictly for one thing and one thing only. There's even some who don't wear any makeup. They are not very much into the baggy pants.

It takes a lot of people to put on a successful rodeo, to make it work the way it should. The bullfighter is as much a part of the competition as anybody.

— Lewis Feild

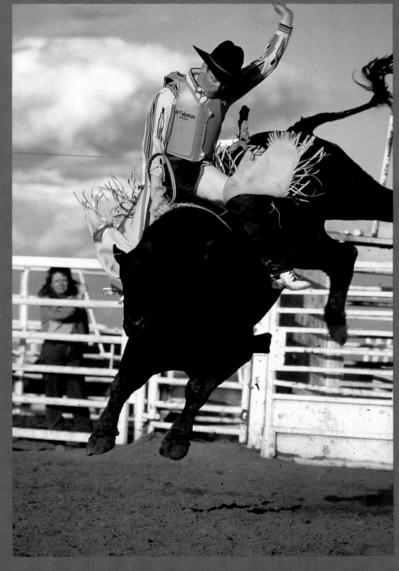

Bullrider Kelly Crystal; Goodyear, Arizona

Hollywood Don Yates
Bull Fighter; Phoenix, Arizona

I CAN TELL BY YOUR HAT WHERE YOU'RE FROM

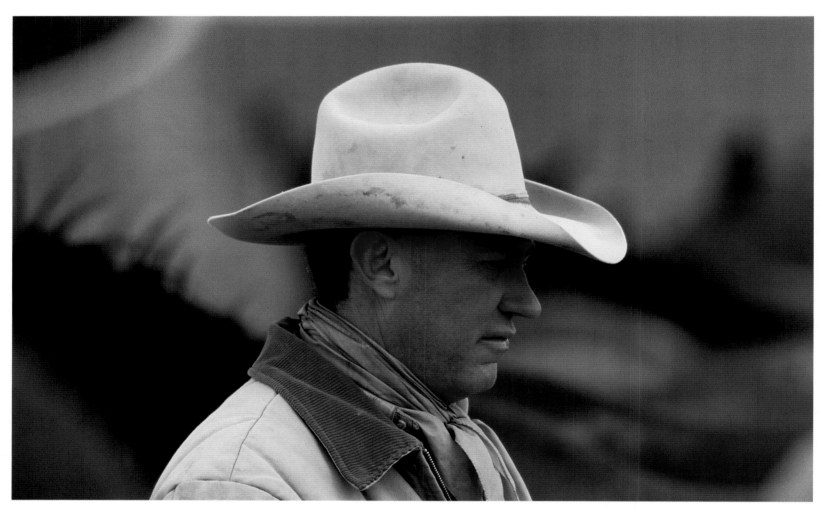

Lynn Bette has worked in Nevada for many years, but he still wears the hat of the Lone Star State, where he spent most of his young life.

Curt Pate; Helena, Montana

Woody Harney; Owyhee, Nevada

Bo Wilson; Weatherford, Texas

Ricky Link; Owens Valley, California

"If you're sleeping on the ground the first thing a man does when he rolls out of his bed roll is put his boots on. 'Cause you don't know what you're gonna be standing on. So you get your feet put on first and then you reach down and put your hat on. And you really don't worry too much what's in the middle—as long as you got a hat and a good pair of boots, you're pretty well fixed. I've seen 'em run around in just their long handles and their hats and their boots."
—Tom B. Saunders IV

Steve Schroder
Dragging Y Ranch; Grant, Montana

andy Rutledge
ack Canyon City, Arizona

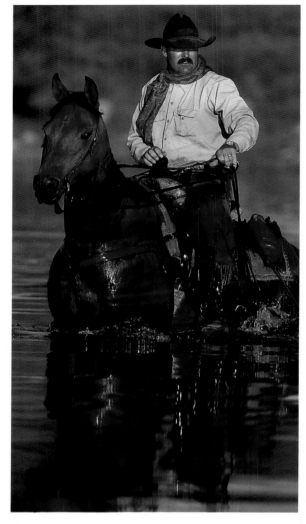

Perry Williams
Perry Williams, Saunders VV Ranch; Weatherford, Texas

Mickey Young
Jerome, Idaho

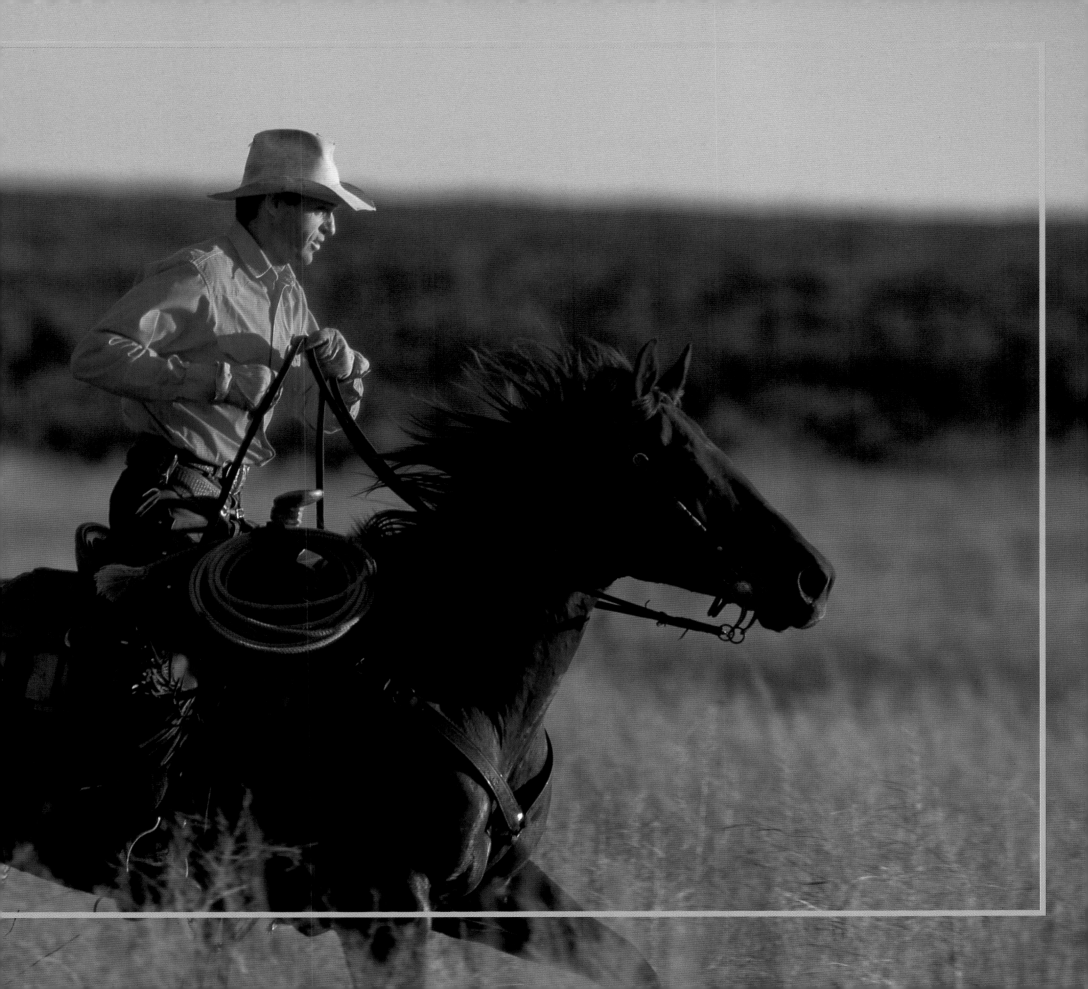

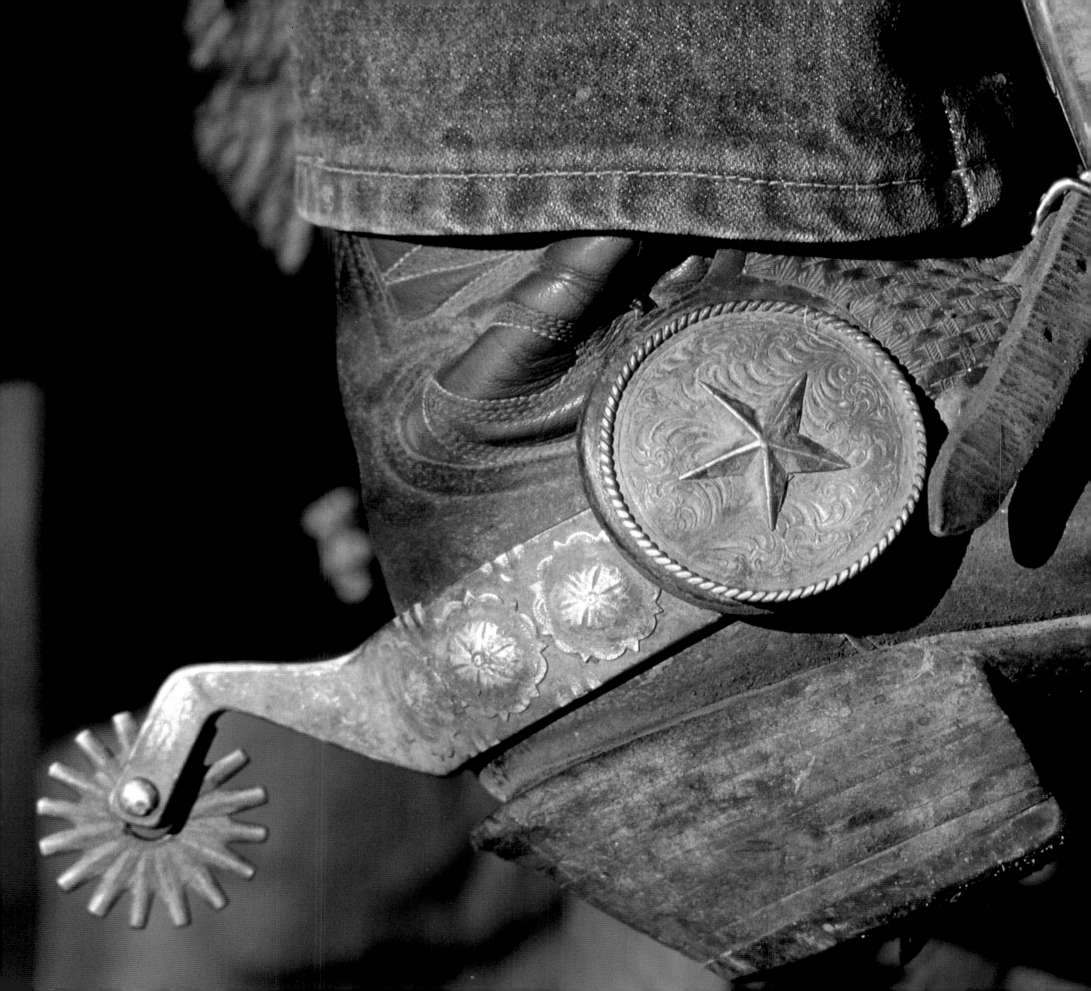

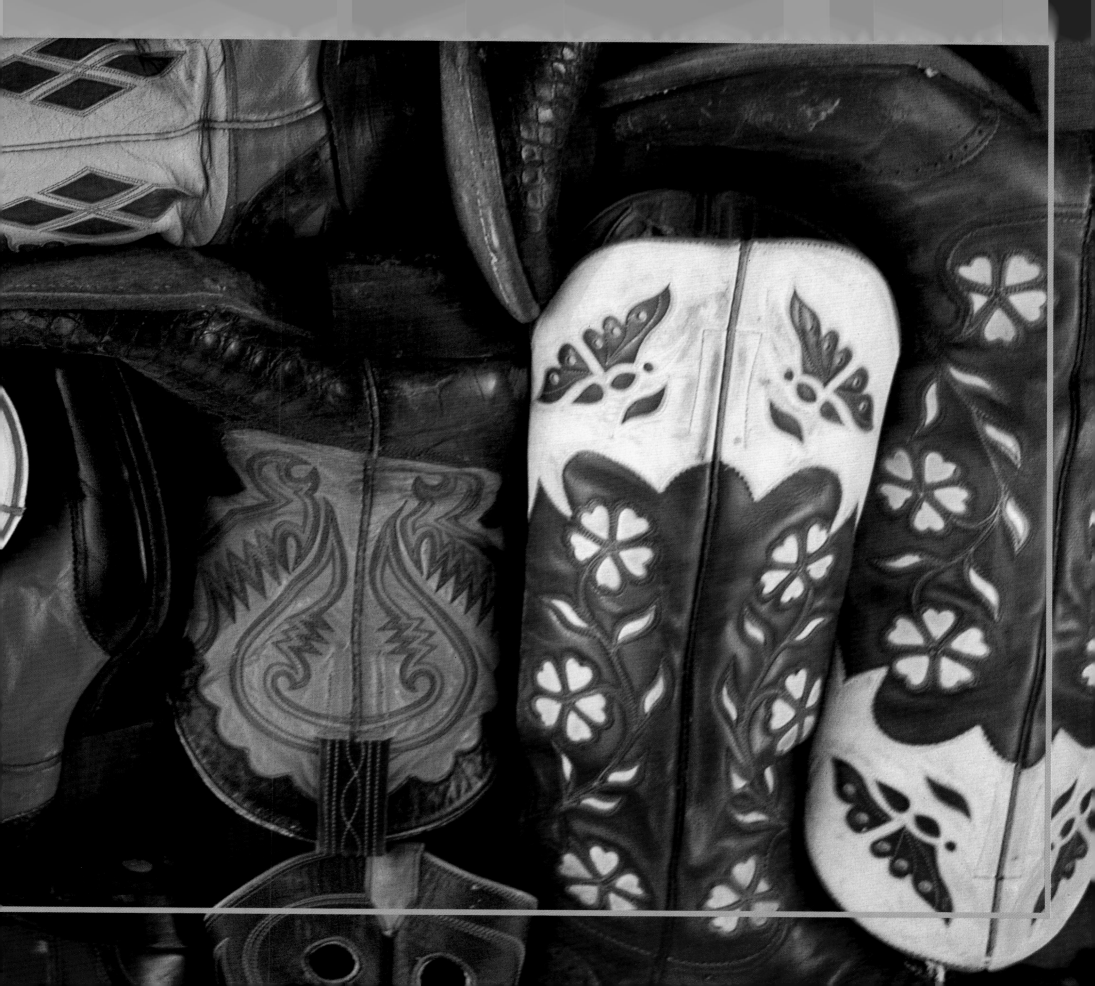

COWBOY BOOTS

By Tom B. Saunders IV

Anybody that's ever ridden a horse with flat heels on, or Reeboks, knows your foot can slip through the stirrup. And probably the biggest fear a cowboy has is to hang from a horse. If you get under a horse, he can kick your head off or drag you to death or whatever. So that's the reason for the big heels on boots—to keep your feet from going through a stirrup. The boots were really never made for walking. A cowboy never would get off if he could help it, and they were little bitty spiked heel boots. Nowadays we have what they call walking heel boots, 'cause we get down and do a lot of work afoot in the pen and so forth. On this ranch, we try to work everything on horseback. Of course, in Texas, we usually wear our britches inside our boots, because it just helps protect your legs from the brush.

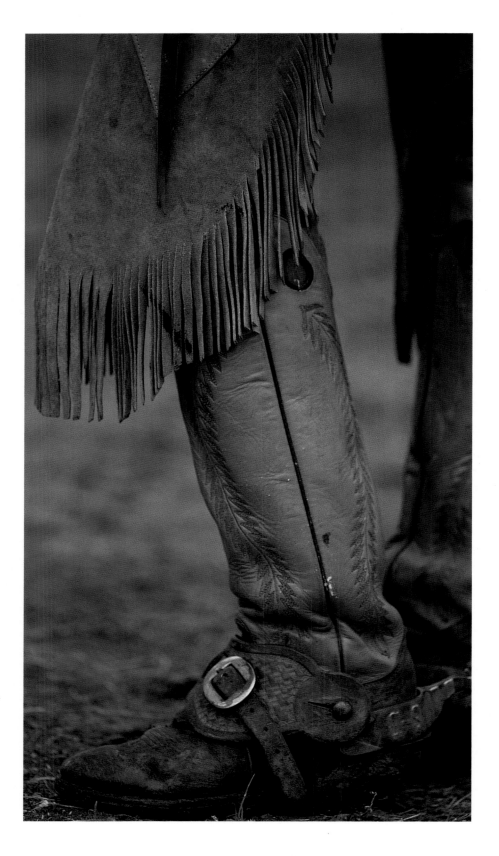

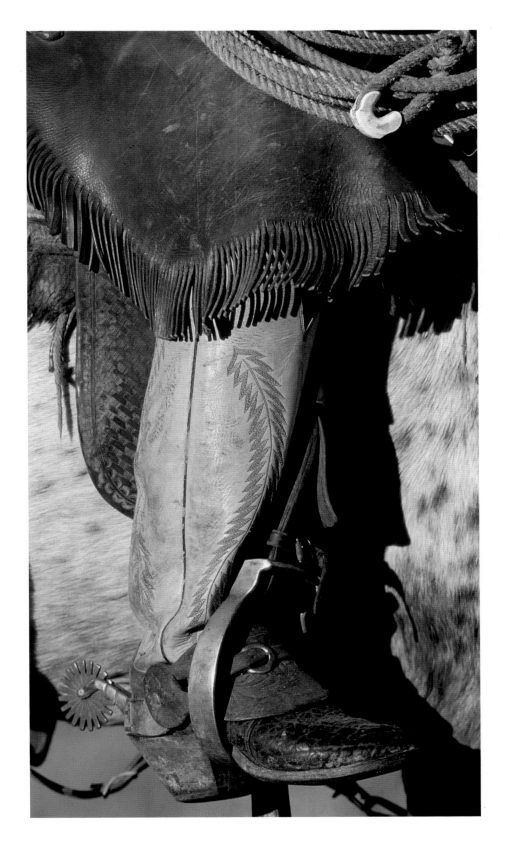

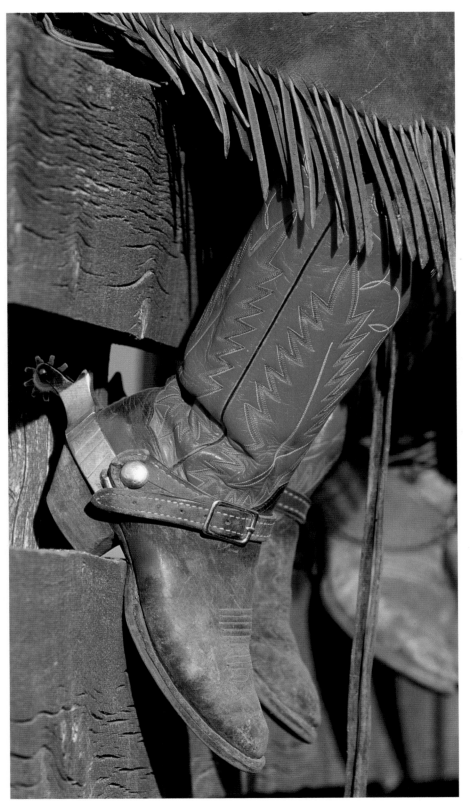

Horse trailers are built to fit the geography that they travel in, but they seem to take on the personality of their owners, just the way dogs seem to.

—David R. Stoecklein

Wagonmaster

Sold to 1879

Ben Howard
Challis, Idaho

"Put the ranch house down by some sycamore trees
so I can lay in the shade and take my ease."

—The far, far west

I'm just living through the winter
To enjoy the coming change
For there is no place so homelike
As a cow camp on the range.

—A Cow Camp on the Range

Jim & Diane Brown's Bar Y Ranch;
Jackson Hole, Wyoming

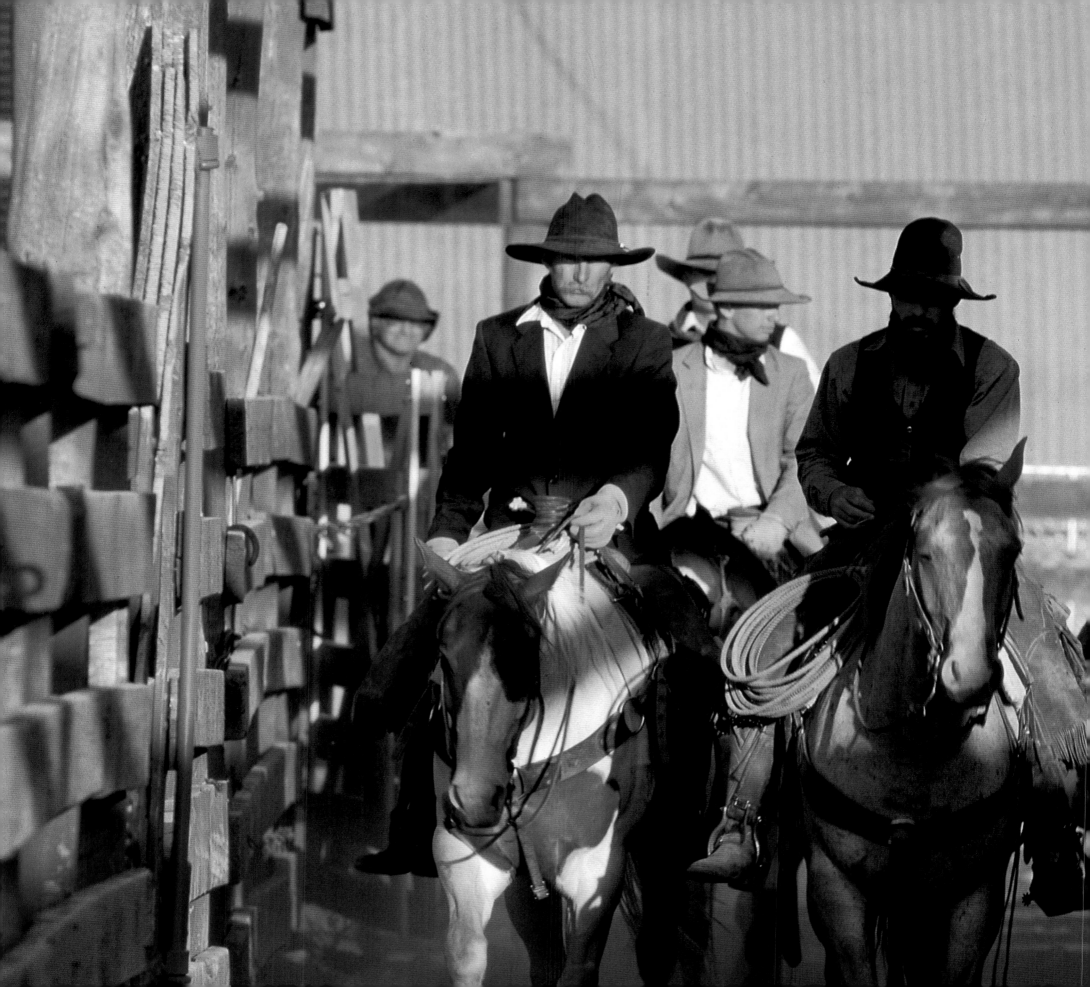

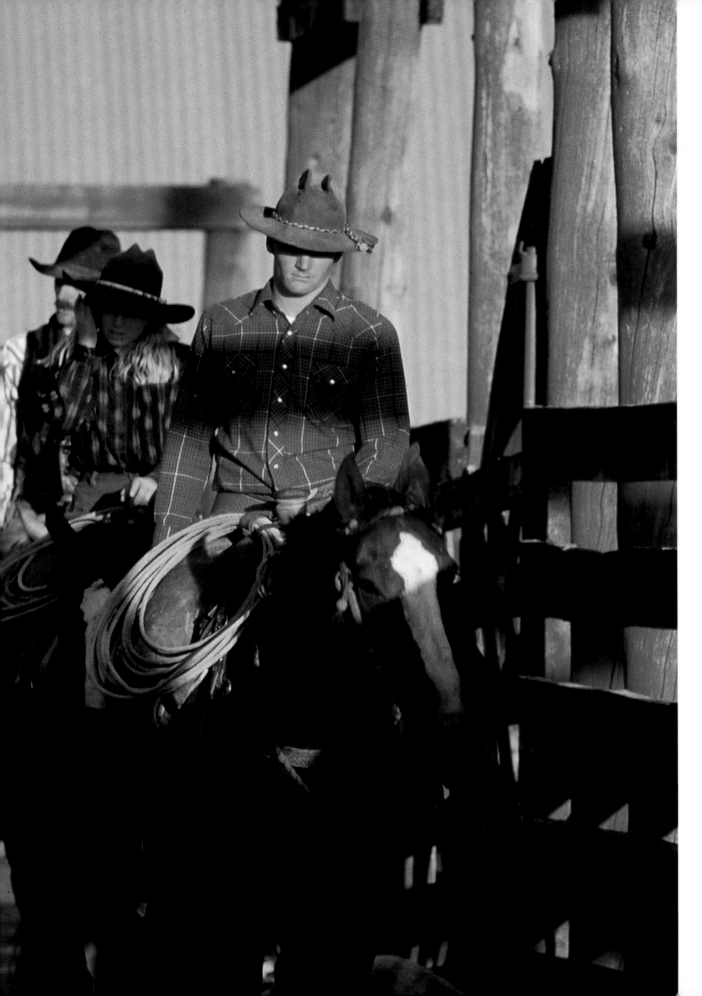

RIDING FOR THE BRAND

Herb Mink recommends
that you do what you do what you're told

I grew up quick and didn't get a hell of a lot of help or sympathy from anyone. But I worked for the brand all the time. If you're going to work for the man who writes the check there's two things you can do. You can do what he says, or you can quit. If he says tie a rock around every cow's neck and hurl it off the tough end of the Snake River, you work at it just as hard as if you was trying to put all the meat on those cows you could.

Riding for the brand is important. You stick up for the outfit you work for. Even if you know the boss is wrong, you stick up for him. You might tell him one-on-one that you think he's wrong, but you don't run to the neighbor, to the pool hall, and tell everybody what a no-good son-of-a-bitch your boss is.

To me, sticking up for the outfit and giving a day's work for a day's pay is just about the most important thing a cowboy can do.

The crew at the Dragging Y Ranch;
Grant, Montana

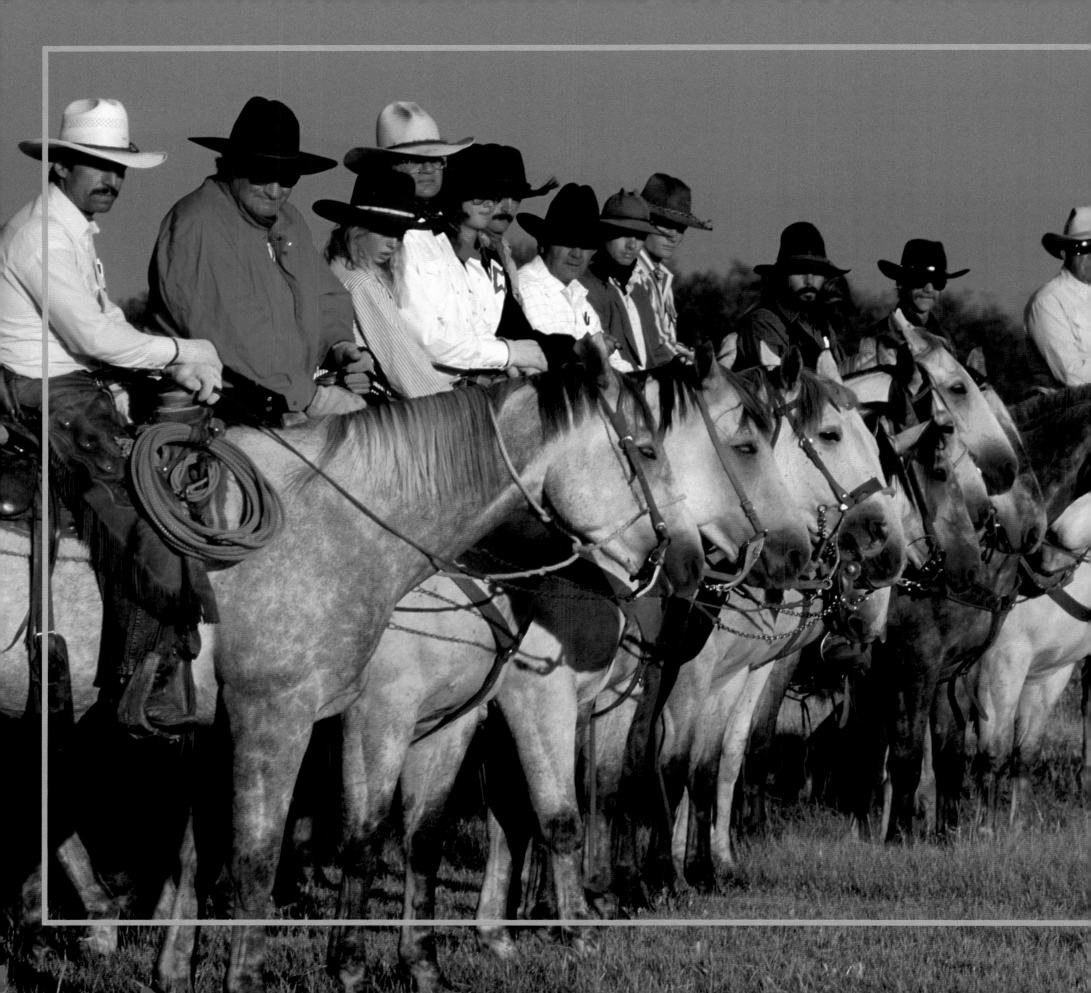

Horse Brand
Dragging Y Ranch; Grant, Montana

Lining Up
Luis Velasco, Joe Foster, Tyla Schroder, Roger Peters, Tracy Peters,
Richard McKay, John Emery, Marc Telford, Chad Williams,
Bruce Matthies, Judy Matthies, Dow Keyes, Carl Holt, and
Steve Schroder; on the Dragging Y Ranch; Grant, Montana

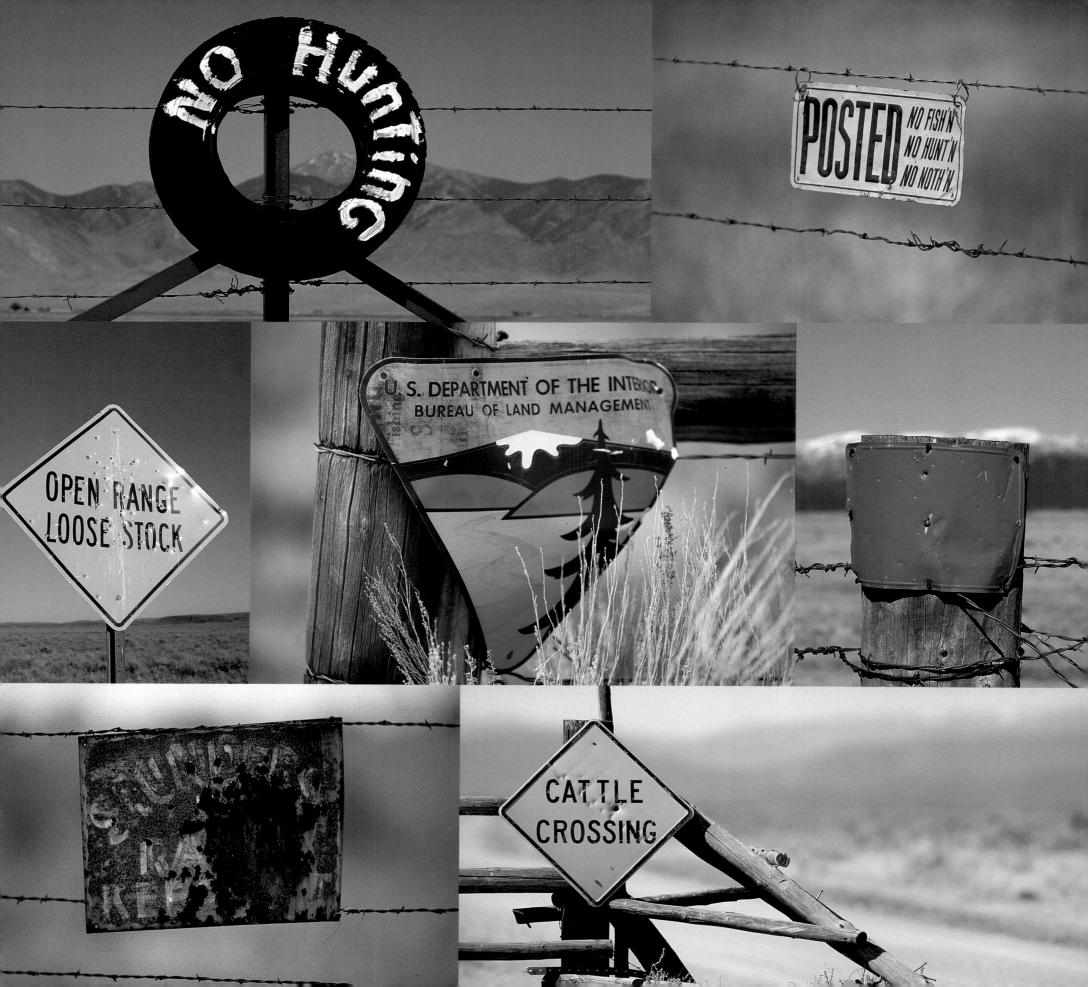

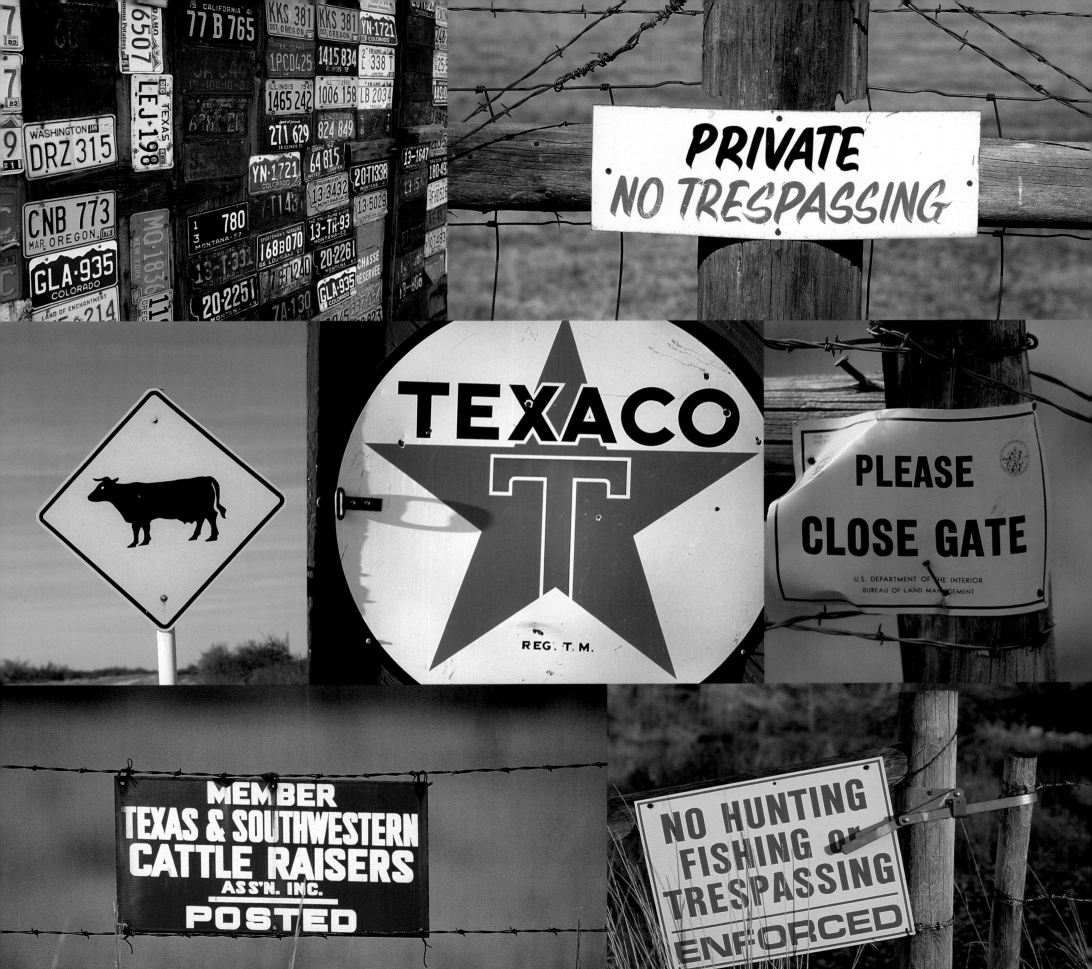

WINTER IN THE HIGH COUNTRY

Darrell Leavitt can tell you just how quickly 35 below can take the romance out of being a cowboy.

I can tell you how it used to be in the fall of the year, back in the '30s and '40s, when we had to go in and ride and didn't have no transportation. There were two rides in the fall. One was in September when they would bring in the beef and everything that anybody wanted. Then in November they had what they called the "last ride." At that time we could stay out gathering cattle until about the 15th of November.

On the last ride, we would go in around the 1st of November. Some years you could do the riding pretty near in your shirtsleeves. But some years we was over there when it got 35 and 40 below, and wound up in two feet of snow. We would ride out of camp, and if we found any cows

Darrell Leavitt, Bar Horseshoe Ranch; Mackay, Idaho

we had to stay with them until we got them back where we could pick them up the next day, or else head them over the mountains for home.

Sometimes it was a mighty long day. We would leave camp when she was 25 to 30 below in the mornings and knew it was kind of tough going. If it was foggy or stormy, we never rode because you couldn't see whether you found cows or not. You could ride right by them, and if you didn't find tracks, why, you would miss them. If it cleared up, then we had to ride.

The last ride was always the coldest. There would be 15 or 20 guys in there; sometimes there would be only 10 or 12. We'd eat in the big cookshack that they had over there, and we slept in the bunkhouses. Quite a few times we would come to the cookshack and eat our meals with all our gear on—our chaps and everything else. We put them on as soon as we got up. In the cookshack, we would get up next to the big fire and get our eggs and bacon, or whatever they had, but then we'd have to go back and sit down to eat. Some of the guys ate with their mittens on, but I never could enjoy my meal that way.

We would ride the whole country, all the basin. It all had to be rode. One of the rides I can tell you about was going from the West Fork cow camp to Antelope Summit, and riding that country. That was a long ride. I don't know how far it is from camp, but

it is 10 miles or so across that flat. It might be more than that.

In the later years we had trucks that softened that up, but in early days you had to ride it all. Then there were times that you rode off into what they call Cherry Creek, a canyon where there have been cows at that time of the year. We found them clear down in there. You didn't know if they were yours, but you had to go down in there and get them out.

I have been up there on Antelope Summit, and all the way along that ridge, when the wind was blowing so hard it had blown the snow all off and it was picking up little sand and stuff and slinging it in your face. The wind always blew up there. To me, that was one of the worst rides there was. You could almost figure even if you didn't find cows you was going to be after dark getting back from there.

And we didn't have real good clothes. I can remember one time I went in there on the last ride and it really got cold. My cowboy boots was a little bit tight. I had overshoes, of course, but because those boots were so tight I froze some of my toes. After that, when I started riding, I left my boots at camp and I wrapped my feet in socks and some extra shirts and rode that way. No cowboy boots. I wore the rubber overshoes. My toes were sore from where they had been froze and I didn't want to freeze them any worse. Those shirts and overshoes kept me warmer than my boots did.

About the worst I can remember was when me and Grant Zollinger took that ride. Grant was a pretty tough cowboy, one of the toughest guys I rode with as far as standing the weather. Him and I took that ride, and on the pass you had to ride down and if you didn't see any tracks down there, or stock, well, you were all right. But this time we did. We had to go about two-thirds of the way down in what they call Cherry Creek, another canyon there.

When we got down to where those cows were, they weren't ours. But there was probably a foot of snow or more and we couldn't leave them there at that time of the year. We didn't make it back to camp that night until it was about 10 o'clock or later.

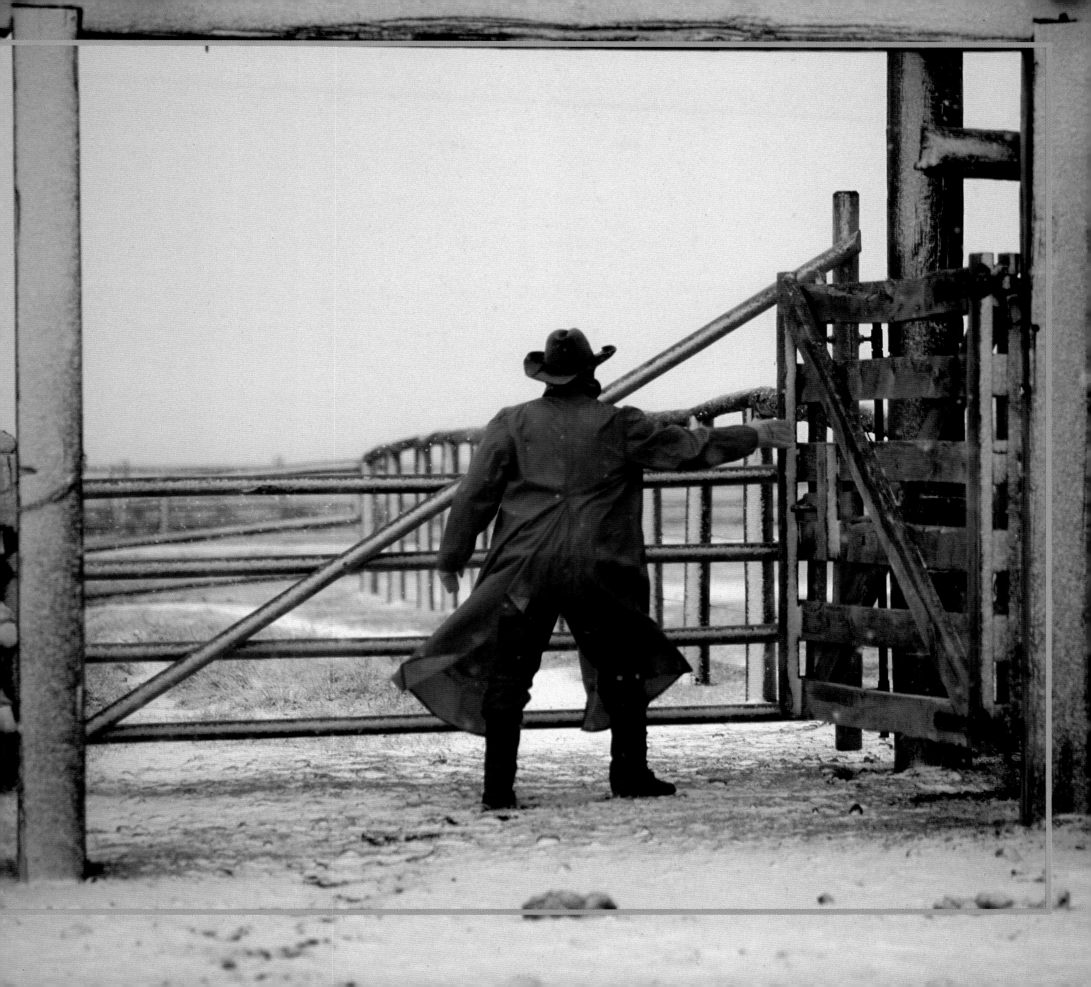

You would hunt all the bare spots you could find to get around there. When you hit those bare spots, I don't know how fast the wind was blowing, but it was blowing hard enough to slap that sand in your face.

In spite of it all, you didn't freeze. You just piled on all the clothes you had and hoped you could stay warm. If the snow wasn't too deep, you got off and walked when you could.

People like pictures of the snowy, blowy days, but it took the romance out of being a cowboy. It is just like going deer hunting and you get a buck way high in the mountains, a big one, too, and start out of there with him in about six inches of snow, in the dark. You have to get off your horse and crawl along to find the trail so you don't fall off into some wash. Well, when you get home from that you say, "That is the last time I am going deer hunting." The same way with cowboying. You take a day like Grant and I had that time, when we got back to camp we both felt that that would be the last day we would ever ride. But we knew better than that, because we had to stay there and do it. But that was a rough day.

You have those bad days, and that is what really makes you enjoy the good ones when they come along. It seems like every time I go anywhere, even as long as I have been in this country, I still see stuff that is interesting and wonder why I didn't notice it before. Even after all these years, I don't know everything there is to know about this country yet.

As bad as it was sometimes, those roundups were the only vacation we got back then. When I was on the Stacey place down there, that was the only time I ever got away from the ranch.

At the beef ride in September, they had a cook and a helper, and there would be anywhere from 25 cowboys in there up to, oh, I've been in there a time or two when there was 60 riders. They were mostly friends that came in to ride.

We would go out and do a certain part of the basin every day. The cow boss would send a couple of riders this way, and another couple that way, and they would just make a circle and bring everything in. Then they would cut out the beef, and a lot of bulls were cut out at that time. They would put them into a bunch and hold them, and then they would brand the calves. We would be in there seven or eight days branding.

At that time, a lot of guys didn't ever take the bulls out, so calves would be born year-round. They would be born after the cows went out in May, and most of the guys branded them when they could because a lot of times the calves got separated from their mothers coming out and then you had a doggie. You didn't know who the calf belonged to.

Out there, usually the first guy who found a doggie got to keep it. If you had that doggie where you could get him home, you took him. I gathered up some doggies back then.

Winter in the high country is kind of tough, but yet it is a beautiful time of the year up there. It changes the country so much. It's a great place to be if you don't have to spend too much time outside.

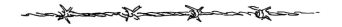

Winter Cowboy Boot, Idaho

When it's November, the days are pretty short and the nights are awfully long. It was so bad that a couple of magpies was staying with those cows. There was a bull in there that wasn't doing very good. I think those magpies figured that bull was going to die, and they followed us all the way out. The next day when we went to pick them cows up, those magpies were still there.

That was one of those days when the wind was whipping the sand up on top of that ridge. You had to ride around big drifts of snow if you couldn't get through them.

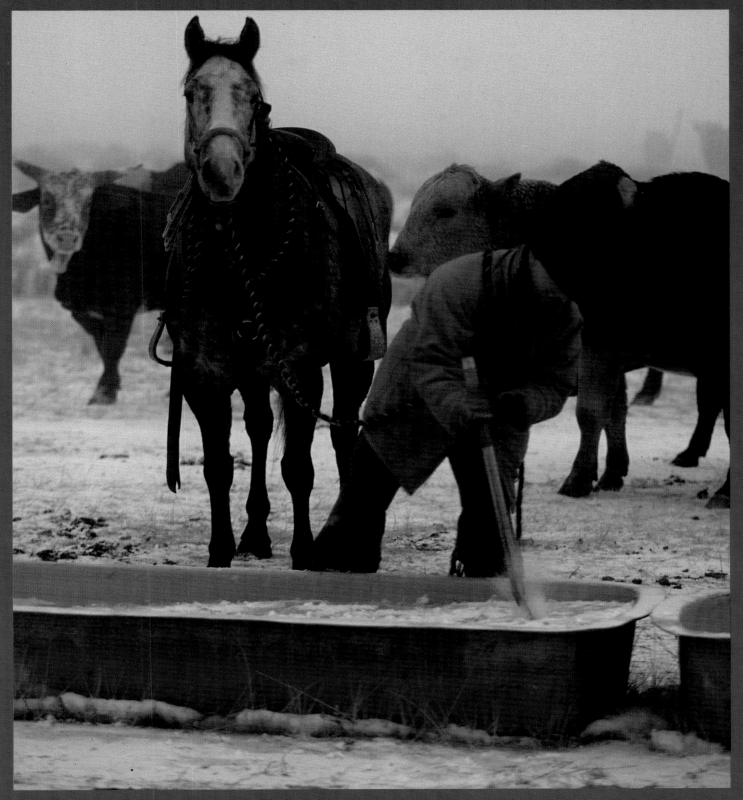

Breaking Ice
Mark Tylford, Hoggan Ranch; Dubois, Idaho

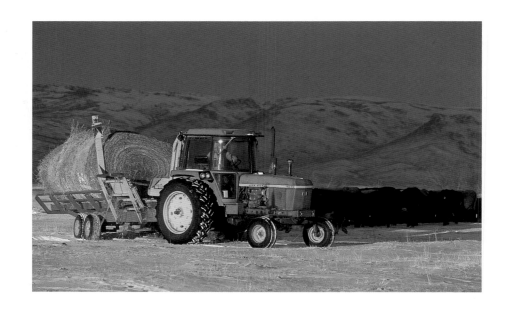

Brett Zollinger Winter Feeding
Zollinger Ranch; Mackay, Idaho

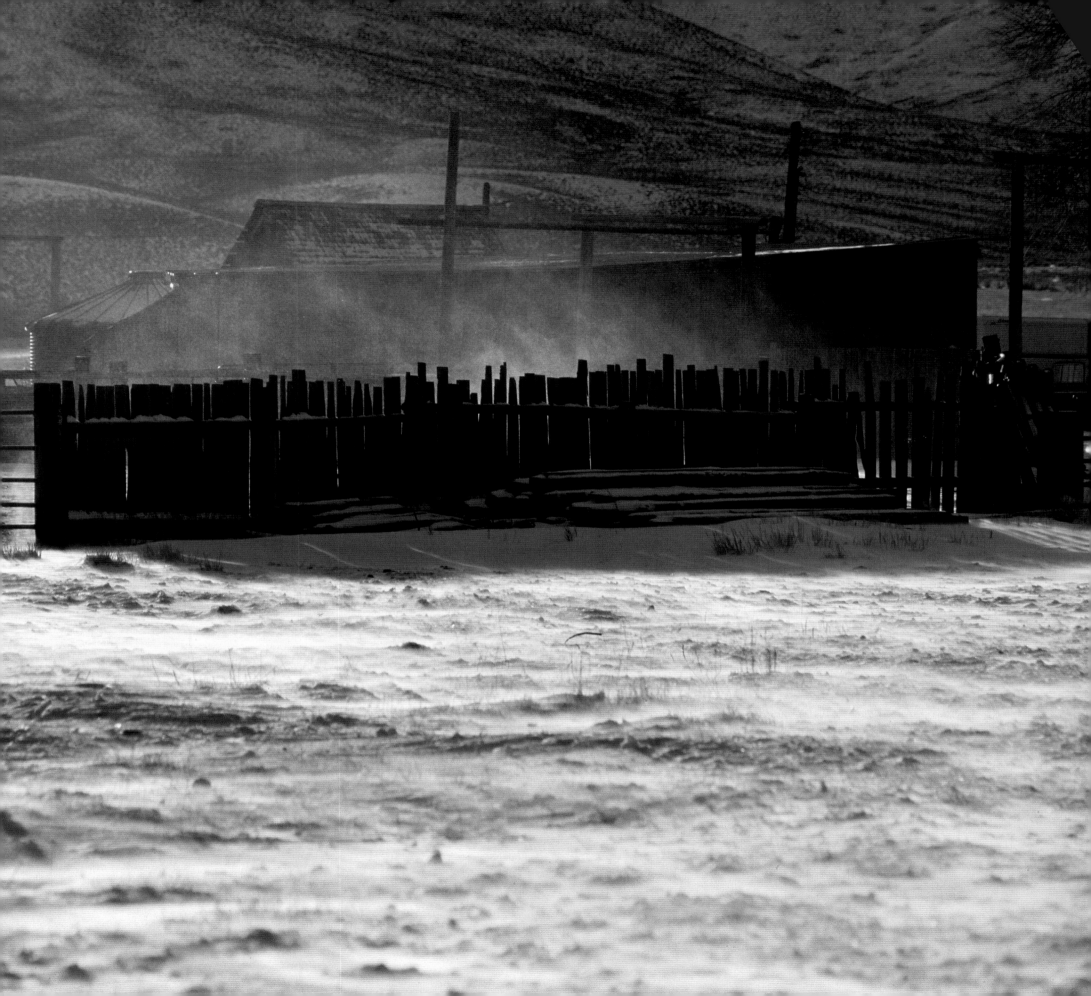

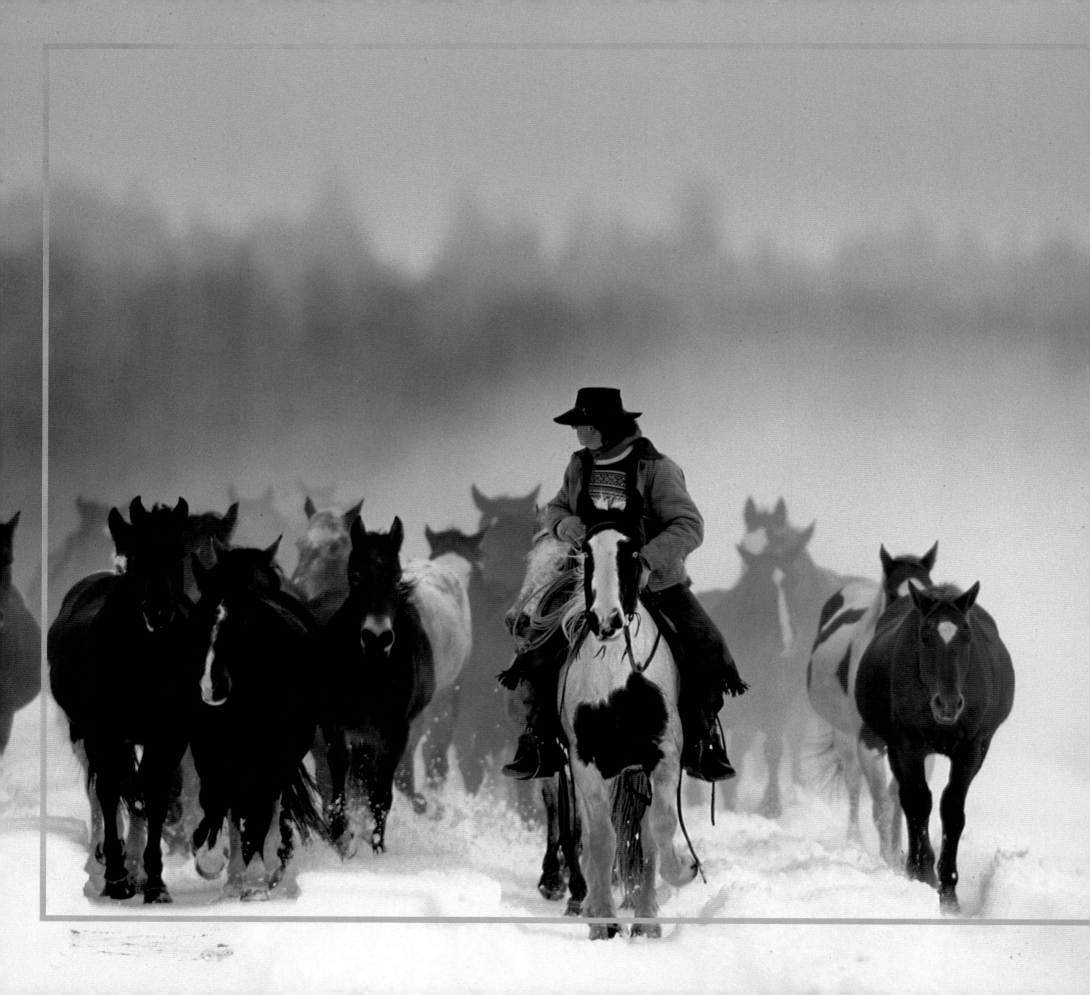

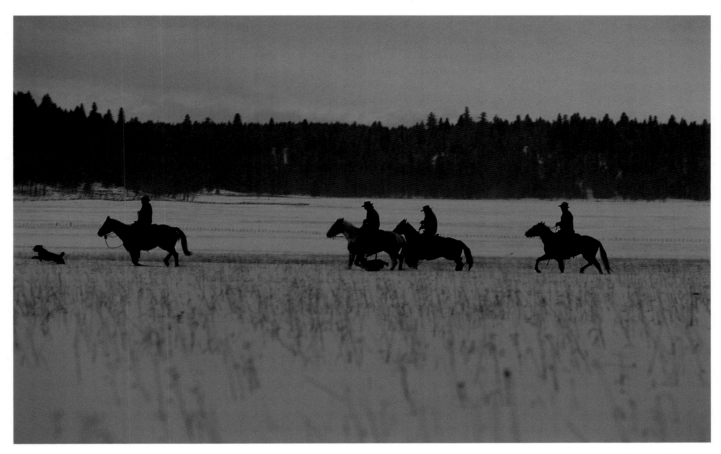

Winter Gathering
Jay Hoggan, Pat McGary, Steve Geisler, and Dan Locke on the Sheridan Ranch; Island Park, Idaho

Following pages: ***Sorting The Herd***
Sheridan Ranch; Island Park, Idaho

Winter Gathering
Dan Locke, Sheridan Ranch; Island Park, Idaho

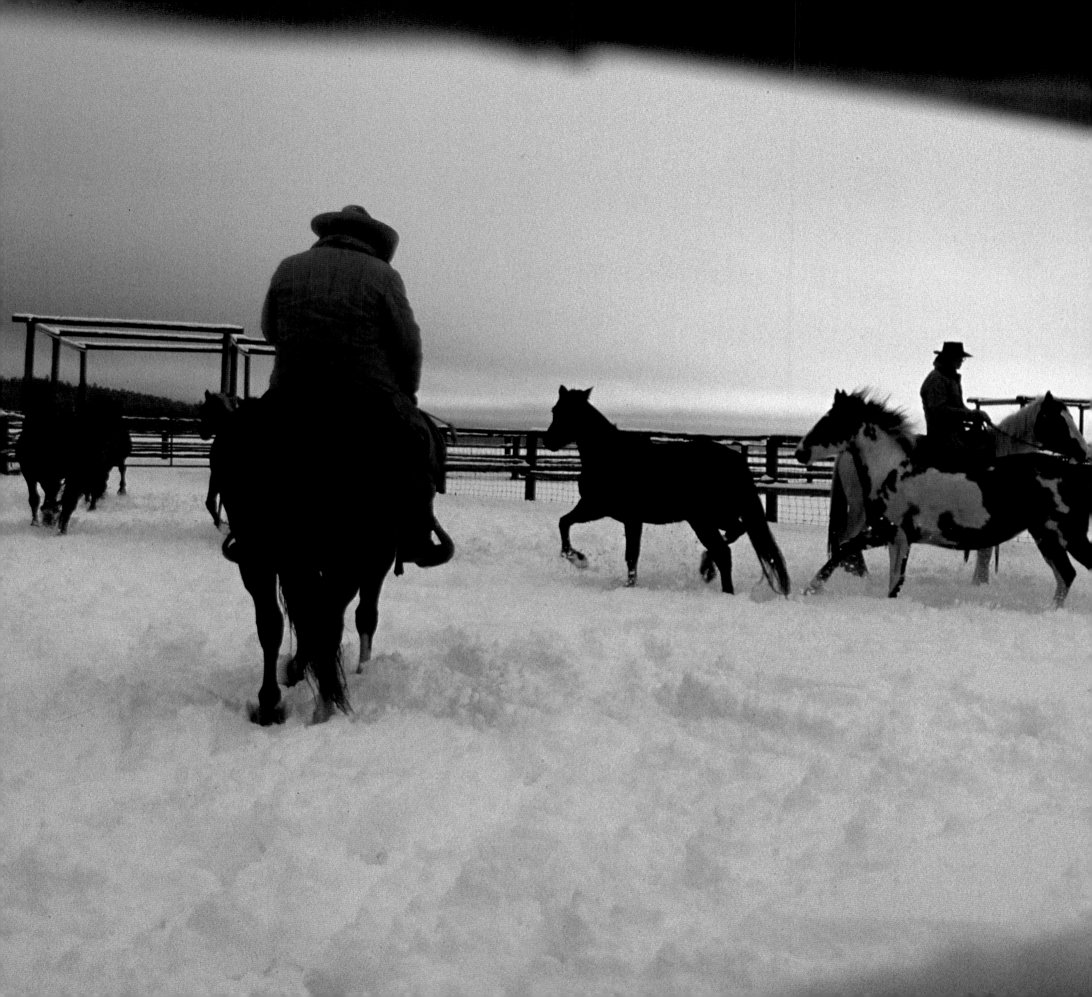

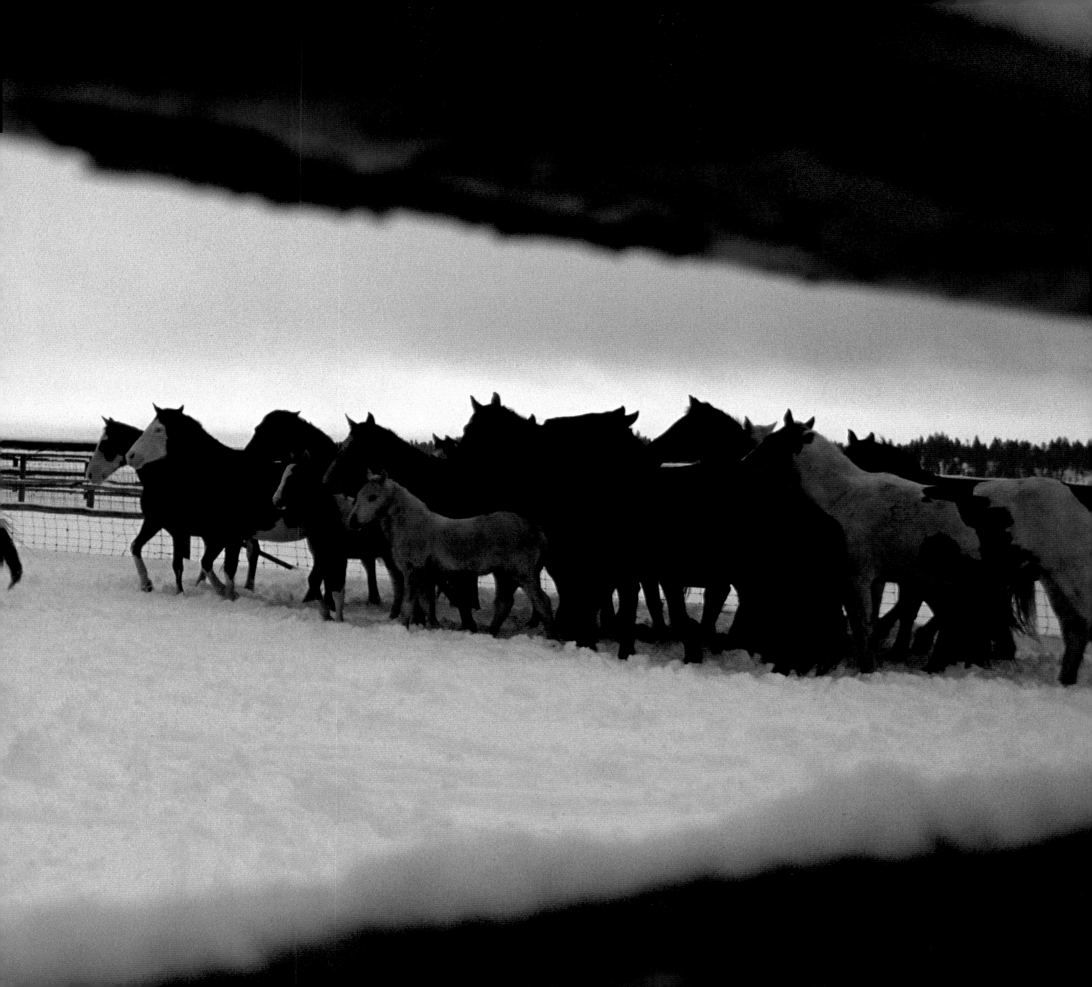

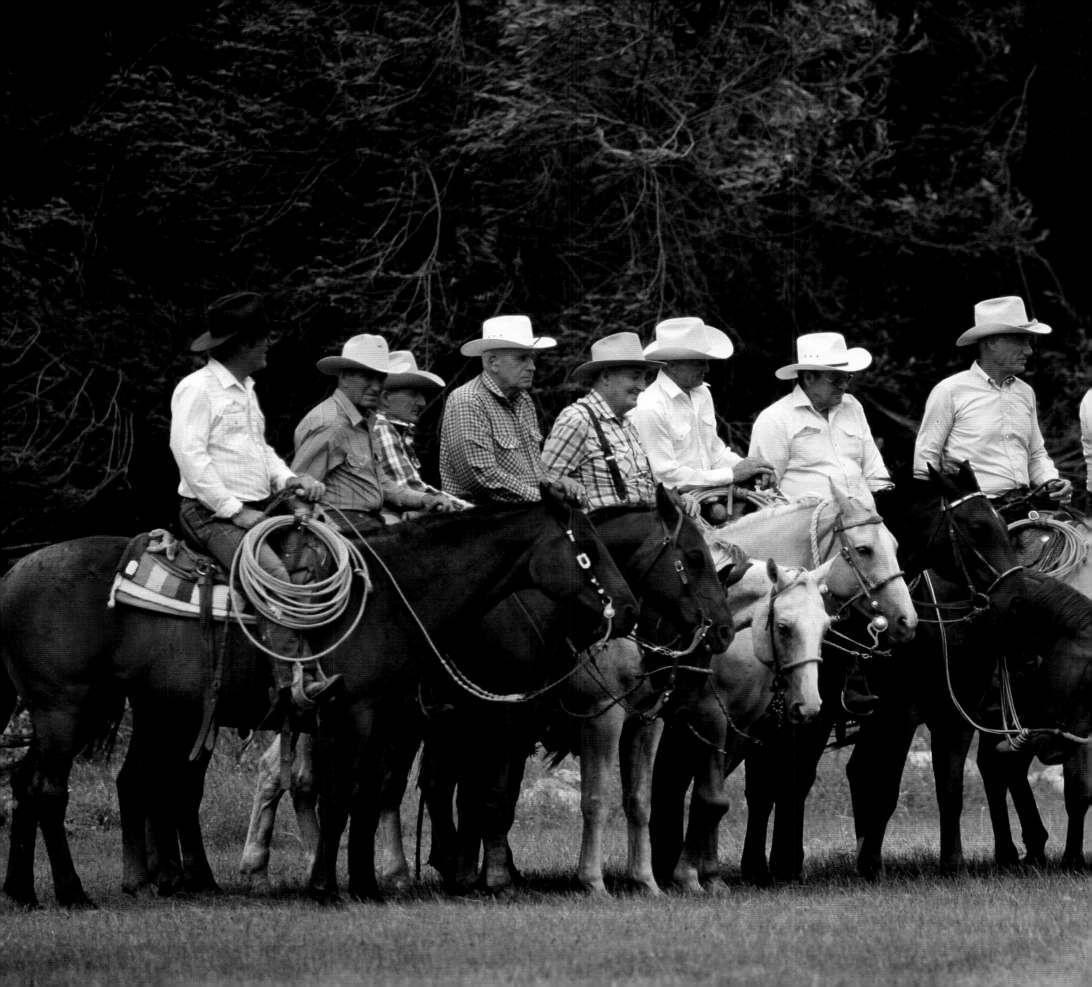

On a hot summer day in August 1994, the oldtime cowboys of the Bruneau Valley gathered at the Hall Ranch for a photograph commemorating years of working together on the ranges of Southwestern Idaho and Northern Nevada. The oldest cowboy was Bill Tindall, 78 years old, and the youngest, Dave Lahtinen, was 60. These men all started riding before the range was fenced and remember well the open range days. They are the generation in passing, the ones who we owe for settling this western land and for keeping the spirit of the West alive.

—David R. Stoecklein

The Men from Bruneau Idaho
Ace Black, Don Davis, Bill Tindall, Tom Hall,
Bob Tindall, Frank Davis, Ray Colyer, Joe Black,
Herb Mink, Ronald Hutchison, and Dave Lahtinen

THE END

THE CONTRIBUTORS

Lewis Feild is a three-time World Champion All-Around Cowboy, two-time World Champion Bareback Rider, and three-time winner of the Bill Linderman Award. He started rodeoing when he was 7 years old and retired at the age of 35 as a million-dollar cowboy. Since retiring from the rodeo in 1991, Lewis operates the Diamond G Rodeo Company in Elk Ridge, Utah, with his wife, Veronica, and their children.

Jack Goddard is a banker in Shelly, Idaho, but his heart is always on the open range. He owns a ranch in Mackay, Idaho, with his mother and brother and he's also a writer and photographer who focuses on the West.

Chuck Hall is a third-generation cowboy and son of Tom Hall, who grew up with the Bruneau Valley in Idaho as his playground. He is now an Idaho Brand Inspector and continues to work on the family ranch.

Tom Hall is a 2nd-generation cowboy and rancher from Bruneau, Idaho. His family has owned the Hall Ranch since 1917 and he has lived in the same house since he was born. Tom knew that he would be a cowboy and rancher when he was ten years old.

Nancy Hoggan is a modern-day saddle maker who designs saddles for working cowboys all over the West. She started working leather when she was only 15 years old. When Nancy isn't building saddles or raising her children, she is helping her husband, Jay, manage his rodeo stock business.

Darrell Leavitt has lived in Mackay, Idaho since 1930, and he still works for the original ranch where he was raised, now the Bar Horseshoe Ranch. There is nothing Darrell would rather do than ride a horse along side a herd of cattle.

Herb Mink was raised at the Circle C Ranch in Idaho and became a cowboss when he was in high school. This range rider is quite a character who spends his summers in the cow camps of Southwestern Idaho near Bruneau. He's been a cowboy all of his life.

Jo Mora wrote two books on the West, *Trail Dust and Saddle Leather* and *Californios*, which are considered to be the best volumes ever written about the history of the West and the California cowboys, the vaqueros.

Curt Pate has been training horses since he was 4 years old. He is a horse trainer and cattle rancher who lives in Helena, Montana, with his wife, Tammy, and their children on their family ranch.

John and Diane Peavey run a fourth generation sheep and cattle ranch in the foothills of the Pioneer Mountains in Southcentral Idaho. John's son, Tom, and his family work by their side. John Peavey was in the Idaho State Senate for 20 years until he finally retired in 1994. Diane writes essays about ranch life and the changing western landscape which broadcast weekly on Idaho Public Radio.

Scott Preston moved to the West in 1980 after dropping out of college in Michigan. He's worked as a ranch hand, ski lift operator, house painter, and Federal Express courier, among other occupations. His interest in cowboy culture was ignited by attending the first Cowboy Poetry Gathering in Elko, Nevada, in 1985, an event he has returned to every year since. His own poetry and prose have been widely published in the American small press.

Donald "Cotton" Riley, from Richfield, Idaho, has been working with mules all of his life. Cotton is a very well known cowboy in Idaho and Northern Nevada, famous for his skills with horses and mules.

Tom B. Saunders IV is a fifth-generation Texas cowboy and rancher who comes from a long line of Texas cowboys dating back to the 1840s. He and his family own the VV Ranch in Weatherford, Texas, where he spends a great deal of his time. He is also very active in the Cattle Raisers Association, as well as other organizations in his home state of Texas.

Dan Streeter is the associate editor of the *Paint Horse Journal*, the official publication of the American Paint Horse Association. An active member of the Outdoor Writers Association of America, he is also a freelance writer and photographer with interests that include travel throughout the Western states, hiking, bicycling, birding, and the cultivation of chile peppers. Originally from Tucson, Arizona, Dan now lives in Hurst, Texas.

Spider Teller is a legend in the branding pen. No one can make a rope dance the way he can. He lives in Owyhee, Nevada, with his family and travels extensively through out the West, branding cattle and competing in ropings.

Ira Walker grew up on a ranch in Owyhee, Nevada, where he started roping when he started walking. He is probably one of the best all around ropers in the saddle today. Ira can rope horses and cows in the brush with the same speed and craftsmanship that he shows in the arena.

Chad Williams was born and raised in Hamer, Idaho, and breaks horses for the Dragging Y Ranch in Grant, Montana. For the last few winters, Chad has been attending college at Idaho State University in Pocatello.

PHOTOGRAPHER'S STATEMENT

David R. Stoecklein

I have been taking photographs professionally for over 27 years, and I am continually striving to improve my work so that my photographs are more interesting and powerful. Over the last ten years, I have devoted a great deal of my personal and professional efforts to photographing the West—its landscapes, its people, its culture, and its heritage.

Eighteen months ago, I started using the Canon system of cameras and lenses, which has allowed me to take photographs that were not possible in the past. I use the new Canon EOS-1N camera with a 400mm f2.8L USM (ultra sonic motor) auto focus lens, along with Canon's 70-200mm f2.8L USM, 28-70mm f2.8L USM and 17-35mm zoom lenses exclusively. Canon's auto focus system allowed me to create the sharp images and quick action shots that you see in *Don't Fence Me In*. The metering system is so accurate that I no longer have any worries about the accuracy of my exposures. The majority of the photographs in this book were taken using this Canon EOS system.

I use Kodak's Ektachrome Lumiere ASA 100 film, as well as Kodachrome ASA 200 for my early morning and late evening shots.
This film has allowed me to shoot more back-lit images to capture even more vivid colors, brighter sunsets, and bluer, colder winter shots.
With the low contrast and high saturation of this film, I have the advantage of getting the shot I want.

All of the film for *Don't Fence Me In* was processed by BWC Chrome Labs in Miami Beach, Florida, and the photo prints and photo CD's used in the production of this book were done at BWC Labs in Dallas, Texas. BWC worked closely with my staff and the technicians at Kodak to ensure that my photos turned out just as they were taken.

Without the technical support of Canon, Kodak, and BWC, this book would not have been possible.

Thank you,

David R. Stoecklein

Some of my favorite images from this book can be seen as limited edition iris prints at the Jordan Gallery in Cody, Wyoming, and at the Stockyards Station Gallery in Fort Worth, Texas. All of my images are available through our office in Ketchum, Idaho. For more information call us at 1-800-727-5191.

Other books by David R. Stoecklein

Sun Valley Signatures III—a beautiful coffee-table book featuring photographs of Sun Valley, Idaho, and its surrounding areas.

The Idaho Cowboy—capturing the life and times of the Idaho Cowboy, this book has become a classic western volume.

Cowboy Gear—a photographic portrayal documenting the early cowboys and their equipment, this coffee-table book features real cowboys in authentic 1800's to pre-1930's gear.

Other books published by Stoecklein Publishing:

Trail Dust and Saddle Leather, by Jo Mora
Californios, by Jo Mora
Budgee Budgee Cottontail, by Jo Mora
Jo Mora: Renaissance Man of the West, by Steve Mitchell

Every year, Stoecklein Publishing produces a line of wall calendars, prints, and cards featuring the western photography of David R. Stoecklein.
For information please write or call:

Stoecklein Publishing
Tenth Street Center, Suite A1
Post Office Box 856
Ketchum, Idaho 83340
208/726-5191 Fax: 208/726-9752
Toll free at 800/727-5191